Digital Photography

Essential Skills

Fourth Edition

Mark Galer

Focal Press is an imprint of Elsevier The Boulevard, Langford Lane, Kidlington, Oxford OX5 1GB, UK 30 Corporate Drive, Suite 400, Burlington, MA 01803, USA

First edition as Location Photography: Essential Sills 1999 Reprinted 2000 Second edition 2002 Third edition as Digital Photography in Available Light 2006 Fourth edition 2008 Reprinted 2009

Copyright © 1999, 2002, Mark Galer. Published by Elsevier Ltd. All rights reserved Copyright © 2006, Mark Galer and Philip Andrews. Published by Elsevier Ltd. All rights reserved Copyright © 1999, 2008, Mark Galer. Published by Elsevier Ltd. All rights reserved

The right of Mark Galer to be identified as the author of this work has been asserted in accordance with the Copyright, Designs and Patents Act 1988

No part of this publication may be reproduced, stored in a retrieval system or transmitted in any form or by any means electronic, mechanical, photocopying, recording or otherwise without the prior written permission of the publisher

Permissions may be sought directly from Elsevier's Science & Technology Rights
Department in Oxford, UK: phone (+44) (0) 1865 843830; fax (+44) (0) 1865 853333;
email: permissions@elsevier.com. Alternatively you can submit your request online by
visiting the Elsevier web site at http://elsevier.com/locate/permissions, and selecting

Obtaining permission to use Elsevier material

Notice

No responsibility is assumed by the publisher for any injury and/or damage to persons or property as a matter of products liability, negligence or otherwise, or from any use or operation of any methods, products, instructions or ideas contained in the material herein. Because of rapid advances in the medical sciences, in particular, independent verification of diagnoses and drug dosages should be made

British Library Cataloguing in Publication Data

A catalogue record for this book is available from the British Library

Library of Congress Cataloging-in-Publication Data

A catalog record for this book is available from the Library of Congress

ISBN: 978-0-240-52112-1

For information on all Focal Press publications visit our website at www.focalpress.com

Printed and bound in China

09 10 11 12 10 9 8 7 6 5 4 3 2

Working together to grow libraries in developing countries

www.elsevier.com | www.bookaid.org | www.sabre.org

ELSEVIER BOOK AID

OK AID Sabre Foundation

Acknowledgements

I would like to pay special thanks to John Child, Andrew Fildes and Michael E. Stem for their editorial input and to Orien Harvey for many of the wonderful images used to illustrate the text. I would also like to thank the students of RMIT University and PSC Melbourne who have also kindly supported this project with their images. I would also like to pay special thanks to my wife Dorothy - without whom this book would never have seen the light of day. Thank you.

mark galer

Picture Credits

Ansel Adams (Ansel Adams Publishing Rights Trust/Corbis), Tim Barker, Shane Bell, John Blakemore, Ricky Bond, Abhijit Chattaraj, Dorothy Connop, Matthew Connop-Galer, Walker Evans (Walker Evans Archive, The Metropolitan Museum of Art), Andy Goldsworthy, Orien Harvey, John Hay, John Henshall, Itti Karuson, Sean Killen, Dorothea Lange, James Newman, Kim Noakes, Matthew Orchard, Ann Ouchterlony, Stephen Rooke, Michael E. Stern, Mikael Wardhana, Michael Wennrich, Amber Williams.

All other images by the author.

Contents

Foreword	i×
Introduction	X
1. Digital cameras Introduction Choosing a digital camera Megapixels Sensors Choice of lens The need for speed Fixed-lens digicams - a viable alternative? Viewfinders and LCDs Image stabilization	1 2 4 4 6 12 13 14 15
Check list overview 2. Asset management Digital asset management (DAM) What is Lightroom? Adopting a Photoshop Lightroom workflow Conclusion	20 21 22 23 25 32
3. Exposure Introduction Intensity and duration TTL light meters Interpreting the meter reading Reading exposure levels Raw format exposure considerations Lowering exposure in ACR	35 36 38 42 45 47 50

4. Framing the image	59
Introduction	60 61
Contract	62
Content Balance	63
Subject placement	64
The decisive moment	65
Vantage point	66
Line	67
Depth	69
Summary of basic design techniques	70
Summary of basic design teeriniques	10
5. Creative controls	71
Introduction	72
Focus	73
Duration of exposure	78
A creative decision	82
Perspective	83
Summary of basic camera techniques	84
Online technical tutorials	84
6. Light	87
Introduction	88
Light source	89
Intensity	90
Quality	92
Color	93
Direction	94
Contrast	95
Exposure compensation	99
Filtration	102

7. Lighting on location	105
Introduction	106
Fill	107
Reflectors	108
Flash	109
Choice of flash	110
Guide numbers	112
Flash as the primary light source	114
Diffusion and bounce	115
Fill flash	116
Flash as a key light	117
Slow-sync flash	119
Double exposures	120
High dynamic range	121
8. Post-production editing	125
Introduction	126
Optimizing photos using Photoshop Lightroom	126
Quick Develop	127
Develop module	129
Tool Strip	147
	1-11
9. Printing	153
Introduction	154
The problem and the solution	155
Printing from Photoshop Lightroom	167

10. Landscape Introduction History Personal expression Expressive techniques Detail Night photography The constructed environment Assignments	169 170 170 174 176 183 184 185
11. Environmental portraits Introduction Design Revealing character Connecting with new people Directing the subject Character study Assignments	189 190 191 194 195 197 198
12. The photographic essay Introduction Visual communication Capturing a story Working styles Editing a story Ethics and law Distribution and sale of photo-essays Assignments	201 202 204 206 209 212 213 215 216
Glossary	219
Index	227

Foreword

Creative, successful professionals are highly motivated to improve their skills by engaging in continuous learning activities. Whether through the formal setting of a classroom, workshops, seminars, on-line learning, or just picking up a book, we are always searching for information on the complex issues of our chosen profession.

When it comes to photography (especially during the past ten years), the amount of information we seek has been compounded by the sheer speed at which innovations are brought to market.

Cameras, sensors, resolution, lens factor, exposure latitude, noise, compression artifacts, Raw, chromatic aberrations, AWB, etc. are some of the topics and skills that have had to be learned as brand new concepts or re-learned from the digital perspective. The speed at which 'new and improved' tools and concepts are being introduced makes everyone seem expert but in fact misinformation is as abundant as poorly crafted digital captures.

How do I put into words my appreciation for a book like this? As a professional photographer for more than 25 years and an educator for 19 years, building a reference library for my studio is an ongoing task.

This book is one of the best I've ever read due to the depth and breadth of topics covered and will find a prominent place in my collection. I particularly appreciate that the author addresses the dynamic changes in the field of digital capture while remembering photography's timeless qualities.

Hooray for Mark for he is speaking to us all with the single-minded goal of disseminating clear and thoughtful information.

Thank you Mark, from all of us.

Michael E. Stern www.CyberStern.com

Adjunct Faculty Brooks Institute

Introduction

Location photography covers a wide range of disciplines. From the captured image of a fleeting moment using existing light to the highly structured and preconceived advertising image using introduced lighting. This book is intended for photographers working on location using primarily the existing or 'available' light source. The information, activities and assignments provide the essential skills for creative and competent photography. The chapters offer a comprehensive and highly structured learning approach, giving support and guidance in a logical and sequential manner. Basic theoretical information is included along with practical advice gathered from numerous professional photographers. An emphasis on useful (essential) practical advice maximizes the opportunities for creative photography.

Acquisition of technique

This book is designed to help you learn both the technical and creative aspects of photography. The initial chapters provide the framework for the assignment briefs that follow. The chapters will help you acquire the essential skills required to confidently undertake a broad range of location work using ambient light. Terminology is kept as simple as possible using only those terms in common usage by practising professionals. The emphasis has been placed upon a practical approach to the subject and the application of the essential skills.

Application of technique

The book concludes with several chapters devoted to the practical application of the skills acquired in the earlier chapters of the book. Assignments can be undertaken in each of the three areas allowing the photographer to express themselves and their ideas through the appropriate application of design and technique. This book offers a structured learning approach that will give the photographer a framework and solid foundation for working independently and confidently on assignment.

The essential skills

To acquire the essential skills required to become a professional photographer takes time and motivation. The skills covered should be practised repeatedly so that they become practical working knowledge rather than just basic understanding. Practise the skills obtained in one chapter and apply them to each of the following activities or assignments where appropriate. Eventually the technical and creative skills can be applied intuitively or instinctively and you will be able to communicate with clarity and creativity.

thoto by Ricky Bond

digital cameras

Mark Galer

essential skills

- Understand the differences between various types of digital cameras.
- Compare specifications and isolate features important to your personal workflow.
- Appreciate the limitations of various systems and their impact on image capture and quality.

Introduction

I first encountered a DSLR when I was working in London in 1993. It was the Kodak DCS100 - the first totally portable Digital Camera System (DCS) that had been released in 1991. It had a 1.3-megapixel sensor mounted in a largely unmodified Nikon F3 SLR body that had a restricted viewfinder, no memory card (just a hard drive that used to get hot) and the image had to be downloaded via an umbilical cord to a separate digital storage unit (DSU) that had a 4-inch black and white monitor. The DSU was about the size and weight of a large camera bag that could be mounted on your belt. Having said all that I was hooked on the very first image that I captured with this beast. I shot a press image with the camera and after glancing at the monitor I realized I had the image in the bag (so to speak) with the very first shot. It felt very, very strange walking away without shooting the other 35 frames and winding off the film. Although I had seen the future - it remained just that for many years. The camera was a bit of a Frankenstein's monster (Kodak digital technology bolted into a Nikon film camera), cost the same as a new family car and the low pixel count made it easy not to invest any personal money into digital capture at that point in time.

Images courtesy of John Henshall

The development of the digital SLR camera

In 1999 Nikon announced its digital independence day (independence from Kodak's branding) with the launch of its landmark camera the D1. Looking at the spec sheet of this camera in 2006 (with just 2.7 megapixels) it is hard to see what all the fuss was about. It was, however, the first digital camera that did not look or feel like a 'bitsa' (bits of this and bits of that) using an all-new camera design rather than the Nikon F4 or F5 film body. The price of the Kodak/Nikon hybrids had been enough to frighten many pro-photographers but the Nikon D1 came in at a price that made many pro-photographers start to take notice. A few pro-photographers took the plunge but unless you were shooting for newspapers, catalogs or real estate magazines the pixel count was still a major issue. The year 2000 (a new millennium), however, saw the capabilities of the D1expanded just 8 months after its original release. The D1x now sported a sensor capable of recording nearly 6 megapixels and many photographers who could do their maths saw the significance of the D1x to their own workflow. Single page illustrations in magazines were now an affordable reality for the pro-photographer.

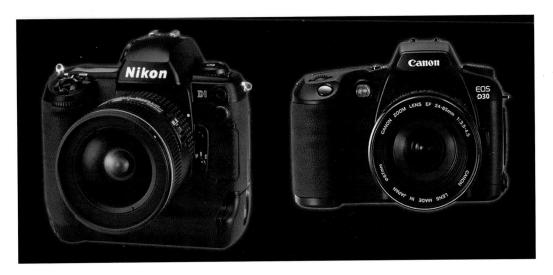

The hardware was still significantly more expensive than the film equivalent but when the savings on film were factored into the equation the DSLR made economic sense for many photographers. The year 2000 also saw Canon realize their independence from Kodak with the release of their built-from-the-ground-up 3-megapixel D30 using a CMOS sensor instead of the CCD technology favored by Nikon. The most notable feature about this camera was not its megapixel count, or its quality (which was pretty impressive) but its comparatively low price (US\$2800 - half that of the D1x) and its user-friendly interface – a sign of things to come. Nikon and Canon - the traditional suppliers of 35mm SLRs to pro-photographers - it seemed, were set to do battle in the digital arena, just as they had in the film arena that preceded it.

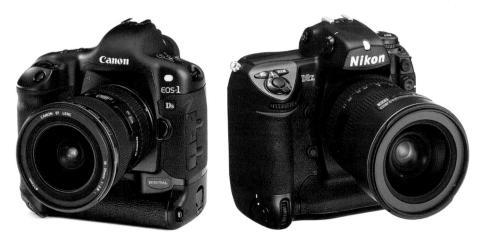

The D2x would be four years in the making but during this period Canon were making some significant advances in DSLR technology that started their rise to market supremacy. In 2001 the incredibly fast EOS 1D outgunned Nikon's D1H (more pixels and faster). In 2002 they released the very impressive 11-megapixel EOS 1Ds that set a new quality benchmark for all the other DSLR manufacturers would have to aspire to. This camera could shoot in low light at high ISO settings with minimal noise.

Choosing a digital camera

Choosing a digital camera that will meet your imaging needs (and not blow a hole in your budget) can seem as difficult and confusing as choosing a new mobile phone plan or setting your neighbor's DVD recorder to record their favorite TV show in two days' time. If we focus on the key differences between the digital cameras currently available the choice can be somewhat clarified, and the range of models that will fulfil your requirements can be narrowed considerably. If you need to go shopping it can be a useful exercise to create a 'must have' list after considering the implications of the various features that digital cameras do, or do not, offer. As the numbers of makes and models of digital cameras are immense this chapter focuses its attention on a few significant cameras (significant in their respective genres) to enable direct comparisons.

Boroka lookout, The Grampians. Captured on a fixed lens digital camera

Megapixels

Top of most people's 'things to consider' list is usually 'megapixels' - how many do I want, how many do I need? 12 or 14 megapixels is great if you like cropping your images a lot or have a constant need to cover double-page spreads in magazines at a commercial resolution or create large exhibition prints.

Many high quality 10-megapixel cameras can, however, create digital files that can be grown to meet these requirements if the need arises. If the ISO is kept low digital files from many cameras can be 'grown' with minimal quality loss. Try choosing the 'Bicubic Smoother' interpolation method in the 'Image Size' dialog box when increasing the pixel dimensions of an image to ensure maximum quality is achieved.

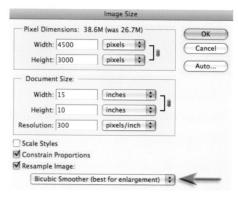

Image Size dialog box in Photoshop

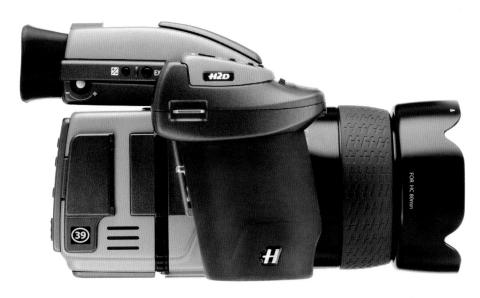

The Hasselblad H2D - who could want for anything more? Ultimate 39-megapixel SLR or resolution overkill?

A 39-megapixel medium-format capture may sound like something everyone would want to aspire to or own (and for some commercial photographers it is the only option) but you have to weigh up the implications of capturing such large files. A 39-megapixel file will place an increased burden on the hardware and software - slowing systems considerably if they do not have the performance to cope with the heavy traffic that multiple 39-megapixel files can impose. Many photographers in this period of transition from analog to digital make the mistake of replacing like with what they perceive to be like, e.g. an analog medium-format camera such as a Hasselblad or Mamiya 645 or RZ67 with what they believe to be the equivalent digital medium-format camera. It is worth noting, however, that the quality that can be achieved with a high-end digital SLR, such as the Canon 1Ds Mark III or Nikon D3, can match the image quality of a medium-format analog camera using a fine-grain film. A digital medium-format camera, one could safely assume, is knocking on the quality door of 5 × 4 film and surpasses the quality that is available from medium-format film. The price differential between a Hasselblad medium-format digital camera and the Canon 1Ds Mark III is considerable and for many photographers the DSLR would outperform the Hasselblad in terms of speed and ease of handling.

Enough is enough

Now that most of the more recent prosumer fixed lens and DSLR cameras sport at least 10 megapixels the need for more is a timely question. A 10-megapixel file will easily cover a full page in your average magazine at commercial resolution. If you need more then you also need to consider whether the need for speed is greater than the need for size. Having both can be a costly venture.

Sensors

Size and aspect ratio

Does size really matter? When it comes to digital imaging it has to be said that bigger really is better. Apart from a few exceptions, the quality that can be achieved with fixed-lens prosumer digicams is limited by the size of sensor that they use. As the individual sensor sites are spread over a larger surface area the pixels tend to suffer less from noise (small white or colored speckles - see camera Raw). Sensors in the prosumer cameras tend to be small, whilst in DSLR cameras the sensor size is comparatively much larger (more than double the dimensions and quadruple the surface area). The use of small sensors in prosumer digicams usually leads to increased levels of noise when compared to the images captured with a DSLR camera at the same ISO - especially when comparisons are made at higher ISO settings. Larger sensor sites typically lead to less problems with noise. Images captured with 35mm full-frame sensors found in DSLRs such as the Canon EOS 1Ds Mark III and Nikon D3 exhibit lower noise levels than budget DSLRs that use slightly smaller sensors (such as the popular four-thirds or DX format sensors). The larger 645 sensors found in medium-format digital cameras such as the Hasselblad D2H or D3H capture images that are pretty much noise free.

Most prosumer digicams and some DSLRs currently available (Olympus and Panasonic) use sensors that have a 4:3 format or 'aspect ratio'. A 4:3 aspect ratio means that for every unit of height, the width is one and a third times wider. This format is the same as a standard computer screen, e.g. 1024×769 pixels. All of the DSLRs made by Canon, Nikon and Sony have image sensors with a 3:2 aspect ratio that matches 35mm film. This is a slightly wider format than 4:3 but not as wide as a widescreen television that has a 16:9 aspect ratio. Some prosumer digicams now offer 3:2 as an alternative aspect ratio (usually cropped from the 4:3 format in camera) whilst some digicams use a CCD image sensor with a 16:9 format. Care needs to be taken when framing images for editorial work. The photographer has to be prepared to lose some of the visible image in the viewfinder if an editor wants to produce either a full-page or double-page spread from an image captured in a different aspect ratio.

Sigma DP1 - small camera with a big sensor

Large sensors in small cameras

A couple of fixed-lens cameras have started incorporating a larger sensor to provide image quality that has typically been associated with DSLR cameras. The Sony R1 introduced the concept of using a larger sensor a few years ago and the Sigma DP1 has proved that DSLR image quality can now be achieved using a pocket sized camera.

Dynamic range

Another advantage that cameras with larger sensors enjoy over cameras with smaller sensors is the fact that larger sensors are able to record a broader dynamic range, i.e. the ability of the sensor to record information in a high contrast scene. Add a white dress, a black suit and a little sunshine and most digicams have met their match as the scene easily exceeds the subject brightness range that most digicams can handle.

The S5 Pro DSLR uses the SuperCCD SR sensor that uses two photodiodes located at each photosite. The 'S' pixel has normal sensitivity whilst the 'R' pixel is smaller and captures information beyond the highlight range of the 'S' pixel. The camera's processor combines the information from the two photodiodes to create an image file with an extended dynamic range

Using a DSLR to record the same high contrast scene has typically only been an advantage when capturing in the Raw format and the photographer extracts the additional detail using the Recovery slider in Lightroom or the Adobe Camera Raw interface (Fuji S5 excepted as it uses a specialized 'SR' sensor). Some manufacturers such as Sony are admirably handling the issue of high subject contrast by implementing an automatic dynamic range optimizer (D-Range Optimizer) that ensures the information from very bright highlights is preserved in an attempt to pass on the advantages of the broader dynamic range of a larger sensor to the JPEG file.

Full-frame or reduced-frame sensors for DSLR cameras

A few of the more expensive DSLR cameras are described as 'full frame' as the size of sensor is the same as a frame from a 35mm film camera (the rest of the DSLR cameras on the market use smaller sensors). The use of a larger sensor has a few advantages and disadvantages for potential buyers of these cameras. As the sensor of a full-frame DSLR is larger it has the potential to offer higher quality images. This is, however, dependent on the lens that is used in conjunction with this larger sensor. These full-frame DSLRs cannot use lenses designed for the DSLR cameras that use smaller sensors without issues or problems arising, e.g. the owner of a DSLR with a smaller sensor who wants to purchase a full-frame camera by the same manufacturer may not be able to use the lenses they already own on this model unless the lenses they have purchased were designed for full-frame sensors or 35mm film. Nikon owners may be able to place a Nikkor DX lens designed for a Nikon D300 on the full-frame Nikon D3 but will have to capture images at 5 megapixels instead of 12 megapixels. This is because lenses designed for reduced-frame sensors do not create an image big enough to cover the larger full-frame sensors. The full-frame lenses are more expensive to build than lenses of similar quality designed for reduced-frame sensors. If a photographer aspires to owning a professional quality DSLR that uses a full-frame sensor they need to purchase wisely.

Magnification factor

full frame or reduced frame?

The size of the sensor has an impact on the magnifaction factor that a photographer will experience with the lenses they are using, e.g. a 200mm lens on a Nikon D300 magnifies the image 50% more than if the photographer uses the same lens on a full-frame Nikon D3 (a magnifaction factor of x1.5). Manufacturers often quote these magnifaction factors for assessing the equivalent focal length of lenses when used in conjunction with a camera with a reduced-frame sensor. Nikon DX is x1.5 while Olympus quote x2 for their cameras using the four-thirds system sensors. A wide-angle 24mm lens is a wide-angle 24mm lens on a camera with a full-frame sensor but becomes a not-so-wide 36mm when attached to a smaller DX sensor. This may have been a big selling point for a photographer who had not yet made the jump from film who owned a more traditional range of lenses but purchasing one of the popular ultra wide zooms designed for reduced-frame sensors gives back the angle of view that the photographer may have lost. The advantage for the owners of DSLRs with smaller sensors is that their telephoto lenses suddenly bring everything a lot closer than if they were using the same lens on a full-frame sensor.

CMOS or CCD

The type of sensor (CMOS or CCD) found in a DSLR camera has a bearing on the levels of noise present in the image. The CMOS sensor has gained a reputation for delivering images with less noise at high ISO settings (400 ISO and higher) than a CCD sensor of a comparable size. The Canon CMOS sensors found in all of their digital SLRs raised the bar in terms of acceptably high ISO speeds that can be used before the level of noise becomes intrusive and the image loses its commercial viability. A high quality CCD sensor, however, can often deliver superior performance when capturing at a low ISO setting when compared to a CMOS sensor. The presence of noise at low ISO settings, however, tends to be less obtrusive and these differences are not usually seen in standard sized prints and screen presentations.

Detail from an image captured at 800 ISO using a CMOS sensor

CMOS for high ISO performance

Canon has always used CMOS sensor technology in their DSLRs while the other manufacturers have favored the CCD for their consumer DSLRs. New models by Sony and Nikon, however, are now using the CMOS sensor for increased performance at high ISO settings. Although most modern sensors are excellent, each has its own characteristics that are evident when the ISO is adjusted. Typically noise levels get worse as the ISO of the sensor is increased or during extended exposure times. The ISO of good quality CCD sensors can often be raised to 400 or 800 ISO before excessive image noise rears its ugly head. The CCD sensor, however, is no match for the performance of modern CMOS sensors at higher ISO speeds. Photographers using cameras sporting these modern CMOS sensors can often find themselves shooting at speeds of 1600 and 3200 ISO before noise becomes problematic. This high ISO performance allows the photographer to shoot color images, hand-held and in low light, without resorting to flash (something that was only recommended with fast black and white film in the days of analog photography). This can be a liberating experience for professionals used to shooting at low ISO and having to resort to fast lenses (those with maximum apertures of f/2.8 or wider) and tripods. The wide aperture pro lenses are considerably more expensive than the consumer zooms. The ability to now work in low light with an f/4 zoom lens instead of a wide aperture fixed focal length lens opens up all sorts of creative and financial possibilities in this new digital era.

Noise - low ISO

Although CMOS sensors are very good news at high ISO the cleanest files at 100 and 200 ISO are usually captured with cameras using a CCD sensor. The difference, however, is usually only noticeable when large prints are being made from these files or where the photographer has been making the deep shadow information lighter using a Curves or Levels adjustment. When post-production editing requires the shadows to be opened to reveal more detail, the files created by a DSLR using a high quality CCD sensor at low ISO are usually able to deliver the goods.

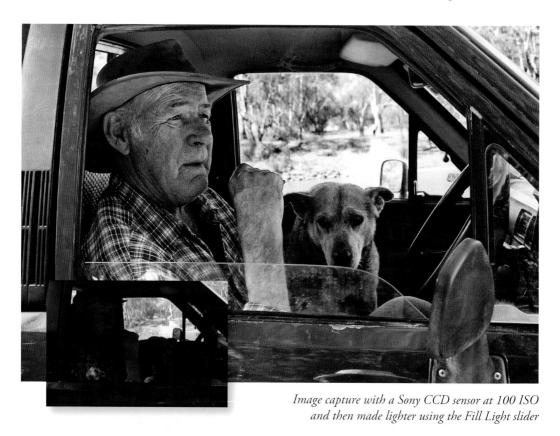

In comparison the deep shadows found in files captured by cameras using CMOS sensors are best left as just that - deep shadows. With such great performance at high ISO, it is somewhat disappointing to see noise still evident at just 100 or 200 ISO in the image files captured by DSLRs with CMOS sensors (even though it would take large print sizes and lightened shadow detail to reveal these differences).

Note > When deep shadows are lightened excessively in digital files the photographer may notice 'tonal posterization' (a visible banding of tones) is often evident - even when the files are clear of luminance noise. This weakness in shadow detail is due to the linear nature of the sensor and is a result of the decreased number of levels dedicated to the shadow tones. The only solution to this problem is to increase the exposure so that more levels are dedicated to these darker tones.

In-camera noise suppression

If we examine the detail (zooming in to 200% or 300% on screen) from an image captured at ISO 400 on the Fuji s9500 in low light we will discover posterization and lumpy tones. These are evident as a result of in-camera processing in an attempt to suppress the noise that is inherent in files captured with the small sensors found in prosumer digicams.

The small sensor of a fixed-lens prosumer camera pushes its luck at 400 ISO - image magnified to 300%

The in-camera processing that can be observed in the image above (captured at 400 ISO) makes it look as if we are viewing the scene through distorted glass. Quality is starting to be compromised. If we were to view the same image as a Raw file in Lightroom or Adobe Camera Raw (with no in-camera processing having been carried out) then the smudged detail would be replaced with luminance and color noise that is reminiscent of images captured with high-speed color film. Many camera manufacturers can be a little overzealous with in-camera noise suppression and it would be good to see options for noise suppression for photographers wanting to capture images using the JPEG file format on these prosumer fixed-lens cameras.

Note > Although the image artifacts are starting to appear at 400 ISO, they are barely noticeable in a 4×6 inch print or monitor preview of the entire image.

Choice of lens

The visual difference between capturing a subject with a 10- and 12-megapixel camera for a magazine double-page spread is hardly likely to be significant or noticeable. The question of quality is much more likely to be decided by the quality of the lens used to capture the image.

Image captured using a full-frame sensor and a Canon EF 16-35mm f/2.8L USM lens (16mm) @ f/11

Camera body only or kit (body and lens)

Kit lenses (attached to the camera when you buy it) are designed for price rather than optical performance. Although they may perform well at some apertures they may not be very sharp at maxium and minimum apertures. If you purchase the body only and invest in a more expensive lens then you are likely to get better optical performance over a broader range of apertures.

Corner sharpness, vignetting and diffraction

Image sharpness deteriorates further away from the center of the image. A lens that can hold its sharpness in the corners of the image requires great optical precision. It therefore follows that quality lenses designed for full-frame sensors are more expensive to make than lenses designed for reduced-frame sensors as the corners of the sensor are further from the center. At wider apertures the corners of the image may also appear lighter than the rest of the image (vignetting), and the problem may be more apparent when using DSLR cameras with full-frame sensors. When using the smallest apertures on the lens (f/16 and f/22) you may notice the effects of diffraction rendering the image less sharp (the effects of the aperture blades in the lens dispersing a greater percentage of the light being used to create a sharp image). The effects of diffraction may be more noticeable on poorer quality lenses and sensors where the pixel size is smaller, e.g. the effects of diffraction may be less obvious on a DSLR using a 12-megapixel full-frame sensor than a camera using a 12-megapixel reduced-frame sensor.

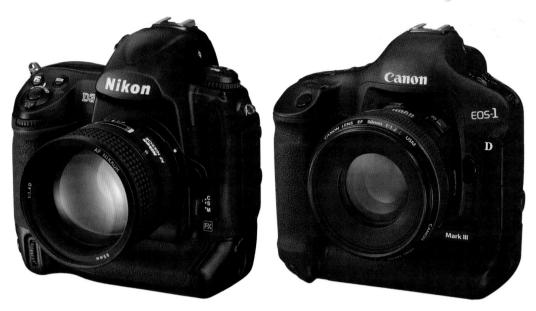

The Nikon D3 Canon EOS 1D Mark III - 9 and 10 frames per second and bursts and in excess of 30 Raw files before the buffer is full. The Canon EOS 1D Mark III should not be confused with the EOS 1Ds Mark III (you may want to read that again and note the little 's' difference) which is Canon's full-frame state-of-the-art quality DSLR

The need for speed

The issue of speed can arise in many stages of a digital workflow. Many of the issues that were connected to the issue of speed that proved problematic in digital cameras only a few years ago have largely been removed from the equation. Delays between switching the camera on and being able to take your first image, achieving focus and the delay between pressing the shutter release and the camera actually capturing the image (called shutter lag) have now been mostly relegated to the cheaper digital compacts. After capturing the image the camera then has to write the file to the memory card. The issue of speed here usually only becomes problematic if the photographer is shooting in the Raw format. Camera manufacturers resolve this issue of write speed by placing a 'buffer' that can store multiple images before the camera has to write the files to the card. If an unfolding action requires the photographer to shoot bursts of images in rapid succession then the size of the buffer is an important issue if the photographer needs to capture in the Raw format. Fast shooting whilst using the camera Raw format is usually the preserve of photographers using higher quality DSLRs. If the photographer is capturing images faster than the camera can write them to the memory card the camera will be unable to capture additional images until the buffer has more available memory. If the camera is continually 'locking up' whilst the camera's processor writes the images to the card the photographer must make the choice to shoot in shorter bursts, switch to the JPEG format or upgrade to a camera with a larger buffer and faster write speed.

Note > If the camera you are looking at is not an SLR it is advised that you test the amount of shutter lag prior to making a purchase. Lag is reduced significantly in the budget digital cameras if the shutter release is already half-pressed prior to capturing the image, i.e. focus and exposure are already set.

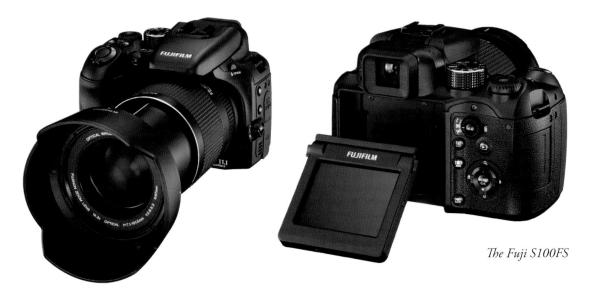

Fixed-lens digicams - a viable alternative?

Most photography enthusiasts may automatically assume that a DSLR camera is the only viable choice to achieve professional-looking results. There are, however, a few fixed-lens cameras on the market (sometimes referred to as 'Prosumer' or 'Bridge' cameras) that can offer surprisingly good results together with a broad range of features that photography enthusiasts often demand, e.g. the ability to save the images as camera Raw files to the memory card and have full manual override of exposure and focus. The Fuji S100FS, for example, is an 11-megapixel camera that has just about every feature that an entry-level DSLR boasts, with the exception of an optical viewfinder (these fixed-lens cameras use an electronic viewfinder or EVF) and the ability to change the lens. The Fuji S100Fs is about the same physical size as a small DSLR camera and is only a little cheaper than a budget DSLR kit - so what is the point of owning a camera that does not allow interchangeable lenses? The zoom lenses on these top-of-the-range fixed lens cameras often have 'super-zooms' with surprisingly bright maximum apertures. The lens on the Fuji S100FS, for example, has a focal length range from 7.1 to 101.5mm (equivalent to a 28-400mm lens on a 35mm DSLR) so the need to change lenses is rendered pretty much a non-issue. Not having to change lenses removes the risk of getting dust on the sensor as the camera is effectively a sealed unit, i.e. there is no need for a dust reduction system. Although the high ISO performance of these cameras is not quite a match for the larger sensors found in DSLR cameras, the fixed lens cameras do, however, offer the advantage of a movie mode that does not appear on the feature list for DSLR cameras. Although the price of one of these super-zoom fixed-lens cameras may be only a fraction cheaper than buying a DSLR camera if you were to factor in the additional lenses you would have to purchase to cover the zoom range then you would start to see why these fixed-lens cameras offer value for money. Perhaps the biggest difference between a DSLR camera and a fixed-lens camera is the optical viewfinder that is an exclusive feature found only on an SLR camera.

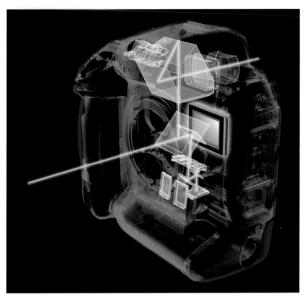

The pentaprism is an integral part of the creation of the optical view in a DSLR camera

Viewfinders and LCDs

Single Lens Reflex (SLR) cameras use a mirror and pentaprism design to display an optical view of your subject in the viewfinder prior to capture. The view is typically bright (especially if you have a wide aperture lens fitted) and detailed so that you can focus the image easily and quickly if you have to switch to manual rather than auto focus. The image is not a 'what-you-see-is-what-you-get' image as feedback on issues such as how the sensor will handle the subject contrast together with the effects of your choice of exposure and depth of field are not being previewed. A depth of field preview button is available on some DSLR cameras that allows you to preview the image with the aperture stopped down to the one that will be used to capture the image rather than the widest aperture which is normally used to provide the optical view. Although useful in some instances the subject can appear very dark in the viewfinder, making precise depth of field difficult to determine. This information is now more easily viewed on the LCD screen and not in the viewfinder after the image has been captured or before if using a DSLR with 'Live View'.

A fixed-lens digicam has no mirror, pentaprism and usually no optical viewfinder* so the view on the LCD screen or in the electronic viewfinder is always a live view.

* Some digicams, such as Ricoh's GR Digital, offer an optional optical finder to overcome the shortcomings of EVF technology (low resolution and excessive blur when panning).

Note > Leica's digital rangefinder camera has an optical viewfinder as standard but this is not the through-the-lens view that we see through a DSLR camera. The view from a rangefinder camera does not mirror exactly what the sensor sees and at close range there are the typical issues of 'parallax error' that is inherent with all rangefinder cameras. Allowances have to be made at close range to readjust the framing from the view that is displayed in the viewfinder.

Several maufacturers are now offering large 3.0-inch LCD screens with 922,000 pixels to enable a more accurate preview of image quality

LCD and EVF resolution

The latest DSLRs now provide large 3.0-inch LCD screens with 922,000 pixels to enable a more accurate preview of image quality. This is a big jump from the old 1.8- and 2.5-inch screens that had just 230,000 pixels (that may sound a lot but that is a resolution of less than 600 x 400 pixels). All the pixels in the world don't make a difference, however, when the lighting conditions are not conducive to viewing the screen at all. When bright sunlight is falling on the LCD screen (making viewing the subject difficult or impossible) or when the photographer requires detailed information to focus, the photographer will need to switch to viewing the scene via the viewfinder. Many prosumer fixed-lens cameras will automatically switch between the two using a proximity sensor that detects when you have put your eye to the viewfinder while others may require a button to be pressed to switch between the LCD and the viewfinder. It's usually at this point where consumer satisfaction with the digicams starts to falter and wane. What the meticulous photographer would expect from an EVF is a bright high-resolution image with a fast refresh rate (reduced flickering). What we usually get is our subject rendered with a view that is all too often less than 600 x 400 pixels which is no match for the information that can be seen when using an optical viewfinder. With dioptre adjustment available on most high-end DSLRs and prosumer digicams the photographer can make the viewfinder image pin sharp - but with an EVF viewfinder this means making the pixels sharp enough to count! Before the Konica-Minolta company stopped making digital cameras they offered one of the few alternatives. They set the benchmark, that the others failed to live up to, when they released a digicam with an EVF with nearly one million pixels (922,000 pixels to be precise). Why manufacturers have been slow to grasp the importance of the EVF to prosumer photographers is anyone's guess. The upshot is that manual focusing is problematic on most digicams. With this in mind it is worth checking that the auto focus options are quick and accurate throughout the zoom range and in low light conditions.

A simulation of an EVF view in low light (central portion magnified to aid manual focusing)

Manual focus when using an electronic viewfinder (EVF)

Some manufacturers of fixed-lens cameras, that ultilize an electronic viewfinder instead of an optical viewfinder, offer a focus check that enlarges the central information so that you can get a clearer picture of the pixel-starved fuzz - not at all helpful. These features would be highly appreciated if the manufacturers were then to quadruple the pixel count. Another feature that adds to the difficulty of focusing is that the manual focus rings on the digicams typically have no stops. They do not stop at infinity or the minimum focusing distance of the lens. Photographers using SLR lenses can, after practice, instinctively move the lens to the correct distance after appreciating the amount of twist they need to make from the stop. The lack of stops on the digicam lens precludes the use of this technique. The long and short of it is that focusing manually using a digicam is a tiresome affair that most users will hand over to the auto focus setting. With some mobile phones offering higher resolution LCD screens than the typical digicam EVF this is a situation I hope will be rectified if these models are to survive. It is perhaps the last real problem that is stopping the prosumer cameras creating a serious alternative to the DSLR market.

Is there a future for the prosumer camera?

Who then will be buying a high-end prosumer camera instead of a DSLR? They can be as expensive and as big as a small DSLR. The lack of an optical viewfinder or good EVF takes the shine off the experience of capturing images in some situations. They are slower when you need to capture bursts of images and can be noisier when you need to hand-hold images in low-light conditions. If, on the other hand, you are not adverse to using a tripod in low-light conditions and really can't be fussed with the whole 'lens-swapping, manual focusing, kit carrying' saga then you may be just the sort of person prosumer digicams have been designed for. These cameras could go from strength to strength over the coming years (if the sales continue), so if you are not quite ready to part company with traditional SLR technology just yet, be sure to keep an eye on the high-end prosumer digicam market.

Live view and adjustable LCDs are the plus points for DSLR owners

Live view

The ability to see your subject on the LCD screen before your press the shutter release was traditionally the preserve of the fixed-lens digicams and not possible with a DSLR camera (the mirror system typically obscuring the sensor prior to capture). Live view, however, is now possible with many DSLR cameras and offers several advantages over DSLR cameras that cannot display a live view. The owner of a DSLR camera with live view can view the scene when the camera is at arm's length for improved feedback when capturing images using high- and low-level vantage points. Live view also enables waist-level shooting for portraiture. This allows the photographer to retain eye-contact with your sitter. As the live view is not an optical view, but a preview of what the sensor will capture, it also provides the photographer with useful information about exposure, white balance and depth of field that could not otherwise be obtained until after the image has been captured. With live view the photographer is now able to override the auto controls to optimize the image quality before the image is captured rather than through a process of trial and error. The optical viewfinder will still offer the photographer the best feedback when focusing an image or working quickly to frame an image. Manufacturers have started to increase brightness, angle of view and the pixel count on the large LCD screens found on the latest DSLR cameras but there are times when the clarity of the information is compromised due to the lighting conditions found in the location where you are working. In brief, the live view can be an invaluable tool for the creative photographer but it will not fully replace the need for an optical viewfinder.

Image stabilization, in the lens or in the camera, reduces the need to raise the ISO to avoid camera shake

Image stabilization

Many cameras now offer some form of 'image stabilization' or 'anti-shake' technology. This allows hand-held shots in low light or at the limit of telephoto extension, where you would normally use a combination of high ISO, fast shutter speed and wide aperture. Image stabilization may be built in to the camera body or be part of lens technology. Canon's IS system (image stabilization) and Nikon's VR system (vibration reduction) are designed into their pro-grade lenses (there is a cost saving, however, if the image stabilization is built into the camera rather than having to buy specialized lenses). If you intend to use a camera for classic telephoto purposes such as wildlife or sports, image stabilization may be important to you. It is also useful for hand-held portrait shots in available light. It is worth remembering that image stabilization may only remove the shake in your own hands and if the subject is not absolutely motionless, then shooting at 200mm and 1/125 second may still result in motion blur.

Alternatives to image stabilization

To retain maximum quality when using a prosumer digicam it is still important to keep the ISO low and when the shutter speed slows to a point where movement blur rears its ugly head, mount the camera on a tripod rather than raise the ISO. When the subject moves in low levels of light the DSLR owner has a distinct advantage - the ability to increase the ISO and yet retain acceptable quality. This is especially noticeable in DSLR cameras that have a CMOS, rather than CCD sensor. The DSLR ISO advantage might be lost if the DSLR owner then uses a lens with a maximum aperture that is less than impressive, e.g. f/4 or f/5.6. The consumer who chooses to buy a DSLR over a prosumer digicam must factor in a lens with a respectable maximum aperture when comparing prices.

Check list overview

Q. How many pixels do I need - how big do I want to print?

A. 8 megapixels for a full page and 10–12 for a double page (more if you like cropping).

Q. Do I need to shoot Raw files in rapid succession?

A. Investigate the buffer size and speed of DSLR cameras.

Q. Do I need to shoot hand-held in low light with raised ISO?

A. Choose a DSLR with a CMOS sensor, wide aperture lens and/or image stabilization and check out whether the budget DSLR comes with an option of upgrading to a better lens.

Q. Do I need to work with a camera that has 'live view'?

A. Check out cameras with LCD displays that tilt and shift to allow more creative freedom to compose the image and provide a more accurate preview prior to capturing the image.

Q. Do I want or need movie capture?

A. Only fixed-lens digicams offer movie capture.

Q. Can I change the ISO, image format setting, self-timer and white balance without referring to the manual or trawling through submenus?

A. Many cameras place all of the important settings within easy reach these days. Some manufacturers still need to talk with the photographers who use their cameras.

Q. Does the camera and lens come with useful features such as PC sync terminals, a threaded cable-release socket or affordable remote, protected LCD displays, lens-hood and twist-barrel zoom control, dual memory card slots and fast USB2 or Firewire data transfer?

A. Grab as many as you can on a single system. An individual feature is easy to overlook unless you are ticking them off a list.

Lake Wartook, Grampians National Park, Victoria - Fuji FinePix

asset management

Mark Galer

essential skills

- Implement fast and efficient systems for managing your image files.
- Create a flexible photographic database system.
- Generate and apply metadata templates and keywords.
- Batch rename and batch process images to alternative file formats.
- Archive images.

Digital asset management (DAM)

It does not seem so long ago that I was shuffling 35mm Kodachrome trannies around on a light box to edit and create narrative sequences. This was followed by the laborious process of labelling the trannie mounts with useful information of minuscule proportions, having inferior quality duplicates made and then creating file sheets to catalog and archive the work before it was lost to the undocumented subconscious of my brain. After sending the work via courier to the picture editor of a magazine, the inevitable long wait, the 'can you send us a copy we seem to have mislaid the first set', followed by the publication of the work, the trannies invariably came back damaged (hence the dupes) and it didn't matter how carefully you cross-referenced your cataloging system you could never seem to lay your hands on a much needed trannie to complete an alternative edit or grouping to maximize the potential of your visual assets.

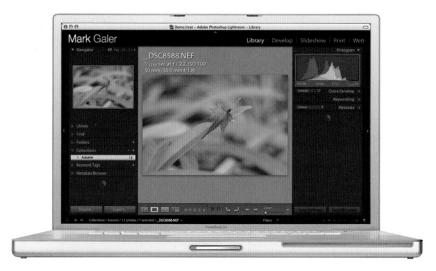

It has been a long time coming - but we now, finally, and after much gnashing of teeth, have an effective (and superior) digital equivalent to this analog asset management process. Many early adopters to digital capture (before Adobe Bridge and Photoshop Lightroom became part of the collective bundle of joy) have understandably acquired some unusual (perhaps unique) workflow processes. The tools needed to complete the task logically, economically and efficiently were not part of Photoshop. Now we are able to adopt a digital asset management system into our daily workflow so that the cataloging task does not get bigger than Ben Hur. Enter Adobe Photoshop Lightroom.

Warning > The danger of NOT integrating a systematic workflow is that hard drive space will quickly become eroded under the sheer weight of digital data. You will, at short notice, backup your images to drives or disks (in a desperate attempt to free up hard drive space so that your computer does not grind to a halt). This will, in turn, prevent your computer's search engines, your Adobe software and your short-term memory from finding these files. Your files may be labelled with memorable names such as _B240100.ORF contained in folders with equally memorable names such as 116_Olympus. Your photographs will become lost in a sea of meaningless data.

What is Lightroom?

Lightroom is a database that can import, organize, sort, rank, optimize and export images that are spread across multiple disks and hard drives (internal or external) - and for a photographer who isn't thinking about running a stock library it is just about the best database money can buy.

Lightroom not only enables you to view all of your files without going to the time-consuming task of opening them in an image editor but it also lets you organize and sort them so that you never lose any of them. It finds images long after you have forgotten the file name and the folder where you placed them and even lets you know which external drive or disk the image is currently living on. It can find an image, wherever its location, through a simple search function that allows you to type in a descriptive word called a keyword. The ability to find a picture of, for example, Sarah on the beach by typing in the words 'Sarah' and 'beach' means that losing images is just about impossible so long as you have spent a little time adding these descriptive keywords to your images.

Why is Lightroom the best database?

Cross-platform capability

Lightroom is cross-platform (Mac or Windows) and can combine catalogs and export one portion of your master catalog as a smaller separate catalog. This feature allows you to synchronize catalogs that you are running on multiple computers. This is essential if you use a laptop when you are shooting on location and a desktop when you get back home. You can purchase one version of the software that can then be installed on a PC or Mac operating system. You will not be locked into running an image bank on one operating system that is rendered useless if you were to ever change your operating system at some point in the future. You could also run a database using multiple operating systems, e.g. a PC laptop and a Mac desktop (or vice versa), and open catalogs created by one operating system on the other operating system.

Digital Photography: Essential Skills

Flexible file management

Lightroom is not fussy where you decide to keep your images or the folder structure that you choose to adopt, i.e. the catalog will just mirror the structure of folders on multiple computer hard drives or disks. Not all databases allow you to choose where the images are stored, e.g. trying to find an image imported into iPhoto without using iPhoto is an exercise in madness.

Synchronized folders

Lightroom has the ability to synchronize what can be seen in the folders viewed in Lightroom and what is actually in the folder of images on your hard drive, e.g. if you were to place an image in the folder of images via your computers' operating system after you have imported them into the Lightroom catalog, you can then synchronize the folder to add this image to the Lightroom catalog so that the content is mirrored (Library > Synchronize Folder).

Intelligent memory management

The metadata for each and every image in the Lightroom database is kept in the memory of the database catalog (independent of each and every image) but it is also possible to save this information (XMP data) to the image files. There is no point in keywording your images in the database catalog if the stock library you use cannot see these keywords, e.g. if you keyword in iPhoto and then browse to these images in Bridge, Bridge would not be able to see these keywords because they reside in the iPhoto database and not in the image files. Lightroom does both.

Photoshop compatibility

Perhaps the most compelling reason for some photographers to choose Lightroom as their database software, however, is that only Lightroom uses the same editing controls to change the visual appearance of the image as those found in Adobe Camera Raw, e.g. Exposure, Recovery, Blacks, Brightness, Contrast, etc. etc. This means that if you save the metadata to the file in Lightroom and then open the file in Adobe Camera Raw all of your adjustments will not only be visible, but also further editable.

Adopting a Photoshop Lightroom workflow

If you are a photographer who wants to take a laptop on location to review your work-in-progress, here are the four essential steps that you need to take to ensure you stay organized when using Adobe Photoshop Lightroom.

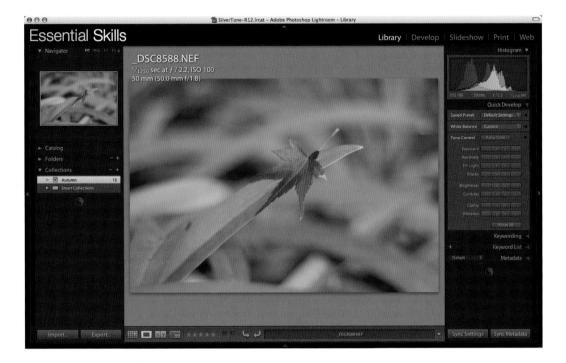

This workflow is optimized for a photographer who owns:

- A laptop computer.
- An external large-capacity hard drive or studio/home-office desktop computer with a large hard-drive capacity.
- A smaller pocket drive that can be powered via the USB or Firewire port off the laptop computer. Some photographers may prefer to burn DVDs using their laptop instead of using a USB/Firewire pocket drive.

The four steps

The four steps in the workflow are as follows:

- Create a master Lightroom catalog.
- 2. Import images on location into a working catalog using a laptop computer.
- 3. Export the working catalog to your USB/Firewire pocket drive or burn the catalog to a DVD.
- 4. Import the catalog from the location shoot into the master catalog and transfer the images to the main hard drive.

Step 1 - Master catalog (at home)

Set up a master Lightroom 'catalog' on your desktop computer in your studio or home office (the image files can be stored on this computer or an external drive).

Note > Prior to creating a Lightroom catalog for the first time it is recommended, but not essential, that you place all your existing folders of images into one master folder on your hard drive (the 'Pictures' or 'My Pictures' folder is the logical choice on your main hard drive. Alternatively, create a master folder on your external hard drive). Consider creating subfolders in this master folder to further organize your images, e.g. Portraits, Landscapes, Wildlife, etc. or Commercial, Non-commercial, etc. You can continue to make subfolders and move shoots to different folders in Lightroom after you have created the initial catalog, but some thought about how you will organize your images prior to creating the initial catalog is recommended.

Preferences

Before importing all of the images in this master pictures folder into your Lightroom catalog, go to the Lightroom Preferences and optimize the way you want Lightroom to handle your images.

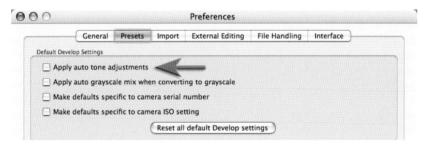

a) Uncheck the 'Apply auto tone adjustments' option in the 'Presets' panel of the Preferences dialog box so that all of the imported images are imported in their original state, i.e. not subjected to any auto adjustments.

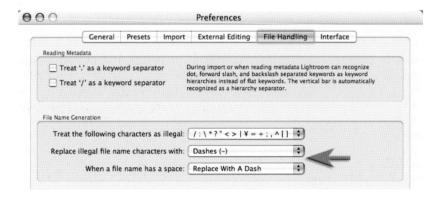

b) Select 'Replace illegal file name characters with: Dashes (-)' from the File Handling panel of the Preferences dialog box. This will ensure that any files that you try to upload to an online server (such as a web gallery) will not be blocked due to the file names having spaces or unsupported characters in their file name.

Import Options

Go to 'File > Import Photos from Disk'. When the Import dialog box opens select the 'Add photos to catalog without moving' in the 'File Handling' options. This will build a catalog but leave the photos where they are, i.e. Lightroom does not need to duplicate or move files in order to make a catalog. Before you click on the Import button inside the Import Photos dialog box you will need to consider the following options:

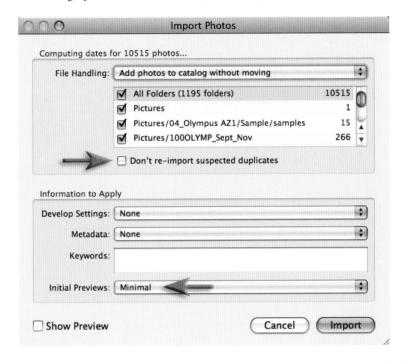

- a) Don't re-import suspected duplicates If the folders of images you are importing for the first time contain the same image, but in different folders, you may want to consider carefully whether to check the 'Don't re-import suspected duplicates' option. Many hard drives owned by photographers, prior to installing a database, are littered with duplicate files. If you select the 'Don't re-import suspected duplicates' option you will only import one of these files the problem is that it may not be in the folder you expect it to be found when you next go looking for it in Lightroom. My recommendation is to import all of the duplicates at this stage and reduce the duplicates over a period of time, rather than face a huge headache now by importing folders that are not complete. As your catalog builds over time and you start managing all of your images via Lightroom this problem of duplicate files will eventually cease to be a problem.
- b) Initial Previews I also recommend that you select 'Minimal' from the 'Initial Previews' menu if you are about to import thousands of photos. Selecting this option will decrease the time it takes for Lightroom to create the catalog. If you were to select 'Standard' you will be creating full-screen previews for old photos that may be viewed very rarely. It is better that Lightroom builds the previews for your archived work as and when you need them (it takes just a second or two when you click on an image for Lightroom to build a full-screen preview after you have already imported the images into the catalog).

Step 2 - Creating a working catalog (on location)

After a shoot you should create a new Lightroom catalog (File > New Catalog) on your laptop computer so that you can review your images while you are still on location.

Preferences and Catalog Settings

Prior to creating a new Lightroom catalog that is optimized for importing images from a camera memory card, go to the Lightroom 'Preferences' and 'Catalog Settings' (File > Catalog Settings) and optimize the way you want Lightroom to handle your photos. In addition to my recommendations for setting up your main catalog on your home computer, as outlined in the first step, I would recommend that you:

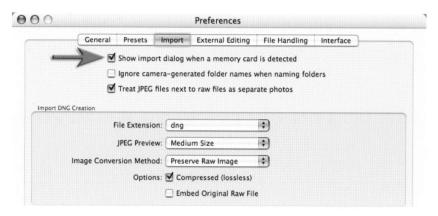

a) Select the 'Show Import dialog when a memory card is detected' option from the 'Import' panel of the Preferences dialog box.

Note > I would also recommend selecting the 'Treat JPEG files next to raw files as separate photos'. I find it too confusing to work with one preview for two image files (even if they are the same image).

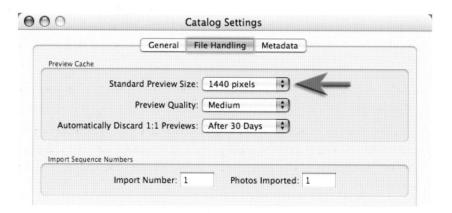

b) Set the 'Standard Preview Size' so that it is optimized for the resolution of your laptop monitor.

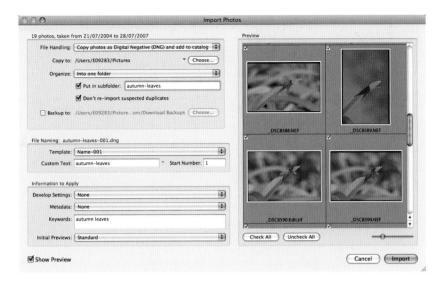

Import Photos

When you connect the camera memory card to your laptop computer and the 'Import Photos' dialog box opens I recommend the following import settings:

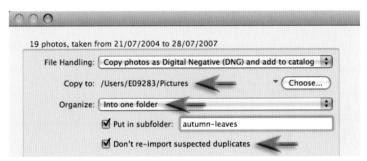

Detailed view taken from the top left-hand corner of the Import Photos dialog box

- a) From the 'File Handling' menu choose the 'Copy photos as Digital Negative (DNG) and add to catalog' option (the DNG file format is a safe archival format for Raw files and is a more convenient vehicle for carrying XMP metadata as it can be saved to the file itself rather than a sidecar file).
- b) In the 'Copy to' section click on the 'Choose' button and browse to the 'Pictures' or 'My Pictures' folder on your laptop.
- c) From the Organize menu choose the 'Into one folder' option if all of the images on the camera card are captured at the same location (or of the same subject matter) or by date if the images were captured over more than one day and the subject matter is different (this will organize your images on the card into different folders in Lightroom).
- d) Select the 'Don't re-import suspected duplicates' option (if you forget to re-format the memory card and take more photos this option will ensure the photos that were imported last time will not be re-imported a second time).

- e) Choose the 'Custom Name Sequence' option from the 'Template' menu of the dialog box (alternatively click on 'Edit' in the 'Templates' menu and create a custom template that includes the custom name followed by a dash and then a numbering option that has a couple of zeros in front of the start number, e.g. 001). In the 'Custom Text' box enter a short name that describes the subject matter, e.g. location, client or model name, etc.
- f) In the 'Keywords' text field write two or three words that describe all of the images on the card. Keywords that describe a unique image from the shoot can be entered later after the images have been imported into the catalog. The Keywords will ensure that you can search for your own images by typing in descriptive words of the files you are looking for even if the images are on a hard drive that isn't connected to your computer (this is the beauty of running a database instead of a super-browser such as Adobe Bridge).

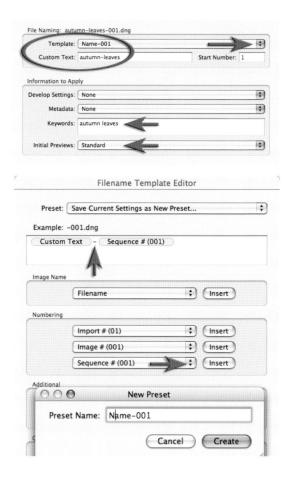

g) From the 'Initial Previews' menu choose 'Standard'. This will create full-screen previews of every image that is imported so that you can quickly cycle through all the images in your shoot. I recommended that you use the 'Minimal' option when you created your first catalog (back in step 1), as I thought that it would be unlikely that you would want to preview every old image in your archives. When 'Standard' is selected the import will take slightly longer but cycling through images after the import has finished will be very fast, especially if your computer is equipped with a modern processor and plenty of RAM (2 gigabytes or more). Selecting '1:1' in the 'Initial Preview' menu will slow the import down considerably and will create a very memory-intensive catalog. The 1:1 view is only of value if you need to check sharpness and levels of noise of every image in the shoot.

Note > If your laptop computer is also your home computer, i.e. you are using the same computer at home and on location, import the images from your shoot directly into your main Lightroom Catalog. It is also recommended, for safety reasons, that the image files for your master catalog are stored on a hard drive that is not taken on location (a hard drive on a typical laptop computer does not have a generous capacity for storing large amounts of image files and you need to avoid keeping your entire image library on a device that is easily stolen, lost or dropped). The images that are imported and stored on your laptop's hard drive on location will be deleted after transferring the images to your secure hard drive back home.

Metadata templates

Metadata starts with the information that was recorded by your camera into the image file, such as aperture, shutter speed and ISO settings. You can add to this metadata to help protect your copyright, provide a client with additional information about the image and to help you keep track of your images when you either forget where you stored your images or (worse still) forget when and where the images were taken. Adobe allows us to add captions, user-friendly titles and information about us - the photographer. A certain portion of this added information is likely to be the same for each and every image we produce. This information can be quickly stamped into the files by appending the metadata using a pre-prepared 'Metadata Template'. Adobe allows you to create multiple templates so it is possible to record more than one photographer's details or to create different versions for different clients.

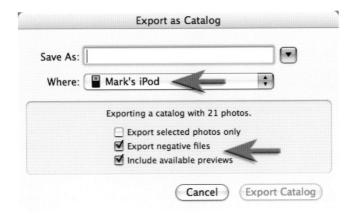

Step 3 - Exporting the working catalog (on location)

Export the catalog you created on your laptop to a pocket drive or export the catalog to the desktop and then burn a DVD* as a backup of your files prior to re-formatting the camera memory cards (File > Export as Catalog). You will now have two copies of your images - one set of images on your computer and another on your pocket drive or DVD.

Note > In the 'Export as Catalog' dialog box make sure the 'Export negative files' option is selected. This Lightroom catalog that you export will now contain the image files from your shoot and also the work that you have carried out on the files in Lightroom while you were on location. The term 'negative' is used by Adobe because although we process different images from the master files we never actually change the file itself. This is similar to the traditional anlaog workflow of taking multiple prints from a master film negative

If the laptop you are using on location is also you main home computer you can back the images up from Lightroom without exporting the entire catalog. Click on the main 'Export' button (rather than the 'Export as Catalog' command) and then create a preset that exports the original files to your pocket drive. Alternatively right-click on the folder in the Library module and select 'Show in Finder/Explorer' and drag this folder of images to a location on your pocket drive.

*Important: A catalog can be imported from a DVD but not opened directly from the DVD itself. Lightroom cannot write changes made to images if the catalog resides on a read-only disk.

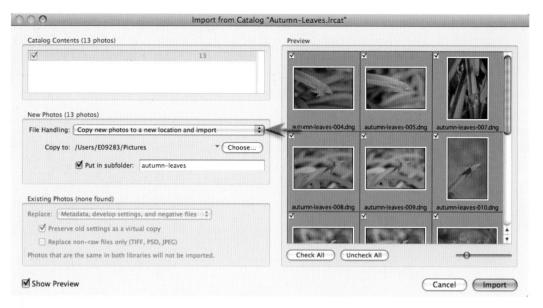

Step 4 - Combining catalogs and archiving images (at home)

On your return to the studio, import the Lightroom catalog you saved to your pocket drive to the main Lightroom catalog on your desktop computer (File > Import from Catalog). From the File Handling menu choose the 'Copy new photos to a new location and import' option. The images can be copied to the computer's hard drive or redirected to the main external drive where you keep your master library of images as the photos are being imported. You will now have three copies of your photos (laptop, pocket drive or DVD and hard drive or external drive connected to your computer). It is important to remember that the catalog is just the database (the metadata, thumbnails and previews). The actual images are copied to a new location of your choosing that Lightroom will refer to when necessary - they are not embedded in the catalog itself.

Note > To free up the smaller hard-drive capacity of your laptop and pocket drive you will need to delete the images and catalogs from both of these devices. This, however, will leave you with only a single copy of your master images. I recommend that you back up to a second external drive or create a library of DVDs of each location shoot prior to deleting the catalogs from the laptop and pocket drive.

Sharing your work using a Lightroom catalog > A Lightroom catalog does not have to be imported before you can view the images. You can just open this catalog directly from an external drive and have immediate access to full-screen previews and the before and after versions of any develop settings used by the photographer.

Conclusion

This workflow offers a practical workflow for location photographers and can be modified to meet your own needs if required. The important thing is that Adobe has now extended its focus beyond the post-production editing tools to embrace the complete workflow of a photographer. The digital workflow has now been embraced and our digital assets well and truly managed - a DAM good idea.

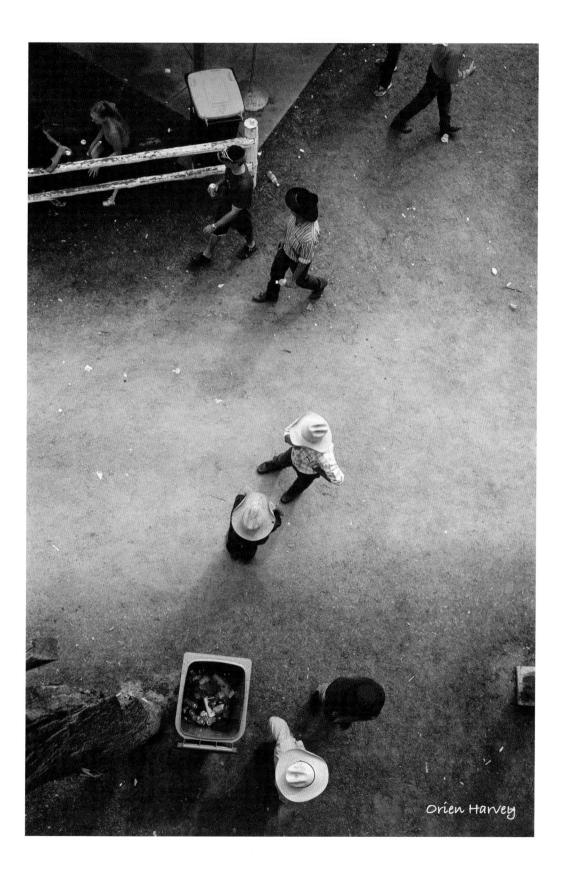

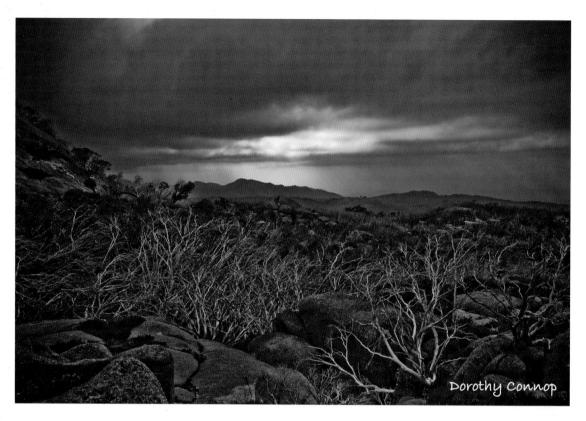

exposure

Mark Galer

essential skills

- Gain a knowledge and understanding of exposure and its relationship to light-sensitive surfaces, depth of field and selective focus.
- Understand the camera's TTL light meter.
- Understand the relationship between subject brightness range and exposure.
- · Create images demonstrating an understanding of metering techniques.

Introduction

An understanding of exposure is without doubt the most critical part of the photographic process. Automatic exposure systems found in many sophisticated camera systems calculate and set the exposure for the photographer. This may lead some individuals to think there is only one correct exposure, when in reality there may be several. The exposure indicated by an automatic system, no matter how sophisticated, is an average. Creative photographers use the meter's indicated exposure reading for guidance only. Other photographers may interpret the same reading in different ways to create different images. It is essential the photographer understands how the illuminated subject is translated by exposure into a photographic image.

Exposure

Exposure is the action of subjecting a light-sensitive medium to light. Cameras and lenses control the intensity of light (aperture) and the duration of light (time) allowed to reach the image sensor. The intensity of light is determined by the size of the aperture in the lens and the duration of light is determined by the shutter.

Exposure is controlled by aperture and time - intensity and duration.

Too much light will result in overexposure. Too little light will result in underexposure. It makes no difference whether there is a large or a small amount of light, the image sensor still requires the same amount of light for an appropriate exposure at any given ISO setting.

Overexposure

Correct exposure

Underexposure

Exposure must be adjusted to compensate for these changes in the brightness of the available light. This is achieved by adjusting either the intensity (**aperture**) or duration of light (**time**) or by adjusting the ISO on the camera. Increasing the size of the aperture gives more exposure, decreasing gives less. Decreasing the duration of the shutter speed reduces exposure, increasing gives more. Changing the ISO on the camera adjusts the sensitivity of the image sensor to the available light.

Measuring light

To calculate correct exposure the intensity or level of light has to be measured. Light is measured by a light meter. Understanding the types of metering used in most cameras is an important skill. All light meters inform the photographer of the amount of light available to obtain an appropriate exposure. This information can be used to set aperture and shutter speed settings in a variety of combinations. Different visual outcomes, such as depth of field and motion blur, can be achieved while retaining the same overall exposure. Working in a creative medium such as photography, 'correct exposure' can sometimes be a very subjective opinion. The photographer may want the image to appear dark or light to create a specific mood.

Exposing for highlights - Mark Galer

Appropriate exposure

A light meter reading should only be viewed as a guide to exposure. Digital image sensors are unable to record the broad range of tones visible to the human eye. If the camera frames a subject with highlights and shadows the image sensor may only be able to capture the highlight tones or the shadow tones, not both. An extremely bright tone and an extremely dark tone cannot both record with detail and texture in the same framed image. Underexposure and overexposure in one image is therefore not only possible but common.

It is often necessary for the photographer to take more than one reading to decide on the most appropriate exposure. If a reading is taken of a highlight area the resulting exposure may underexpose the shadows. If a reading is taken of the shadows the resulting exposure may overexpose the highlights. The photographer must therefore decide whether highlight or shadow detail is the priority, change the lighting or reach a compromise. A clear understanding of exposure is essential if the photographer is to make an informed decision.

Intensity and duration

Intensity

Light intensity is controlled by the aperture in the lens. The aperture is a mechanical copy of the iris existing in the human eye. The human iris opens up in dim light and closes down in bright light to control the amount of light reaching the retina. The aperture of the camera lens must also be opened and closed in different brightness levels to control the amount or intensity of light reaching the image sensor. The right amount of light is required for correct exposure. Too much light and the image will be overexposed, not enough light and it will be underexposed.

As the aperture on a lens (as fitted to an SLR camera) is opened or closed a series of clicks may be felt. These clicks are called f-stops and are numbered. When the numerical value of the f-stop **decreases** by one stop exactly **twice** as much light reaches the image sensor as the previous number. When the numerical value of the f-stop **increases** by one stop **half** as much light reaches the image sensor as the previous number. This is called the 'halving and doubling principle'. The only confusing part is that maximum aperture is the f-stop with the smallest value and minimum aperture is the f-stop with the largest numerical value. The larger the f-stop the smaller the aperture. From a small aperture of f/22 to a wide aperture of f/2.8 the stops are as follows (not all lenses have the range of stops indicated below):

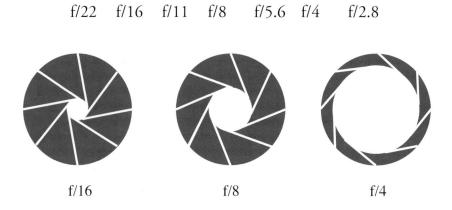

Note > When using a command dial on the camera body to adjust the aperture you may notice that the aperture reading indicates numerical values between the f-stops shown in the illustration above. The aperture is being opened up or stopped down in 1/3 stop increments, e.g. between f/5.6 and f/8 you will notice values of 6.4 and 7.1. When photographers talk about opening up or stopping down by 1 stop they are referring to a whole stop and not a third of a stop.

Practical activity

On older style lenses it is possible to adjust the aperture on the lens as well as via a command dial on the camera body. If this is done while the lens is detached from the camera you can observe the aperture in the lens opening and closing as you adjust the f-stop.

Relationship between aperture and f-number

The reasoning behind the values given to the f-stops can be explained by the following example:

- The diameter of a selected aperture on a standard 50mm lens for a full-frame digital SLR such as the Canon 1Ds or Nikon D3 measures 12.5mm.
- This measurement divides into the focal length of the lens (50mm) exactly four times.
- The aperture is therefore given the number f/4.
- The diameter of another selected aperture on the same lens measures 6.25mm.
- This measurement can similarly be divided into the focal length of the lens to give an f-number of f/8, thereby explaining why the higher f-numbers refer to the smaller apertures.

Dorothy Connop

The diameter of the same f-number may vary for different focal-length lenses but the intensity of light reaching the image plane remains constant. F/4 on a long focal-length lens is physically much larger than the same aperture on a shorter focal-length lens. The intensity of the light striking the image sensor is the same, however, due to the increased distance the light has to travel through the longer focal-length lens. See 'Inverse Square Law' on page 91.

Practical activity

Set your camera to Program or Auto mode and observe what happens to the indicated aperture when you move from full sun to dark shade.

Duration

Light duration is controlled by the shutter. The time the image sensor is exposed to light is measured in whole and fractions of a second. This time is regulated by the shutter speed. Until the invention of the focal plane shutter, exposure time had been controlled by devices either attached to or within the lens itself. These shutters regulated the length of exposure. Early cameras had no shutter at all and relied upon the photographer removing and replacing a lens cap to facilitate correct exposure times. Other rudimentary shutters, very similar in appearance to miniature roller blinds, were tried but it was not until the invention of a reliable mechanical shutter that exposure times could be relied upon. As film emulsions became faster (increased sensitivity to light) so did the opportunity to make shorter exposures. Within a relatively brief period exposures were no longer in minutes but in fractions of a second.

Mark Galer

The shutter

The main types of shutter systems used in photography are the digital shutter, the leaf shutter and the focal plane shutter. The primary function of all systems is exposure. When the shutter is released it opens for the amount of time set on the shutter speed dial or LCD. These figures are in whole and fractions of seconds. The length of time the shutter is open controls the amount of light reaching the image plane. Each shutter speed doubles or halves the amount of light reaching the image sensor. Leaving the shutter open for a greater length of time will result in a slower shutter speed. Shutter speeds slower than 1/60 second, using a standard lens, can cause motion blur or camera shake unless you brace the camera, mount it on a tripod or use some form of image stabilization. Using a shutter speed faster than 1/250 or 1/500 second usually requires a wide aperture, more light or an image sensor of increased sensitivity (raised ISO). These measures are necessary to compensate for the reduced amount of light passing through a shutter open for a short period of time.

The same exposure or level of illumination can be achieved using different combinations of aperture and shutter speed. For example, an exposure of f/11 @ 1/125 second = f/8 @ 1/250 second = f/16 @ 1/60 second and so forth.

Due to the circumstances of a particular scene the photographer may require different combinations of aperture and shutter speed to capture the intended effect that the photographer feels is correct, e.g. the photographer may want to prioritize motion or image sharpness.

Leaf shutter

Leaf shutters are situated in the lens assembly of most medium-format and all large-format cameras. They are constructed from a series of overlapping metal blades or leaves. When the shutter is released the blades swing fully open for the designated period of time.

Focal plane shutter

A focal plane shutter is situated in the camera body directly in front of the image plane (where the image is focused), hence the name. This system is used extensively in SLR cameras and a few medium-format cameras. The system can be likened to two curtains, one opening and one closing the shutter's aperture or window. When the faster shutter speeds are used the second curtain starts to close before the first has finished opening. A narrow slit is moved over the image plane at the fastest shutter speed. This precludes the use of high-speed flash. If flash is used with the fast shutter speeds only part of the frame is exposed.

The advantages of a focal plane shutter over a leaf shutter are:

- fast shutter speeds in excess of 1/1000 second;
- lenses are comparatively cheaper because they do not require shutter systems.

The disadvantage is:

- limited flash synchronization speeds.

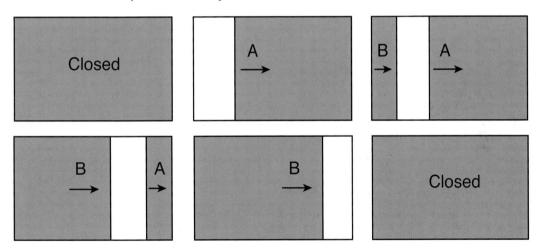

Focal plane shutter firing faster than the fastest flash synchronization speed

Practical activity

Create exposures of a stationary subject at a variety of shutter speeds between 1/125 and 1/4 second whilst hand holding your camera.

Set the lens to 50mm (or equivalent) and correct the exposure using the aperture each time the shutter speed is adjusted (use shutter priority [Tv] or manual mode).

Look at the images on a computer screen, zoom in to 50% (1:2) or Actual Pixels (1:1) and assess at what shutter speed the subject no longer appears sharp?

TTL light meters

TTL or 'through the lens' light meters, built into cameras, measure the level of reflected light prior to exposure. They measure only the reflected light from the subject matter within the framed image. The meter averages or mixes the differing amounts of reflected light within the framed image, and indicates an average level of reflected light. The light meter readings are translated by the camera's CPU and used to set aperture and/or shutter speed.

Center-weighted and matrix metering

Center-weighted and selective metering systems (matrix metering), common in many cameras, bias the information collected from the framed area in a variety of ways. Center-weighted metering takes a greater percentage of the information from the central area of the viewfinder. The reading, no matter how sophisticated, is still an average - indicating one exposure value only. Any single tone recorded by the photographer using a TTL reading will reproduce as a midtone, no matter how dark or light the tone or level of illumination. This tone is the midpoint between black and white. If the photographer takes a photograph of a black or white wall and uses the indicated meter reading to set the exposure, the final image produced would show the wall as having a midtone (the same tone as a photographer's 18% gray card).

Center-weighted TTL metering

Automatic TTL exposure modes

If the camera is set to fully automatic or program mode both the shutter speed and aperture will be set automatically, ensuring an average exposure in response to the level of light recorded by the meter. In low light the photographer using the program mode should be aware of the shutter speed being used to achieve this exposure. As the lens aperture reaches its widest setting the program mode will start to use shutter speeds slower than those usually recommended to avoid camera shake. Many cameras alert the photographer to this using an audible or visual signal. This should not be treated as a signal to stop taking photographs but to take precautions to avoid camera shake, such as bracing the camera or by using a tripod.

Semi-automatic

The disadvantage of a fully automatic or program mode is it can often take away the creative input the photographer can make to many of the shots. A camera set to fully automatic is programmed to make decisions not necessarily correct for every situation. If your camera is selecting both the aperture and shutter speed you will need to spend some time finding out how the camera can be switched to semi-automatic and manual operation.

Semi-automatic exposure control, whether aperture priority (Av) or shutter priority (Tv), allows creative input from the photographer (**depth of field** and **movement blur**) but still ensures the meter indicated exposure or 'MIE' is obtained automatically.

Aperture priority (aperture variable or Av)

This is a semi-automatic function where the photographer chooses the aperture and the camera selects the shutter speed to achieve 'MIE'. This is the most common semi-automatic function used by professional photographers as the depth of field is usually a primary consideration. The photographer using aperture priority needs to be aware of slow shutter speeds being selected by the automatic function of the camera when selecting small apertures in low-light conditions. To avoid camera shake and unintended blur the aperture has to be opened and the depth of field sacrificed (see the chapter 'Creative controls').

Orien Harvey

Shutter priority (time variable or Tv)

This is a semi-automatic function where the photographer chooses the shutter speed and the camera selects the aperture to achieve correct exposure. In choosing a fast shutter speed the photographer needs to be aware of underexposure as light levels decrease. The fastest shutter speed possible is often limited by the maximum aperture of the lens. In choosing a slow shutter speed the photographer needs to be aware of overexposure when photographing brightly illuminated subject matter. Movement blur may not be possible when using an image sensor set to a high ISO in bright conditions.

Incident light meter readings

An **incident reading** is where a light meter measures the light falling on the subject rather than the light being reflected from the subject. These light meter readings can prove to be very accurate. To measure the incident light a plastic diffuser must be used both to diffuse the light and transmit 18% of the light. The light meter in a digital camera is designed to measure the reflected light and can only take an incident light meter reading if an additional product is purchased.

Creating an incident reading using the camera's TTL meter

You can place a diffuser such as the 'expodisc' over a camera lens in order to create an incident light meter reading using the camera's own TTL meter (attaching the expodisc allows the lens to collect and 'average out' the light intensity from a much broader angle of view). This type of product is also excellent at creating a custom white balance setting or can be used to capture a reference image that can be used to create a white balance setting in Adobe Camera Raw.

Practical activity

Move in close and take a picture of someone wearing a dark shirt or jacket with your camera set to Auto or Program mode. Now ask your subject to put on a white shirt or jacket and take another picture in the same lighting conditions. You should notice that the two exposures are different even though the level of lighting has remained constant (take a look at how different the brightness of the skin tones appear in the two images). Using an incident light meter reading and setting the camera to Manual exposure would have created two images where the skin tones would have remained the same level of brightness.

Interpreting the meter reading

The information given by the light meter after taking a reading is referred to as the 'meter-indicated exposure' (MIE). This is a guide to exposure only. The light meter should not be perceived as having any intelligence or creative sensibilities. The light meter cannot distinguish between tones or subjects of interest or disinterest to the photographer. It is up to the photographer to decide on the most appropriate exposure to achieve the result required. A photographer with a different idea and outcome may choose to vary the exposure. It is the photographer's ability to interpret and vary the meter-indicated exposure to suit the mood and communication of the image that separates their creative abilities from others.

If light or dark tones dominate, the indicated exposure will be greatly influenced by these dominant tones. Using the MIE will expose these dominant dark or light tones as midtones, whilst other tones may become overexposed or underexposed. If you consider that interest and visual impact within a photograph are created by the use of lighting and subject contrast (amongst many other things), the chances of all the elements within the frame being midtones are remote. The information, mood and communication of the final image can be altered through adjusting exposure from MIE.

Indian market (average tones) MIE

Average tones

If a subject of average reflectance (a midtone) is framed together with dark and light tones in equal proportions (and all of the tones are lit equally by the same diffuse light source) the resulting meter reading will give correct exposure, i.e. the midtone will record as a midtone. If, however, a reading is taken from only the dark tones this exposure will render these dark tones as midtones and overexpose the mid- and light tones. An exposure using the reflected reading off only the lighter tones will render these lighter tones as midtones and underexpose the midtones and dark tones.

Dominant tones

If dark tones dominate the framed image the MIE will result in the dark tones being recorded as midtones. Midtones will be recorded as light tones and any light tones may be overexposed. If light tones dominate the framed image the meter indicated exposure will result in the light tones being recorded as midtones. Midtones will be recorded as dark tones and dark tones may be underexposed. If the midtones present in amongst these dominant dark or light tones are to be recorded accurately the exposure must be either reduced (for dominant dark tones) or increased (for dominant light tones) from the MIE.

Black swan (dominant dark tones) MIE

Decreased exposure

White wall (dominant light tones) MIE

Increased exposure

The amount the exposure needs to be reduced or increased is dictated by the level of dominance of these dark or light tones (see the chapter 'Light > Exposure compensation').

Practical activity

Select Manual mode on your camera. Adjust the aperture and shutter speed until the camera indicates that you have the correct exposure for the subject that you are photographing. Adjust the aperture or shutter speed to either increase or decrease the exposure. Now find a subject where the dominant tones are either dark or light. Take one image using the recommended exposure settings and then another with increased or decreased exposure. Review the images on the camera's LCD screen.

Reading exposure levels

When taking a picture with a digital camera it is sometimes possible to check the exposure during the capture stage to ensure that the full tonal range of the image has been recorded. The most accurate indication of the exposure does not come from the image on the LCD screen but the histogram (all DSLR cameras and the better fixed-lens compact cameras are able to display these histograms). Some fixed-lens cameras can even display the histogram before the image has been captured. This 'live preview' is also available on a few DSLR cameras that have a second sensor designed to feed this live view to the LCD screen prior to capture.

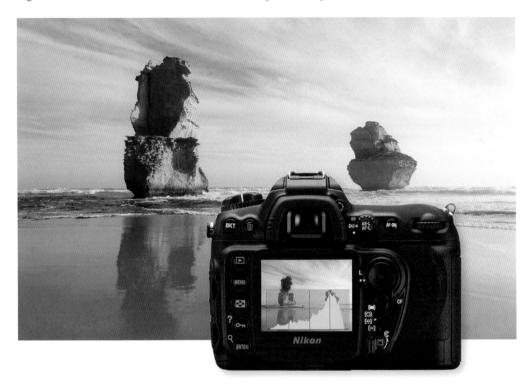

The levels of brightness in the histogram are displayed as a simple graph. The horizontal axis displays the brightness values from left (darkest) to right (lightest). The vertical axis of the graph shows how much of the image is found at any particular brightness level. If the subject contrast is too high or the exposure is either too high or too low then tonality will be 'clipped' (shadow or highlight detail will be lost). Most digital camera sensors can only record a limited range of information when compared to the range of tones human vision is capable of seeing detail in. The tones that are out of the range of the image sensor of the digital camera record as black or white with no detail. We should attempt to adjust the exposure or reduce the contrast of the subject matter to ensure maximum information is recorded.

Note > When using the JPEG file format you should attempt to modify the brightness, contrast and color balance at the capture stage to obtain the best possible histogram before editing begins in the software.

Correcting exposure

The photographer can either increase or decrease exposure to ensure a full range of tones is recorded during the capture stage. Photoshop will not be able to replace information in the shadows or highlights that is missing due to inappropriate exposure or excessive subject contrast. The information should extend all the way from the left to the right side of the histogram if the subject contrast and the exposure are appropriate.

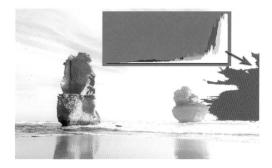

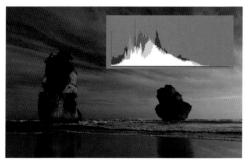

Overexposure and underexposure

If the exposure is too high a tall peak will be seen to rise on the right side of the histogram (level 255). If the digital file is underexposed the peaks are crowded on the left-hand side of the histogram and there are little or no peaks on the right-hand side of the histogram. Some cameras can be programmed to blink in the areas that are overexposed.

Solution: Adjust the exposure in the camera using either the exposure compensation controls or the manual controls. If exposure is too low due to bright backlights in the image you can try moving the camera to exclude the bright light source, locking the exposure by half-pressing the shutter release and then reframing.

Lowering contrast

If the contrast is too high tall peaks may be evident at either end of the histogram.

Solution: Decrease the subject contrast by either repositioning the subject matter or by lowering the contrast of the lighting. The light source can be diffused or additional lighting can be provided in the form of fill flash or reflectors. In the image above the camera's tiny built-in flash unit has been used to increase the exposure in the shadows. This allows the overall exposure to be lowered, which in turn prevents the sky behind the children from becoming overexposed.

Optimizing a histogram in levels

The final histogram should show that pixels have been allocated to most, if not all, of the 256 levels. If the histogram indicates large gaps between the ends of the histogram and the sliders (indicating a low-contrast subject photographed in flat lighting) the relationship between the subject contrast and light quality could be reconsidered.

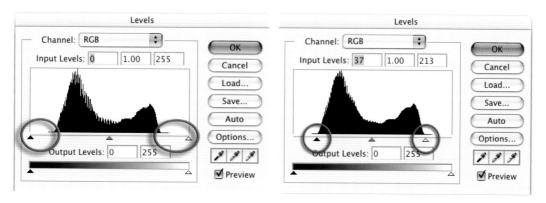

Small gaps at either end of the histogram can, however, be corrected in Photoshop by dragging the sliders in the 'Levels' adjustment dialog box to the start of the tonal information. Holding down the Alt key (Option key on a Mac) when dragging these sliders will indicate what, if any, information is being clipped. Note how the sliders have been moved beyond the short thin horizontal line at either end of the histogram. These low levels of pixel data are often not representative of the broader areas of shadows and highlights within the image and can usually be clipped (moved to 0 or 255).

Moving the 'Gamma' slider can modify the brightness of the midtones. If you select a Red, Green or Blue channel (from the Channel's pull-down menu) prior to moving the Gamma slider you can remove a color cast present in the image. For those unfamiliar with color correction the adjustment feature 'Variations' in Photoshop gives a quick and easy solution to the problem. After correcting the tonal range using the sliders click 'OK' in the top right-hand corner of the Levels dialog box.

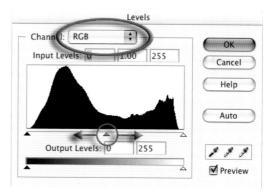

Note > Variations is not available for Photoshop users working in 16 Bits/Channel mode.

Color

Neutral tones in the image should appear without a warm or cool color bias.

Solution: Select the correct white balance for your lighting or use a manual white balance setting to get the correct tone without any color cast or tints. Do not use the Auto white balance setting that is best for one-off snapshots.

Raw format exposure considerations

One of the big topics of conversation since the release of Photoshop CS has been the subject of 'Raw' files and 'digital negatives'. This section of the chapter guides you through the advantages of choosing the Raw format and the steps you need to take to process a Raw file from your camera in order to optimize its exposure.

All digital cameras capture in Raw but only digital SLRs and the medium- to high-end 'Prosumer' cameras offer the user the option of saving the images in this Raw format. Selecting the Raw format in the camera instead of JPEG or TIFF stops the camera from processing the color data collected from the sensor. Digital cameras typically process the data collected by the sensor by applying the white balance, sharpening and contrast settings set by the user in the camera's menus. The camera then compresses the bit depth of the data from 12 to 8 bits per channel before saving the file as a JPEG or TIFF file. Selecting the Raw format prevents this image processing taking place. The Raw data is what the sensor 'saw' before the camera processes the image, and many photographers have started to refer to this file as the 'digital negative'. The term 'digital negative' is also used by Adobe for their archival format (.dng) for Raw files.

The sceptical among us would now start to juggle with the concept of paying for a 'state-of-the-art' camera to collect and process the data from the image sensor, only to stop the high-tech image processor from completing its 'raison d'être'. If you have to process the data some time to create a digital image why not do it in the camera? The idea of delaying certain decisions until they can be handled in the image-editing software is appealing to many photographers, but the real reason for choosing to shoot in Camera Raw is QUALITY.

Processing Raw data

The unprocessed Raw data can be converted into a usable image file format by Adobe Camera Raw (ACR). Variables such as bit depth, white balance, exposure, brightness, contrast, saturation, sharpness, noise reduction and even the crop can all be assigned as part of the conversion process. Performing these image-editing tasks on the full high-bit Raw data (rather than making these changes after the file has been processed by the camera) enables the user to achieve a higher quality end-result.

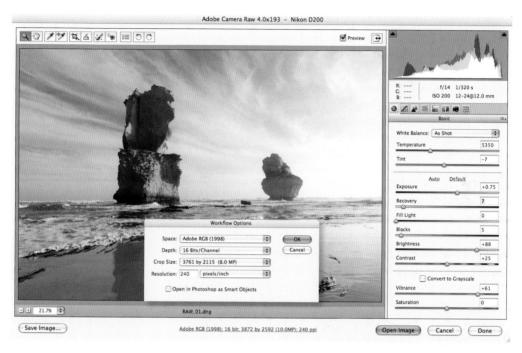

Double-clicking a Raw file, or selecting 'Open in Camera Raw' in Bridge, opens the Adobe Camera Raw (ACR) dialog box, where the user can prepare and optimize the file for final processing in the main Photoshop editing interface. If the user selects 16 Bits/Channel in the Workflow Options, the 12 bits per channel data from the image sensor is rounded up - each channel is now capable of supporting 32,769 levels* instead of the 256 levels we are used to working with in the 8 bits per channel option. Choosing the 16 Bits/Channel option enables even more manipulation in the main Photoshop editing space without the risk of degrading the image quality. When the file is opened into the image-editing work space of your Photoshop software, the Raw file closes. Any changes you make to the appearance of the image in the ACR dialog box will be applied to the image that is opened in Photoshop's main editing space but won't alter the original image data of the Raw file. The adjustments you make in the ACR dialog box are saved as XMP metadata in the DNG file as an XMP sidecar file or in the computer's Camera Raw database or cache.

*Note > Photoshop's 16-bit editing is 15-bit + 1 (15-bit processing gave the Photoshop engineers a midpoint). In Photoshop CS2 we had the option to set the Info palette to 16-bit values to confirm this but this option was removed for Photoshop CS3.

Distribution of data

Most digital imaging sensors capture images using 12 bits of memory dedicated to each of the three RGB color channels, resulting in 4096 tones between black and white. Most of the imaging sensors in digital cameras record a subject brightness range of approximately five to eight stops (five to eight f-stops between the brightest highlights with detail and the deepest shadow tones with detail).

Tonal distribution in 12-bit capture

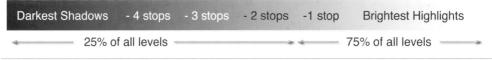

Distribution of levels

One would think that with all of this extra data the problem of banding or image posterization due to insufficient levels of data (a common problem with 8-bit image editing) would be consigned to history. Although this is the case with mid tones and highlights, shadows can still be subject to this problem. The reason for this is that the distribution of levels assigned to recording the range of tones in the image is far from equitable. The brightest tones of the image (the highlights) use the lion's share of the 4096 levels available while the shadows are comparatively starved of information.

An example of posterization or banding

Shadow management

CCD and CMOS chips are, however, linear devices. This linear process means that when the amount of light is halved, the electrical stimulation to each photoreceptor on the sensor is also halved. Each f-stop reduction in light intensity halves the amount of light that falls onto the receptors compared to the previous f-stop. Fewer levels are allocated by this linear process to recording the darker tones. Shadows are 'level starved' in comparison to the highlights that have a wealth of information dedicated to the brighter end of the tonal spectrum. So rather than an equal amount of tonal values distributed evenly across the dynamic range, we actually have the effect as shown above. The deepest shadows rendered within the scene often have fewer than 128 allocated levels, and when these tones are manipulated in post-production Photoshop editing there is still the possibility of banding or posterization.

Accessing a broader dynamic range by using camera Raw

The histogram displayed on the back of a digital camera may not accurately reflect the precise range of tones that is being captured when the photographer elects to shoot in the camera Raw format. Most cameras provide information that is geared to the photographer capturing in the JPEG or TIFF format only. A photographer may therefore underestimate the dynamic range that is capable of being recorded by their camera. Instead of capturing a dynamic range of approximately five stops the Raw format may be capable of capturing images with a dynamic range that exceeds 7 or 8 stops when using a DSLR camera. The precise dynamic range will depend on the type of sensor being used as the smaller sensors fitted to the prosumer digicams do not enjoy the same dynamic range as the APS and full-frame sensors fitted to the DSLR cameras.

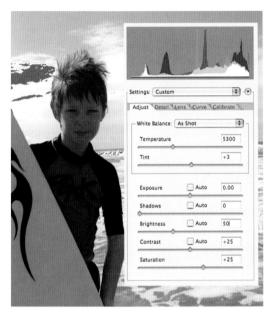

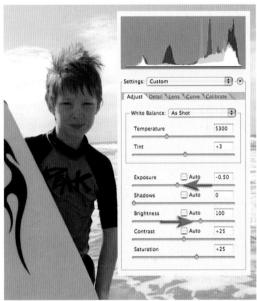

In the example above the highlights of the distant clouds were flashing when the image was reviewed in the camera (a common option on many digital cameras for indicating when overexposure has occurred). The histogram associated with the file clearly indicated that the highlights were being clipped. When the file was opened in camera Raw the exposure slider was moved to a value of -0.50 and usable detail (level 245) was returned to this area of the image. The Brightness slider was raised to compensate for the negative exposure value. If the exposure had been lowered in camera the dark top that the boy is wearing would have required rescuing instead of the highlights. Most photographers find that it is preferable to rescue the highlights rather than the shadows although due care must be taken not to allow the highlights to become completely overexposed. Taking two spot meter readings will enable the experienced photographer to ascertain the subject brightness range and assess whether this is compatible with the dynamic range of the sensor they are using.

Lowering exposure in ACR

For those digital photographers interested in the dark side, an old SLR loaded with a fine-grain black and white film is a hard act to follow. The liquid smooth transitions and black velvet-like quality of dark low-key prints of yesteryear are something that digital capture is hard pressed to match. The sad reality of digital capture is that underexposure in low light produces an abundance of noise and banding (steps rather than smooth transitions of tone). The answer, however, is surprisingly simple for those who have access to a DSLR and have selected the Raw format from the Quality menu settings in their camera. Simply be generous with your exposure to the point of clipping or overexposing your highlights and only attempt to lower the exposure of the shadows in Adobe Camera Raw.

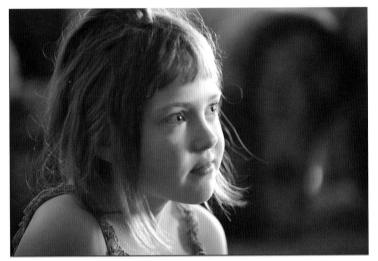

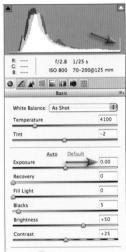

1. The first step is the most difficult to master for those who are used to using Auto or Program camera exposure modes. Although the final outcome may require deep shadow tones, the aim in digital low-key camera exposure is to first get the shadow tones away from the left-hand wall of the histogram by increasing and NOT decreasing the exposure. It is vitally important, however, not to increase the exposure so far that you lose or clip highlight detail. The original exposure of the image used in this project reveals that the shadow tones (visible as the highest peaks in the histogram) have had a generous exposure in-camera so that noise and banding have been avoided (the tones have moved well to the right in the histogram). The highlights, however, look as though they have become clipped or overexposed. The feedback from the histogram on the camera's LCD would have confirmed the clipping at the time of exposure (the tall peak on the extreme right-hand side of the histogram) and if you had your camera set to warn you of overexposure, the highlights would have been merrily flashing at you to ridicule you of your sad attempts to expose this image. The typical DSLR camera is, however, a pessimist when it comes to clipped highlights and ignorant of what is possible in Adobe Camera Raw. Adobe Camera Raw can recover at least one stop of extra highlight information when the Exposure slider is dragged to the left (so long as the photographer has used a DSLR camera that has a broader dynamic range than your typical fixed-lens compact digicam).

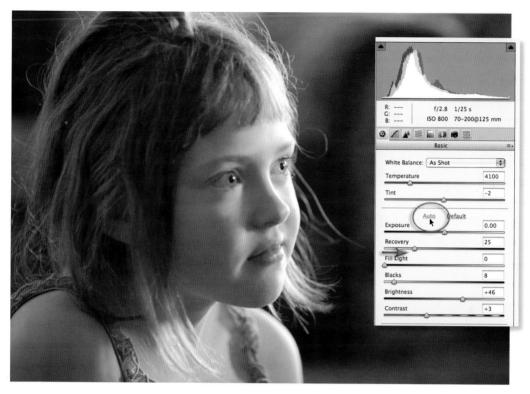

Adobe Camera Raw rescues the highlights - sometimes automatically

'Exposing right'

When the Auto checkbox in the Exposure slider is checked, Adobe Camera Raw often attempts to rescue overexposed highlights automatically. With a little knowledge and some attention to the camera's histogram during the capture stage, you can master the art of pushing your highlights to the edge. So if your model is not in a hurry (mine is watching a half-hour TV show) you can take an initial exposure on Auto and then check your camera for overexposure. Increase the exposure using the exposure compensation dial on the camera until you see the flashing highlights. When the flashing highlights start to appear you can still add around one extra stop to the exposure before the highlights can no longer be recovered in Adobe Camera Raw. The popular term for this peculiar behavior is called 'exposing right'.

PERFORMANCE TIP

If the highlights are merrily flashing and the shadows are still banked up against the left-hand wall of the histogram, the solution is to increase the amount of fill light, i.e. reduce the difference in brightness between the main light source and the fill light (see Lighting on Location > Fill flash).

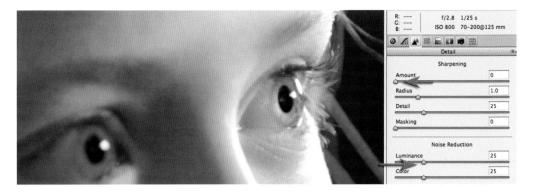

2. Before we massage the tones to create our low-key image we must first check that our tones are smooth and free from color and luminance noise. Zoom in to 100% magnification for an accurate preview and look for any problems in the smooth dark-toned areas. Setting both the Luminance Smoothing and Color Noise Reduction sliders to 25 (found in the Detail tab) removes the noise in this image. I would also recommend that the Sharpness slider be set to 0 at this point. Rather than committing to global sharpening using the Adobe Camera Raw dialog box, selective sharpening in the main Photoshop editing space may help to keep the tones as smooth as possible.

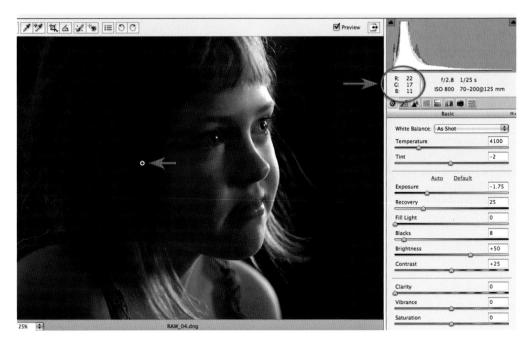

3. Create the low-key look by moving the Exposure and/or the Brightness sliders to the left in the Basic tab. You can continue to drop these sliders until the highlights start to move away from the right-hand wall of the histogram. Select the 'White Balance Tool' and move your mouse cursor over the deeper shadows - this will give you an idea of the RGB values you are likely to get when this image is opened into the editing space. Once you approach an average of 15 to 20 in all three channels the low-key look should have been achieved.

Expose right and adjust left

'Expose right' and multiple exposures

As we have seen in the previous example the inequitable distribution of levels has given rise to the idea of 'exposing right'. This work practice encourages the user seeking maximum quality to increase the camera exposure of the shadows (without clipping the highlights) so that more levels are afforded to the shadow tones. This approach to making the shadows 'information rich' involves increasing the amount of fill light (actual light rather than the ACR's fill light) or lighting with less contrast in a studio environment. If the Camera Raw file is then opened in the Camera Raw dialog box the shadow values can then be reassigned their darker values to expand the contrast before opening it as a 16 Bits/Channel file. When the resulting shadow tones are edited and printed, the risk of visible banding in the shadow tones is greatly reduced.

Separate exposures can be combined in Adobe Photoshop

This approach is not possible when working with a subject with a fixed subject brightness range, e.g. a landscape, but in these instances there is often the option of bracketing the exposure and merging the highlights of one digital file with the shadows of a second. The example above shows the use of a layer mask to hide the darker shadows in order to access the bit-rich shadows of the underlying layer and regain the full tonal range of the scene. See *Photoshop CS3/CS4: Essential Skills* or *Photoshop Elements Maximum Performance* for detailed post-production editing techniques.

framing the image

Mark Galer

essential skills

- Develop an awareness of how a photographic image is a two-dimensional composition of lines, shapes and patterns.
- Develop an understanding of how differing photographic techniques can affect both the emphasis and the meaning of the subject matter.
- Look at the composition of different photographs and the design techniques used.
- Create digital images through close observation and selection that demonstrate how the frame can create compositions of shape, line and pattern.
- Document the progress and development of these skills

Introduction

Capturing or creating strong images relies primarily on the photographer's ability to study the subject carefully, enthusiastically, imaginatively and sympathetically. The equipment can only help to craft the photographer's personal vision. Most people are too preoccupied to look at a subject for any great amount of time. Skilled observation by the photographer can release the extraordinary from the ordinary. The famous British photographer Bill Brandt in 1948 is quoted as saying:

'It is the photographer's job to see more intensely than most people do. He must keep in him something of the child who looks at the world for the first time or of the traveller who enters a strange country.'

Mark Galer

Framing techniques

The following techniques should be considered when the photographer wants to control the communication, impact and design of any image:

- Communication and context
- ~ Format
- ~ Content
- Balance
- Subject placement
- The decisive moment
- Vantage point
- Line
- Depth.

Communication and context

Photographs provide us with factual information. With this information we can make objective statements concerning the image. Objective statements are indisputable facts. Photographic images are an edited version of reality. With limited or conflicting information within the frame we are often unsure of what the photograph is really about. In these cases we may make subjective decisions about what the photograph is communicating to us personally. Subjective statements are what we think or feel about the image. Subjective opinion varies between individuals and may be greatly influenced by the caption that accompanies the image and/or our cultural or experiential background.

Mark Galer

What do we know about this woman or her life other than what we can see in the photograph? Can we assume she is lonely as nobody else appears within the frame? Could the photographer have excluded her partner purchasing coffee to improve the composition or alter the meaning? Because we are unable to see the event or the surroundings that the photograph originated from we are seeing the subject out of context.

'To quote out of context is the essence of the photographer's craft. His central problem is a simple one: what shall he include, what shall he reject? The line of decision between in and out is the picture's edge. While the draughtsman starts with the middle of the sheet, the photographer starts with the frame.

The photograph's edge defines content. It isolates unexpected juxtapositions. By surrounding two facts, it creates a relationship. The edge of the photograph dissects familiar forms, and shows their unfamiliar fragment. It creates the shapes that surround objects.

The photographer edits the meanings and the patterns of the world through an imaginary frame. This frame is the beginning of his picture's geometry. It is to the photograph as the cushion is to the billiard table.'

The Photographer's Eye by John Szarkowski.

Content

An essential skill of framing is to view the subject in relation to its background. This relationship between subject and background is often referred to as 'figure and ground'. Many photographers stand too far away from the subject. In a desire to include all the subject their photographs become busy, unstructured and cluttered with unwanted background detail. This extra detail can distract from the primary subject matter. If a photographer moves closer, or chooses an alternative vantage point from which to take the image, distracting background can be reduced or eliminated. With fewer visual elements to be arranged the photographer has more control over composition. If background detail does not relate to the subject the photographer should consider removing it from the frame. Unless the photograph is to act as a factual record the need to include everything is unnecessary. William Albert Allard, a photographer for National Geographic, says:

'What's really important is to simplify. The work of most photographers would be improved immensely if they could do one thing: get rid of the extraneous. If you strive for simplicity, you are more likely to reach the viewer.'

Matthew - Mark Galer

In the image above the protective hands provide all the information we need to understand the relationship between these people. In order to clarify this, the photographer could have moved further back. With increased background information the power of this portrait would have been lost. Photographers have the option, however, of taking more than one photograph to tell a story.

Practical activity

Create an image demonstrating how you can use a simple background to remove unwanted detail and help keep the emphasis or 'focal point' on the subject.

Balance

In addition to content a variety of visual elements such as line, color and tone often influence a photographer's framing of an image. The eye naturally or intuitively seeks to create a symmetry or a harmonious relationship between these elements within the frame. When this is achieved the image is said to have a sense of balance. The most dominant element of balance is visual weight created by the distribution of light and dark tones within the frame. To frame a large dark tone on one side of the image and not seek to place tones of equal visual weight on the other side will create imbalance in the image. An image that is not balanced may appear heavy on one side. Visual tension is created within an image that is not balanced.

Itti Karuson

Balance, although calming to the eye, is not always necessary to create an effective image. Communication of harmony or tension is the deciding factor of whether balance is desirable in the image.

Practical activity

Create an image where the main subject is not in the middle of the picture but where the image has retained a sense of balance. Create another image and one image where the main subject is off-center and the image has a sense of imbalance.

Subject placement

Balance may be easily achieved by placing the subject in the middle of the frame. The resulting image does not encourage the viewer's eye to move around the image. This leads to a static composition, making little demand on the viewer. The photographer should think carefully where the main subject is placed within the image, only choosing the central location after much consideration. When the subject is framed the photographer should examine the image as if it was a flat surface. This action will help the photographer become aware of unnecessary distractions to the basic design. A common mistake made by photographers is to become preoccupied with the subject, forgetting to notice background detail. This can lead to the problem of previously unnoticed trees or lampposts apparently growing out of the top of people's heads in the final image.

The rule of thirds

Mark Galer

Rules of composition can help photographers create harmonious images. The most common of these rules are the 'golden section' and the 'rule of thirds'. The golden section is the name given to a traditional system of dividing the frame into unequal parts which dates back to the time of Ancient Greece. The rule of thirds is the simplified modern equivalent. Visualize the viewfinder as having a grid which divides the frame into three equal segments, both vertically and horizontally. Photographers often use these lines and their intersection points as key positions to place significant elements within the picture. Placing elements closer to the edges of the frame can often be effective in creating dynamic tension where a more formal design is not needed.

Practical activity

Create an image that conforms to the rule of thirds. There may be an option in your camera's menus to display a grid in the viewfinder to help frame your subject. Crop the image in your image-editing software to refine the composition.

The decisive moment

The famous photographer Henri Cartier-Bresson in 1954 described the visual climax to a scene which the photographer captures as being the 'decisive moment'.

The moment when the photographer chooses to release the shutter may be influenced by the visual climax to the action and the moment when the moving forms create the most pleasing design. In the flux of movement a photographer can sometimes intuitively feel when the changing forms and patterns achieve balance, clarity and order, and when the image becomes for an instant a picture.

Orien Harvey

To capture decisive moments the photographer needs to be focused on, or receptive to, what is happening rather than the camera equipment they are holding. Just like driving a car it is possible to operate a camera without looking at the controls. The photographer must spend time with any piece of equipment so that they are able to operate it intuitively. When watching an event unfold the photographer can increase their chances of capturing the decisive moment by presetting the focus and exposure.

Practical activity

Create an image that captures the decisive moment of an interaction between a moving subject and its environment. One way to achieve this is to frame a pleasing design that incorporates a staircase or road where the path of the moving element is fairly predictable.

Vantage point

A carefully chosen viewpoint or 'vantage point' can often reveal the subject as familiar and yet strange. In designing an effective photograph that will encourage the viewer to look more closely, and for longer, it is important to study your subject matter from all angles. The 'usual' or ordinary is often disregarded as having been 'seen before' so it is sometimes important to look for a fresh angle on a subject that will tell the viewer something new.

Mark Galer

The use of a high or low vantage point can overcome a distracting background by removing unwanted subject matter, using the ground or the sky as an empty backdrop.

Practical activity

Create an image that makes use of an unusual or interesting vantage point. Try to simplify the content by your choice of vantage point.

Line

The use of line is a major design tool that the photographer can use to structure the image. Line becomes apparent when the contrast between light and dark, color, texture or shape serves to define an edge. The eye will instinctively follow a line. Line in a photograph can be described by its length and angle in relation to the frame (itself constructed from lines).

Horizontal and vertical lines

Horizontal lines are easily read as we scan images from left to right comfortably. The horizon line is often the most dominant line within the photographic image. Horizontal lines within the image give the viewer a feeling of calm, stability and weight. The photographer must usually be careful to align a strong horizontal line with the edge of the frame. A sloping horizon line is usually immediately detectable by the viewer and the feeling of stability is lost.

Vertical lines can express strength and power. This attribute is again dependent on careful alignment with the edge of the frame. This strength is lost when the camera is tilted to accommodate information above or below eye level. The action of perspective causes parallel vertical lines to lean inwards as they recede into the distance.

Suggested and broken lines

Line can be designed to flow through an image. Once the eye is moving it will pick up a direction of travel and move between points of interest. The photograph to the right is a good example of how the eye can move through an image. Viewers of this image will be guided towards the distant hills on the right side of the image. The lines created by the dry stone wall and the converging lines created by the ridges of the hills all serve to guide the viewer in this direction. A photographer can strategically frame an image and position the lines within the frame to aid this process (note the dry stone wall entering the image from the bottom left-hand corner). The use of simple and uncluttered backgrounds (without distracting detail) can also help to isolate focal points that use line as an important part of the design.

Mark Galer

Shane Bell

Diagonal lines

Whether real or suggested, these lines are more dynamic than horizontal or vertical lines. Whereas horizontal and vertical lines are stable, diagonal lines are seen as unstable (as if they are falling over), thus setting up a dynamic tension or sense of movement within the picture.

Curves

Curved line is very useful in drawing the viewer's eye through the image in an orderly way. The viewer often starts viewing the image at the top left-hand corner and many curves exploit this. Curves can be visually dynamic when the arc of the curve comes close to the edge of the frame or directs the eye out of the image.

Practical activity

Create a photograph using straight lines as an important feature in constructing the picture's composition.

Create a second image where the dominant line is either an arc or S-curve.

Create a third image where the viewer is encouraged to navigate the image by the use of suggested line and broken line between different points of interest.

Depth

When we view a flat two-dimensional print which is a representation of a three-dimensional scene, we can often recreate this sense of depth in our mind's eye. Using any perspective present in the image and the scale of known objects we view the image as if it exists in layers at differing distances. Successful compositions often make use of this sense of depth by strategically placing points of interest in the foreground, the middle distance and the distance. Our eye can be led through such a composition as if we were walking through the photograph observing the points of interest on the way.

Mark Galer

In the image above our eyes are first drawn to the figure occupying the foreground by use of focus. Our attention moves along a sweeping arc through the bench to the people on the far left side of the frame and finally to the distant figures and tower.

A greater sense of depth can be achieved by making optimum use of depth of field, careful framing, use of line, tone and color. In this way the viewer's attention can be guided through an image rather than just being drawn immediately to the middle of the frame, the point of focus and the principal subject matter.

Practical activity

Create an image by placing subject matter in the foreground, the middle distance and the distance in an attempt either to fill the frame or draw our gaze into the image.

Summary of basic design techniques

- Simplify content.
- Vary the use of horizontal and vertical formats.
- ~ Limit static compositions by placing the main subject off-center.
- Create balance or tension by arrangement of tone within the frame.
- Explore alternative vantage points from which to view the subject.
- Arrange lines within the frame to reinforce or express feeling and to guide the viewer through the image.

Mark Galer

creative controls

Michael E Stern

essential skills

- Increase your knowledge and understanding about aperture, shutter speed and focal length, and their combined effects on visual communication.
- Increase your familiarity and fluency with your personal camera equipment.
- Research professional photographic practice to demonstrate a visual understanding of applied camera technique.
- Create images that demonstrate a working knowledge of depth of field, timed exposures and perspective.
- Control communication and visual effect through considered use of focus, blur and perspective.

Introduction

In the chapter 'Framing the image' we have looked at how the camera is a subjective recording medium that can communicate and express the ideas of individual photographers. We have seen how the choice of subject and the arrangement or design of this subject within the frame has enormous potential to control communication. This communication can be further enhanced by varying the way we use the equipment and its controls in order to create or capture images. The photographer is advised to consider the application of technical effects very carefully so that the resulting images are primarily about the communication of content and not technique. Technique should never be obtrusive. The principal techniques that enable photographers on location to communicate in controlled ways are:

- Focus
- Duration of exposure
- Perspective.

Mark Galer

Familiarity with equipment

Owning a large amount of equipment does not necessarily make us a better photographer. It is essential that you first become familiar with what you own before acquiring additional equipment. The camera must become an extension of the photographer so it can be operated with the minimum of fuss. The equipment must not interfere with the primary function of seeing.

The camera is a tool to communicate the vision of the photographer. Creative photography is essentially about seeing.

Focus

The word 'focus' refers to either the point or plane at which an image is sharp or the 'center of interest'. When an image is being framed the lens is focused on the subject which is of primary interest to the photographer. The viewer of an image is instinctively drawn to this point of focus or the area of the image which is the most sharp. This becomes the 'focal point' of the image. In this way the photographer guides or influences the viewer to not only look at the same point of focus but also share the same point of interest.

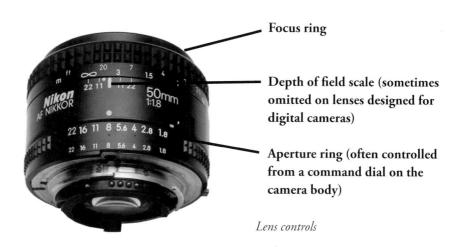

Limitations of focus

When an object is made sharp by focusing the lens all other subjects at the same distance are equally sharp. Subjects nearer or further away are progressively less sharp.

On DSLR cameras the focusing ring on the lens can be rotated between two stops, at which point it can no longer be turned to alter focus. As the subject moves closer to the lens a distance is reached where the subject can no longer be focused. The focusing ring will not turn further and reaches its stop (no stops may be present on the focusing ring of a prosumer digicam). This represents the 'closest point of focus'. As the subject moves further away the focusing ring again reaches a point where it will not turn further. This distance is called 'infinity' on the lens and is represented by the symbol ∞. At increasing distances from the camera the subject will continue to remain in focus. The closest point of focus and the point of infinity changes between different lenses. Prosumer digicams usually offer manual focusing as an option, but the absence of stops can make the process a little more time-consuming.

Practical activity

Check the closest focusing distance of all your lenses. If you have a zoom lens check the closest focusing distance at the shortest and longest focal lengths.

Capture images using the closest focusing distance at different focal lengths.

Depth of field

In addition to choosing the focal point of the image the photographer can also control how much of the image appears sharp or 'in focus'. As the aperture of the lens is progressively reduced in size, subjects in front and behind the point of focus steadily begin to appear sharper. By choosing the aperture carefully the photographer may be able to single out one person in a crowd or the entire crowd to be in focus. In this way communication can be dramatically altered. The zone of acceptable sharp focus is described as the 'depth of field'.

Depth of field can be described as the nearest to the furthest distances from the lens where the subject appears acceptably sharp.

Aperture wide open

Aperture stopped down to f/22

Shallow depth of field (above left) is created using the wider aperture settings of the lens. Subject matter behind and in front of the point of focus appears progressively out of focus. Due to the smaller sensors used in the prosumer digicams it is often difficult to achieve shallow depth of field unless you are working at the closest focusing distance of the lens, i.e. capturing an image using a prosumer camera using a small sensor will lead to greater depth of field than a DSLR using a lens set to the same aperture.

Maximum depth of field (above right) is created using the smaller aperture settings of the lens. Subject matter immediately in front of the lens and subject matter in the distance may appear acceptably sharp in the same image.

The widest apertures (f/2, f/4) give the least depth of field. The smallest apertures (f/16, f/22) give the greatest depth of field.

Depth of field preview

The changes to depth of field affected by aperture are not readily seen in most DSLR cameras. The subject is often viewed through the widest aperture that is held permanently open until the actual exposure is made. This is to give the photographer a bright image in the viewfinder. If the photographer wishes to check the depth of field at any given aperture they must use a 'depth of field preview' or review the image using the camera's LCD screen. An advantage of using a prosumer digicam is that a live preview of the depth of field is available before the image is captured.

Contributory factors affecting depth of field

Distance - Depth of field is also affected by the distance the photographer is positioned from the subject. As the photographer moves closer to the subject the depth of field becomes narrower. As the photographer moves further away the depth of field becomes greater.

Focal length - Telephoto lenses appear to create images with shallower depth of field when compared to wide-angle lenses but this is only because the subject appears bigger in the frame when viewing images captured with a telephoto lens. If the subject is the same size in the viewfinder when captured with a wide-angle and a telephoto lens then the depth of field would be virtually the same. Using a longer focal length lens also appears to create images with shallow depth of field because they flatten perspective (distant objects appear closer together).

The narrowest depth of field is achieved with the widest aperture on a telephoto lens whilst working at the lens's minimum focusing distance.

Point of focus - Unless you are very close to your subject, you'll find that depth of field, your acceptable focus range, extends more behind the subject than in front, especially when using lenses with a shorter focal length.

Mark Galer

Practical application

All factors affecting depth of field are working simultaneously. Aperture remains the photographer's main control over depth of field as framing (usually a primary consideration) dictates the lens and working distance. For maximum control over depth of field the photographer is advised to select aperture priority or manual mode and use a DSLR camera. Firstly decide on the subject which is to be the focal point of the image. Secondly decide whether to draw attention to this subject, isolate the subject entirely or integrate the subject with its surroundings. Precisely focusing the lens is unnecessary when photographing in bright conditions with small apertures (f/11, f/16 and f/22). Depth of field on a wide-angle lens stopped down to f/16 may extend from less than one meter to infinity.

Diffraction

Depth of field increases as the aperture is stopped down or made smaller but so do the effects of 'diffraction'. Diffraction is an optical effect that can make the image appear less sharp at smaller apertures. As light passes through the smaller apertures of the camera lens the light begins to disperse and is less precisely focused on the image sensor. The converging light rays that are a result of diffraction begin to spill into neighboring sensor sites, resulting in a softening of image sharpness. The effects of diffraction are more noticeable when the sensor sites are smaller, i.e. the effects of diffraction will be more noticable on a 10-megapixel compact camera than on a 10-megapixel DSLR due to the fact that the sensor sites on the compact are much smaller due to the smaller size of the sensor.

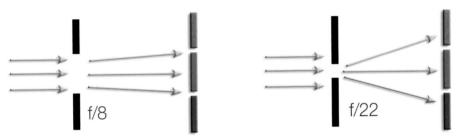

At wider apertures (illustration on left) the effects of diffraction are small but at smaller apertures light begins to disperse and hit neighboring sensor sites that results in a softening of sharp detail

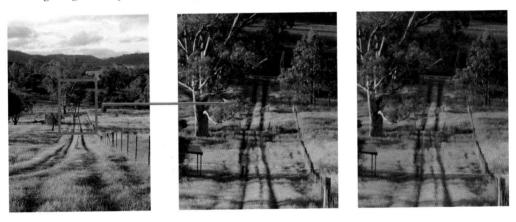

In the illustration above we can take a look at the detail of the same image captured on the same high quality 50mm prime lens at different apertures on a Nikon DSLR. The image in the center has been captured with an aperture of f/11 while the image on the right was captured with an aperture of f/22. Not only is there a fall-off of sharpness but also localized contrast.

Practical activity

Capture the same subject using every aperture of each lens you own.

Open the images in your image-editing application and zoom in to 1:1 view or Actual Pixels. Try to establish where the effects of diffraction first start to degrade the image sharpness of your lens.

Selective and overall focus

By selecting the quantity of information within the image to be sharp the photographer is said to be using 'selective focus'. This is a powerful tool to control communication. The photographer is telling the viewer what is important and what is less important.

When the aperture is reduced ('stopped down') sufficiently, and the other contributory factors to great depth of field are favorable, it is possible to produce an image where the content of the entire frame is sharp. This effect is described as 'overall focus'. Overall focus is often difficult to achieve. Unless the level of illumination is bright, or a tripod is available, the photographer runs the risk of 'camera shake'. Small apertures, such as f/16 or f/22, often require the use of a very slow shutter speed.

Mark Galer

Maximizing depth of field

The photographer can maximize the depth of field and ensure overall focus by using a small aperture and focusing approximately one-third of the way into the subject when using wide-angle lenses.

Practical activity

Create an image using selective focus to control the communication.

Discuss the visual communication of the image.

Duration of exposure

All photographs are time exposures of shorter or longer duration, and each describes an individually distinct parcel of time. The photographer, by choosing the length of exposure, is capable of exploring moving subjects in a variety of ways.

By choosing long exposures moving objects will record as blurs. This effect is used to convey the impression or feeling of motion. Although describing the feeling of the subject in motion, much of the information about the subject is sacrificed to effect. By selecting fast shutter speeds photographers can freeze movement. We can see the nature of an object in motion, at a particular moment in time, that the human eye is unable to isolate.

Fast shutter speeds

By freezing thin slices of time, it is possible to explore the beauty of form in motion. A fast shutter speed may freeze a moving subject yet leave others still blurred. This is dependent on the speed of the subject matter and the angle of movement in relation to the camera. For subject matter travelling across the camera's field of view, relatively fast shutter speeds are required, compared to the shutter speeds required to freeze the same subject travelling towards or away from the camera.

Mark Galer

Limitations of equipment

Wide apertures in combination with bright ambient light and/or high ISO allows the use of fast shutter speeds in order to freeze rapidly moving subject matter. Some telephoto and zoom lenses only open up to f/4 or f/5.6. If used with a low ISO there is usually insufficient light to use the fastest shutter speeds available on the camera.

Panning

Photographers can follow the moving subject with the camera in order to keep the subject within the frame. This technique, called 'panning', allows the photographer to use a slower shutter speed than would otherwise have been required if the camera had been static. The ambient light is often insufficient to use the very fast shutter speeds, making panning essential in many instances. For successful panning the photographer must aim to track the subject before the shutter is released and follow through or continue to pan once the exposure has been made. The action should be one fluid movement without pausing to release the shutter. A successful pan may not provide adequate sharpness if the focus is not precise. In order to have precise focusing with a moving subject the photographer may need to use a fast predictive autofocus system or pre-focus on a location which the moving subject will pass through. Locking off a focus point and exposure setting by half-pressing the shutter release button is especially important when using a prosumer digicam where the shutter lag may otherwise prevent the photographer from capturing the precise point in the action.

Note > When panning a camera you may need to switch off any image stabilization that may be activated in the camera body or lens, e.g. Sony Steady Shot, Nikon VR or Canon IS. Some image stabilization settings will allow the photographer to pan with the camera, e.g. Nikon's 'Normal' mode on their VR lenses will disable two of the four stabilizers when panning is detected.

Tim Barker

Practical activity

Try to capture a running or jumping figure using fast shutter speeds (faster than 1/250 second). Vary the direction of travel in relation to the camera and attempt to fill the frame with the figure. Examine the image for any movement blur.

Capture the same moving subject using shutter speeds between 1/15 and 1/125 second with any image stabilization or vibration reduction switched off. Pan the camera to follow the movement. The primary subject should again fill the frame.

Slow shutter speeds

When the shutter speed is slowed down movement is no longer frozen but records as a streak across the image. This is called 'movement blur'. Movement blur can be created with relatively slow moving subject matter. Speeds of 1/30, 1/15, 1/8 and 1/4 second can be used to create blur with a standard lens. If the camera is on a tripod the background will be sharp and the moving subject appear blurred. If the camera is panned successfully with the moving subject the background will provide most of the blur in the form of a streaking effect in the direction of the pan.

Mark Galer

Camera shake

Movement blur may also be picked up from camera movement as a result of small vibrations transmitted to the camera from the photographer's hands. This is called 'camera shake'. To avoid camera shake a shutter speed roughly equal to the focal length of the lens is usually recommended, e.g. 1/30 second at 28mm, 1/60 second at 50mm and 1/125 at 135mm. Many cameras give an audible or visible signal when shutter speeds likely to give camera shake are being used. Using a camera with an image stabilizer or by carefully bracing the camera, slower speeds than those recommended can be used with great success. When using slow shutter speeds the photographer can rest elbows on a nearby solid surface, breathe gently and release the shutter with a gentle squeeze rather than a stabbing action to ensure a shake-free image.

Extended shutter speeds

If the shutter speeds are further reduced information about the subject is eventually lost and the effect of movement may disappear. The technique of very long exposures is often explored in landscape photography where the photographer wants to record the passage of weather or water. For very long exposures the camera can be mounted on a tripod and the shutter fired using a cable release or via a shutter delay feature. Small apertures in combination with an image sensor set to a low ISO and light-reducing filters such as a neutral density filter or polarizing filter will extend the shutter speed to seconds or even minutes.

Orien Harvey

Increased noise

When using exposures of longer than 1 second increased levels of noise may become apparent with many image sensors (especially the smaller sensors fitted to most prosumer digicams). Test the digital camera you intend to use for any long exposures to establish acceptable levels of noise at extended exposures.

Practical activity

Capture an image using shutter speeds longer than 1 second. The camera should be braced or secured on a tripod so that stationary subject matter is sharp.

A creative decision

The choice between depth of field and shutter speed is often a compromise. Choosing one effect impacts upon the other. The need for correct exposure requires the photographer to make one effect a priority over the other. When the photographer requires overall focus, movement blur is likely to occur from the use of a slow shutter speed. When the aperture is opened to achieve shallow depth of field the shutter speed is relatively fast. Movement blur is unlikely unless the photographer is photographing in subdued lighting conditions. Similarly when the photographer requires a reasonably fast shutter speed to avoid camera shake or freeze motion, shallow depth of field is often the result.

Orien Harvey

Limitations of semi-automatic

When selecting shutter priority mode on a built-in metering system the photographer must take care not to underexpose images. Excessively fast shutter speeds for the available light may require an aperture greater than that available on the lens.

When selecting aperture priority mode on a built-in metering system the photographer must take care not to overexpose images. Excessively wide apertures to create shallow depth of field in bright light may require shutter speeds faster than that available with the camera being used.

Practical activity

Record the widest aperture available on each of your lenses when photographing in bright sunlight that does not lead to overexposure.

Record the fastest shutter speeds available when photographing in a variety of interior locations using the existing light only without raising the ISO higher than 400 ISO.

Create an image that contains a mixture of solid (sharp) and fluid (blur) forms.

Perspective

Visual 'perspective' is the way we gain a sense of depth and distance in a two-dimensional print. Objects are seen to diminish in size as they move further away from the viewer. This is called 'diminishing perspective'. Parallel lines converge as they recede towards the horizon. This is called 'converging perspective'.

The human eye has a fixed focal length and a fixed field of vision. A photographer using a lens set to 50mm (or equivalent) can emulate the perspective perceived by human vision. Perspective can, however, be altered by changing the focal length of the lens together with the distance of the camera from the subject.

Steep perspective

Due to a close viewpoint a wide-angle lens exaggerates distances and scale, creating 'steep perspective'. Subjects close to the lens look large in proportion to the surroundings. Distant subjects look much further away.

Taken with a wide-angle lens, the woman in the foreground looks prominent and the city in the background looks distant. Viewers are drawn into the image via the steep perspective. The use of a wide-angle lens in bright sunlight enables great depth of field whilst handholding a camera.

Perspective compression

Due to a distant viewpoint a telephoto lens compresses, condenses and flattens threedimensional space. Subject matter appears closer together. The viewer of an image taken with a telephoto lens often feels disconnected with the subject matter.

Taken with a telephoto lens, the perspective compression gives more emphasis to the distant city. It is easy to isolate the subject from the background using wide apertures on telephoto lenses. In overcast conditions or when photographing in the shade slow shutter speeds may cause camera shake.

Practical activity

Capture the same subject with a zoom lens set to different focal lengths to alter the perspective and sense of depth in the image. Move closer or further away from your subject to keep the subject the same relative size in the viewfinder window in each image.

Summary of basic camera techniques

- Select the focal point of the image and choose selective or overall focus.
- ~ Select the depth of field required using the aperture control.
- Consider the combined effects of: aperture, focal length and distance from the subject.
- ~ To maximize depth of field focus one-third of the way into the subject.
- Use a depth of field preview, a depth of field scale or the camera's LCD display to calculate focus.
- ~ Consider the most appropriate choice of shutter speed to freeze or blur the subject.
- Brace the camera when using slower shutter speeds to avoid camera shake.
- Pan the camera to maximize sharpness of a moving subject.
- Use predictive focus when panning a moving subject.
- Allow for increased levels of noise with exposure times longer than 1 second.
- Choose the desired perspective by considered use of focal length and viewpoint.

Online technical tutorials

http://www.cambridgeincolour.com http://www.luminous-landscape.com

Michael E. Stern

light (

Mark Galer

essential skills

- Gain an understanding of how light changes the character and mood of an image.
- Develop an awareness of subject contrast and the dynamic range of image sensors.
- Understand the relationship between lighting contrast, lighting ratios, subject contrast and subject brightness range.
- · Learn about exposure compensation and 'appropriate' exposure.
- Learn how to manage difficult lighting conditions on location.

Introduction

Light is the essence of photography. Without light there is no photography. Light is the photographer's medium. The word photography is derived from the ancient Greek words, 'photos' and 'graph', meaning 'light writing'. To understand light the photographer must be fully conversant with its qualities and behavior. In mastering the medium the photographer learns to take control over the creation of the final image. This takes knowledge, skill and craftsmanship. It can at first seem complex and sometimes confusing. However, with increased awareness and practical experience light becomes an invaluable tool to communication.

Seeing light

In order to manage a light source, we must first be aware of its presence. Often our preoccupation with content and framing can make us oblivious to the light falling on the subject and background. We naturally take light for granted. This can sometimes cause us to simply forget to 'see' the light. When light falls on a subject it creates a range of tones we can group into three main categories: highlights, midtones and shadows.

Each of these can be described by their level of illumination (how bright, how dark) and their distribution within the frame. These are in turn dictated by the relative position of subject, light source and camera.

Image 1

Image 2

Practical activity

Try to describe the above images in terms of highlights, midtones and shadows and see if you can work out where the light source is coming from.

Light source

Ambient light is the existing available light present in any environment. Ambient light can be subdivided into four major categories:

- Daylight
- ~ Tungsten
- Fluorescent
- ~ Firelight.

Daylight - A mixture of sunlight and skylight. Sunlight is the dominant or main light. It is warm in color and creates highlights and shadows. Skylight is the secondary light. It is cool in color and fills the entire scene with soft diffused light. Without the action of skylight, shadows would be black and detail would not be visible.

Orien Harvey

Tungsten - A common type of electric light such as household bulbs/globes and photographic lamps. A tungsten element heats up and emits light. Tungsten light produces very warm tones when the white balance is set to daylight. Make sure you adjust the white balance to the dominant light source or capture in the Raw format and set the white balance in post-production.

Fluorescent - Fluorescent light can produce a strong green cast (not apparent to the human vision) if captured using a daylight white balance. If used as a primary light source the results are often unacceptable due to the broad flat light from above. Underexposure is again experienced when using this light source and the cast can be difficult to correct. Fluorescent light flickers and causes uneven exposure with focal plane shutters. To avoid this, shutter speeds slower than 1/30 second should be considered.

Firelight - Light from naked flames can be very low in intensity. With very long exposures it can be used to create atmosphere and mood with its rich red tones.

Intensity

Light intensity is a description of the level of a light's brightness. The intensity of light falling on a subject can be measured using a light meter. This is called an 'incident reading'. A light meter built into a camera does not directly measure the intensity of light falling on the subject but the level of light reflected from it. This is called a 'reflected reading'.

Itti Karuson

Reflectance

Regardless of the intensity of the light falling on the subject, different levels of light will be reflected from the subject. The amount of light reflecting from a surface is called 'subject reflectance'. The levels of reflectance vary according to the color, texture and angle of the light to the subject. A white shirt will reflect more light than a black dress. A sheet of rusty metal will reflect less light than a mirror. In all cases the level of reflectance is directly proportional to the viewpoint of the camera. If the viewpoint of the camera is equal to the angle of the light to the subject the reflectance level will be greater. The level of reflected light is therefore determined by:

- Reflectance of the subject.
- Intensity of the light source.
- Angle of viewpoint and light to the subject (the angle of reflectance equals the angle of incidence).
- Distance of the light source from the subject.

Although the intensity of the light source may remain constant (such as on a sunny day) the level of reflected light may vary.

'Fall-off' and the Inverse Square Law

The way that light decreases as you move away from the light source is expressed scientifically by the Inverse Square Law, which states:

'When a surface is illuminated by a point source of light, the intensity of the light at the surface is inversely proportional to the square of the distance from the light source.'

Now, just before you panic this is really quite simple. It means that if your subject moves away from your camera's flash, there is a fall-off in the light that they receive. In fact, if they are now twice as far away, they do not receive half as much light but one-quarter. Four times the distance, one-sixteenth of the light! This does not happen in sunlight because we are all the same distance from that big point source in the sky, the sun. But it is essential that the Inverse Square Law is applied when dealing with flash, other artificial lights, reflected light or window light as the visual effect of subjects at differing distances to the light source is uneven illumination.

Orien Harvey

Practical activity

Notice how quickly the level of illumination drops as someone moves further away from a window that is illuminating them. Capture an image of two people standing at different distances from the window and notice the fall-off of light that occurs for the figure standing further away from the window.

Quality

Light from a point light source such as an open flash or the sun is described as having a 'hard quality'. The directional shadows created by this type of light are dark with well-defined edges. The shadows created by the sun are dark but not totally devoid of illumination. This illumination is provided by reflected skylight. The earth's atmosphere scatters some of the shorter blue wavelengths of light and provides an umbrella of low-level light. Artificial point light sources create a much harsher light when used at night or away from the softening effects of skylight. The light from a point light source can also be diffused, spread or reflected off larger surface areas. Directional light maintains its 'hard quality' when reflected off a mirror surface but is scattered in different directions when reflected off a matte surface. This lowers the harshness of the light and the shadows now receive proportionally more light when compared to the highlights. The light is said to have a softer quality. The shadows are less dark (detail can be seen in them) and the edges are no longer clearly defined.

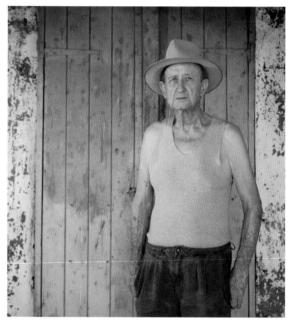

Harsh light

Soft light - Orien Harvey

The smaller the light source, the harder the light appears. The larger the light source, the softer the light appears.

The control over quality of light is an essential skill when on location. Often the photographer will encounter scenes where the quality of the available light creates enormous difficulties for the latitude of the image sensor. The photographer must learn techniques to alter the quality of light or risk loss of detail and information. The quality of light, whether hard or soft, can be changed by diffusion and reflection.

Color

The visible spectrum of light consists of a range of wavelengths from 400 nanometers (nm) to 700nm. Below 400nm is UV radiation and X-rays and above 700nm is infrared (all capable of being recorded photographically). When the visible spectrum is viewed simultaneously we see 'white light'. This broad spectrum of colors creating white light can be divided into the three primary colors: red, green and blue. The precise mixture of primary colors in white light may vary from different sources. The light is described as cool when predominantly blue, and warm when predominantly red. Human vision adapts to different mixes of white light and will not pick up the fact a light source may be cool or warm unless compared directly with another in the same location.

The light from tungsten bulbs and firelight consists predominantly of light towards the red end of the spectrum. The light from tungsten lamps is also predominantly light towards the red end of the spectrum. The light from flash consists predominantly of light towards the blue end of the spectrum. Daylight is a mixture of cool skylight and warm sunlight. Image sensors balanced to 'Daylight' will give fairly neutral tones with noon summer sunlight. When the direct sunlight is obscured or diffused, however, the skylight can dominate and the tones record with a blue cast. As the sun gets lower in the sky the light gets progressively warmer and the tones will record with a yellow or orange cast unless the white balance in the camera is adjusted. The color of light is measured by color temperature, usually described in terms of degrees Kelvin (K). This scale refers to a color's visual appearance (red - warm, blue - cold).

Color correction

When using a digital camera and saving to JPEG or TIFF color correction is achieved by adjusting the white balance to the dominant light source. Alternatively save to the camera Raw format and assign the white balance in post-production.

Note > To avoid small inconsistencies of color reproduction it is NOT recommended to use Auto White Balance when using a print service provider to print from a batch of images captured using the same light source. Use a manual white balance setting or a specific white balance setting to create consistency of color temperature and tint.

Direction

The direction of light determines where shadows fall and their source can be described by their relative position to the subject. Shadows create texture, shape, form and perspective. Without shadows photographs can appear flat and visually dull. A subject lit from one side or behind will not only separate the subject from its background but also give it dimension. A front-lit subject may disappear into the background and lack form or texture. In nature the most interesting and dramatic lighting occurs early and late in the day.

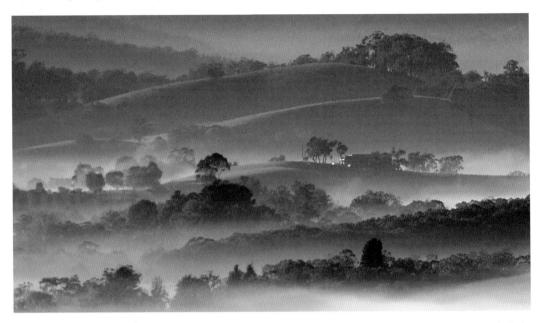

Mark Galer

Early and late light

Many location photographs can look flat and uninteresting. Photographers arriving at a location when the sun is high find a flat, even illumination to the environment. The colors can look washed out and there is little or no light and shade to create modelling and texture. The mood and atmosphere of a location can be greatly enhanced by the realization that most successful location images are taken when the sun is low, dawn or dusk, or as it breaks through cloud cover to give uneven and directional illumination. When the sun is high or diffused by cloud cover the mood and the subject contrast usually remain constant. When the sun is low the photographer can often choose a variety of moods by controlling the quantity, quality and position of shadows within the image. Colors are often rich and intense and morning mists can increase the mood dramatically.

Practical activity

Capture photographs at the same location at dawn, midday and sunset.

Compare the color and quality of lighting effect and the mood of the images.

Try to capture some images that use long shadows as an essential component of the design.

Contrast

The human eye simultaneously registers a wide range of light intensity. Due to their limited latitude image sensors are unable to do this. The difference in the level of light falling on or being reflected by a subject is called contrast. When harsh directional light strikes a subject the overall contrast increases. The highlights continue to reflect high percentages of the increased level of illumination whilst the shadows reflect little extra. Without contrast photographic images can appear dull and flat. It is contrast within the image that gives dimension, shape and form. Awareness and the ability to understand and control contrast is essential to work successfully in the varied and complex situations arising in photography.

Subject contrast

Different surfaces reflect different amounts of light. A white shirt reflects more light than black jeans. The greater the difference in the amount of light reflected the greater the subject contrast or 'reflectance range'. The reflectance range can only be measured when the subject is evenly lit. The difference between the lightest and darkest tones can be measured in stops. If the difference between the white shirt and the black jeans is three stops then eight times more light is being reflected by the shirt than by the jeans (a reflectance range of 8:1).

One stop = 2:1, two stops = 4:1, three stops = 8:1, four stops = 16:1

Mark Galer

A 'high-contrast' image is where the ratio between the lightest and darkest elements is 32:1 or greater.

A 'low-contrast' image is where the ratio between the lightest and darkest elements is less than 16:1.

Brightness range

Light is reflected unevenly off surfaces, light tones reflecting more light than dark tones. Each subject framed by the photographer will include a range of tones. The broader the range of tones the greater the contrast.

When harsh directional light such as sunlight strikes a subject the overall contrast of the scene increases. The tones facing the light source continue to reflect high percentages of the increased level of illumination whilst the shadows may reflect little extra. The overall contrast of the framed subject is called the SBR or 'subject brightness range'.

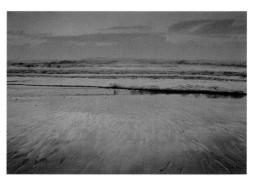

SBR of approximately five stops (32:1)

SBR of approximately three stops (8:1)

The SBR can be measured by taking a meter reading of the lightest and darkest tones. If the lightest tone reads f/16 @ 1/125 second and the darkest tone reads f/4 @ 1/125 second the difference is four stops or 16:1.

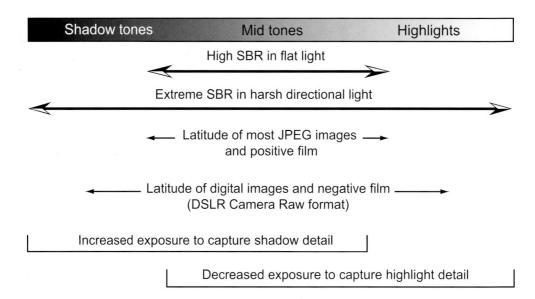

A subject with a high or extreme brightness range can exceed the latitude of the image sensor

Latitude

Image sensors are capable of recording a limited tonal range or brightness range. A subject photographed in high-contrast lighting may exceed this recordable or 'dynamic range'. The ability for the image sensor to accommodate a brightness range is referred to as its 'latitude'. Digital image sensors capturing JPEG images typically capture a brightness range of only 32:1 or five stops. It is essential for digital photographers to understand that when capturing JPEG images with directional sunlight, shadow and highlight detail may be lost. The photographer capturing Raw files has increased flexibility to capture a broader range of tones and with careful exposure, post-production processing and printing techniques they can extend this range dramatically.

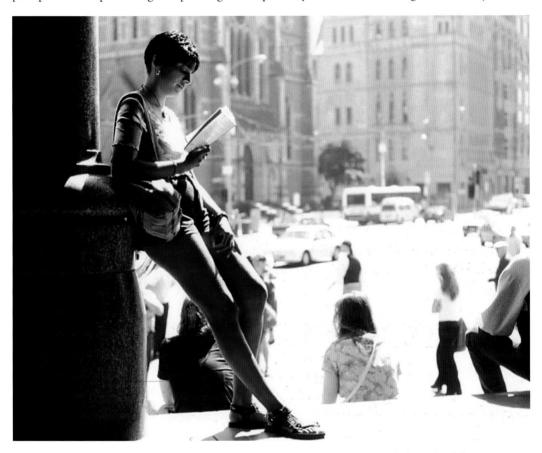

SBR exceeding the latitude of the image sensor

Previsualization

Awareness of the subject brightness range and the capability of the photographic medium to capture this range of tones allows the photographer to previsualize or predict the outcome of the final image. When the brightness range exceeds the sensor's capabilities the photographer has the option to increase or decrease exposure to protect shadow or highlight detail that would otherwise not record or switch to Raw capture when using a DSLR. These scenes are described as 'extreme contrast'.

Extreme contrast

In an attempt to previsualize the final outcome of a scene with a high brightness range, many photographers use the technique of squinting or narrowing the eyes to view the scene. This technique removes detail from shadows and makes the highlights stand out from the general scene. In this way the photographer is able to predict the contrast of the resulting image. If the photographer fails to take into account the image sensor's limited capabilities both shadow detail and highlight detail can be lost. It is usual for photographers to protect the highlight detail in the exposure and fill the shadow detail with additional lighting.

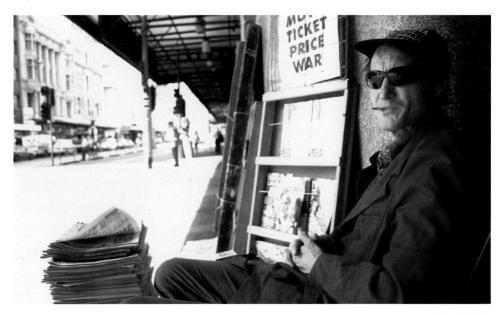

Mark Galer

In many instances when the photographer is expected to work quickly it is all the photographer can do to notice the extreme brightness range and make quick judgements from experience to alter the exposure. The least appropriate exposure in extreme contrast situations is often the exposure indicated by a camera's TTL meter. This average exposure may not be suitable if the subject or detail is located in the deep shadows or bright highlights. In these instances the photographer must override the exposure indicated by the meter and either open up (increase exposure) if shadow detail is required, or stop down (decrease exposure) if highlight detail is required.

In the photograph above the lighting contrast between the noon sun and the shadows was too great to record using the JPEG format. Increased exposure over the indicated meter reading was required to capture the shadow detail.

Practical activity

Capture an image where the tonal range of the subject will exceed the tonal range that can be recorded by your camera. Take additional images at different exposures to see how many stops adjustment is required to capture the missing detail.

Exposure compensation

When working on location the lighting (sunlight) already exists. There is often little the photographer can do to lower the brightness range. In these instances exposure compensation is often necessary to protect either shadow or highlight detail. The results of exposure compensation are easily assessed via the camera's LCD monitor. The amount of compensation necessary will vary depending on the level of contrast present and what the photographer is trying to achieve. Compensation is usually made in 1/3 stop increments but when a subject is back-lit and TTL metering is used the exposure may need increasing by two or more stops depending on the lighting contrast. Alternatively a spot TTL metering option can be used to assess accurate exposure.

Increasing exposure will reveal more detail in the shadows and dark tones. Decreasing exposure will reveal more detail in the highlights and bright tones.

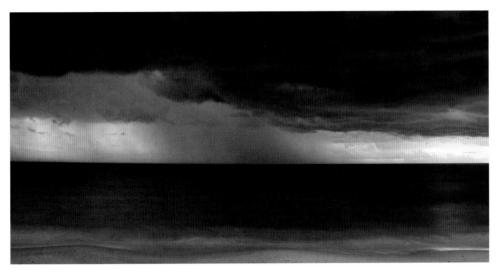

Orien Harvey

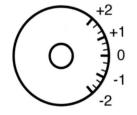

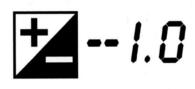

Exposure compensation adjustment

A compensation setting is required when the photographer wishes to continue working with an automatic metering system instead of manual controls. Using an automatic metering mode the photographer cannot simply adjust the exposure, from that indicated by the meter, using the aperture or shutter speed. The automatic mode will simply re-compensate for the adjustment in an attempt to record the overall tone of the framed subject matter as a midtone equal to the 18% gray card. The photographer must use the exposure compensation feature on the camera if they intend to use the camera in an automatic or semi-automatic exposure mode.

Assessing the degree of compensation

Photographers calculate the degree of compensation from MIE in a variety of different ways. The method chosen is often dictated by whether speed or accuracy is required.

Digital histogram - Most DSLR cameras and high-end prosumer digicams allow the user to view a 'histogram' of the exposure immediately after capture and/or indication of highlight clipping (overexposure). In the case of many of the prosumer cameras the histogram can be viewed live with the preview before capture takes place. This is now the most popular method for assessing whether exposure compensation is required when capturing images with digital cameras. It is worth noting, however, that DSLR cameras shooting in the Raw format are capable of capturing a broader dynamic range than the histogram may indicate (see the chapter 'Exposure'). Although this is a reliable method for assessing appropriate exposure compensation it does not replace some of the traditional methods where compensation must be immediate and reasonably accurate.

Bracketing - The photographer can estimate the necessary compensation by bracketing the exposures. To bracket the exposure the photographer must expose several frames, varying the exposure in 1/3 or 2/3 stop increments either side of the MIE.

18% Gray card - Photographers can use a midtone of known value from which to take a reflected light meter reading. A midtone of 18% reflectance is known as a 'gray card'. The gray card must be at the same distance from the light source as the subject. Care must be taken to ensure the shadow of neither the photographer nor the light meter is cast on the gray card when taking the reading. When capturing in JPEG make sure the indicated exposure is suitable for an SBR not exceeding 32:1. If highlight or shadow detail is required the exposure must be adjusted accordingly. When capturing Raw files the indicated exposure is suitable for an SBR of approximately 128:1 or greater.

Caucasian skin - A commonly used midtone is Caucasian skin. A reflected reading of Caucasian skin placed in the main light source (key light) is approximately one stop lighter than a midtone of 18% reflectance. Using this knowledge a photographer can take a reflected reading from their hand and increase the exposure by one stop to give an exposure equivalent to a reflected reading from an 18% gray card. Adjustments would be necessary for an SBR exceeding the latitude of the image sensor.

Re-framing - If the photographer is working quickly to record an unfolding event or activity the photographer may have little or no time to bracket or take an average midtone reading. In these circumstances the photographer may take a reading quickly from a scene of average reflectance close to the intended subject. This technique of re-framing may also include moving closer to the primary subject matter in order to remove the light source and the dominant light or dark tones from the framed area. Many modern cameras feature an exposure lock to enable the photographer to find a suitable exposure from the environment and lock off the metering system from new information as the camera is repositioned.

Judgement - The fastest technique for exposure compensation is that of judgement, gained from experience and knowledge. The photographer must previsualize the final image and estimate the degree of compensation required to produce the desired effect.

Compensation for back lighting

The most common instance requiring exposure compensation is 'back lighting' using a TTL meter. The metering system will be overly influenced by the light source and indicate a reduced exposure. As the light source occupies more and more of the central portion of the viewfinder so the indicated exposure is further reduced. The required exposure for the subject may be many times greater than the indicated exposure.

Mark Galer

If the camera is in manual mode or equipped with an exposure lock, the photographer can meter for the specific tonal range required and then re-frame the shot. An alternative used by many professionals is to adjust the exposure using the exposure compensation facility. Using this technique can avoid re-framing after first metering.

Practical activity

Choose a lighting situation where the subject is back-lit.

Take a photograph of the subject with the 'meter-indicated exposure' or MIE.

Review the exposure on the camera's LCD screen.

Do not reposition the frame and take a second image using your own judgement to assess the amount of exposure compensation required to capture an image that is exposed appropriately.

How accurate were you at guessing the correct exposure compensation needed?

With practice you should be able to adjust the exposure intuitively without making initial errors.

Filtration

The purpose of a filter is to selectively modify the light used for exposure. Filters are regularly used by professional photographers. They are an indispensable means of controlling the variations in light the photographer is likely to encounter. The range of filters used varies according to the range of situations likely to be encountered. However, when capturing Raw file images it is possible to undertake color correction in post-production.

Mark Galer

UV filters

Ultraviolet (UV) radiation present in the spectrum of light is invisible to human vision but adds to the overall exposure of the image. It is most noticeable with landscape images taken at high altitude and seascapes. To ensure the problem is eliminated, UV filters can be attached to all lenses used on location. If the optical quality of the filter is good the filters may be left permanently attached to the lenses. The added benefit of this practice is the front lens element of each lens will be protected from scratching.

Neutral density filters

With manufacturers going to great lengths to create fast lenses with wide maximum apertures it may seem strange to find a range of filters available which reduce the amount of light at any given aperture. These are neutral density filters and are available in a range of densities. If only one is purchased the photographer should consider one that can reduce the light by at least two stops (four times less light). Neutral density filters are used for two reasons:

- Reducing depth of field
- Increasing duration of exposure.

Polarizing filters

Polarized light is the light reflected from non-metallic surfaces and parts of the blue sky. A polarizing filter can reduce this polarized light and the effects are visible when viewing the image in the camera.

A polarizing filter is gray in appearance and when sold for camera use consists of the actual filter mounted onto a second ring, thus allowing it to rotate when attached to the lens. The filter is simply turned until the desired effect is achieved.

The polarizing filter is used for the following reasons:

- Reducing or removing reflections from surfaces
- Darkening blue skies at a 90 degree angle to the sun
- Increasing color saturation.

Mark Galer

Possible problems

The filter should be removed when the effect is not required. If not removed the photographer will lose two stops and reduce the ability to achieve overall focus.

When the polarizing filter is used in conjunction with a wide-angle lens, any filter already in place should be removed. This will eliminate the problem of tunnel vision or clipped corners in the final image. Photographing landscapes when the sun is lower in the sky can result in an unnatural gradation, ranging from a deep blue sky on one side of the frame to a lighter blue sky on the other.

Practical activity

Create an image on a sunny day eliminating polarized light and one without using the filter. Try to remove reflections from a shop window or the surface of water using a polarizing filter.

lighting on location

Mark Galer

essential skills

- Change the character and mood of subject matter using lighting.
- Develop an awareness of overall subject contrast and how this is translated by the capture medium.
- · Develop skills in controlling introduced lighting on location.
- Research a range of fill and flash lighting techniques.
- Produce photographic images demonstrating how lighting techniques control communication.

Introduction

The lighting in a particular location at any given time may not be conducive to the effect the photographer wishes to capture and the mood they wish to communicate. In these instances the photographer has to introduce additional lighting to modify or manipulate the ambient light present. In some instances the ambient light becomes secondary to the introduced light, or plays little or no part in the overall illumination of the subject. The following conditions may lead a photographer towards selecting additional lighting:

- The lighting may be too dull and the resulting slow shutter speeds would cause either camera shake or subject blur.
- Color temperature of artificial lights causing undesired color casts.
- The available light is leading to an unsuitable brightness range for the image sensor, e.g. the contrast is too high for the latitude of the capture medium and would lead to either overexposed highlights or underexposed shadows.
- The direction of the primary light source is giving unsuitable modelling for the subject, e.g. overhead lighting creating unsuitable shadows on a model's face.

James Newman

Practical activity

Research commercial images captured on location where you feel the photographer has used additional lighting to the available light present. Try to figure out where the additional light is coming from and the effect it is having on the subject.

Fill

In high and extreme contrast scenes where the subject brightness range exceeds the latitude of the imaging sensor, it is possible for the photographer to lower the overall lighting ratio by supplying additional fill light. The two most popular techniques include using reflectors to bounce the harsh light source back towards the shadows or by the use of on-camera flash at reduced power output. Before the photographer jumps to the conclusion that all subjects illuminated by direct sunlight require fill, the photographer must first assess each scene for its actual brightness range. There can be no formula for assessing the degree of fill required when the subject is illuminated by direct sunlight. Formulas do not allow for random factors which are present in some situations but not in others. Photographers must, by experience, learn to judge a scene by its true tonal values and lighting intensity.

Mark Galer

The photograph above was taken in Morocco in harsh sunlight. The photographer could be mistaken for presuming this is a typical scene which would require fill light. If the scene is read carefully, however, the photographer would realize that the shadows are not as dark as one would presume. Meter readings taken in the shadows and highlights would reveal that the shadows are being filled by reflected light from the brightly painted walls.

Reflectors

Fill light can occur naturally by light bouncing off reflective surfaces within the scene. It can also be introduced by reflectors strategically placed by the photographer. This technique is often used to soften the harsh shadows cast on models in harsh sunlight.

The primary considerations for selecting a reflector are surface quality and size.

Natural fill - Mark Galer

Surface quality

Reflectors can be matt white, silver or gold depending on the characteristics and color of light required. A matt white surface provides diffused fill light whilst shiny surfaces, such as silver or gold, provide harsher and brighter fill light. Choosing a gold reflector will increase the warmth of the fill light and remove the blue cast present in shadows.

Size

Large areas to be filled require large reflectors. The popular range of reflectors available for photographers are collapsible and can be transported to the location in a carrying bag. A reflector requires a photographer's assistant to position the reflector for maximum effect. Beyond a certain size (the assistant's ability to hold onto the reflector on a windy day) reflectors are often not practical on location unless they are used in conjunction with large stands and lots of sandbags.

Practical activity

Create an image by experimenting with different reflectors to obtain different qualities of fill light. Keep a record of the type of reflector used with each image and the distance of the reflector from the subject so you can evaluate your results when your review the work on your computer.

Flash

Flash is the term given for a pulse of very bright light of exceptionally short duration. The light emitted from a photographic flash unit is balanced to daylight and the duration of the flash is usually shorter than 1/500 second.

When the photographer requires additional light to supplement the daylight present flash is the most common source used by professional photographers. Although it can be used to great effect it is often seen as an incredibly difficult skill to master. It is perhaps the most common skill to remain elusive to photographers when working on location. Reviewing the image via the LCD screen will help the photographer master the skills more quickly. The flash is of such short duration that integrating flash with ambient light is a skill of previsualization and applied technique. The photographer is unable to make use of modelling lights that are used on studio flash units (modelling lights that can compete with the sun are not currently available). The skill is therefore mastered by a sound understanding of the characteristics of flashlight and experience through repeated application and testing the performance of your equipment.

Flash, rather than reflectors, is used to preserve shadow detail - Shane Bell

Characteristics

Flash is a point light source used relatively close to the subject. The resulting light is very harsh and the effects of fall-off are often extreme (see page 91, 'Light > Intensity > Fall-off'). One of the skills of mastering flash photography is dealing with and disguising these characteristics that are often seen as professionally unacceptable.

Choice of flash

Choosing a flash unit for use on location may be decided on the basis of degree of sophistication, power, size and cost.

Most commercially available flash units are able to read the reflected light from their own flash during exposure. This feature allows the unit to extinguish or 'quench' the flash by a 'thyristor' switch when the subject has been sufficiently exposed. When using a unit capable of quenching its flash, subject distance does not have to be accurate as the duration of the flash is altered to suit. This allows the subject distance to vary within a given range without the photographer having to change the aperture set on the camera lens or the flash output. These sophisticated units are described as either 'automatic' or 'dedicated'.

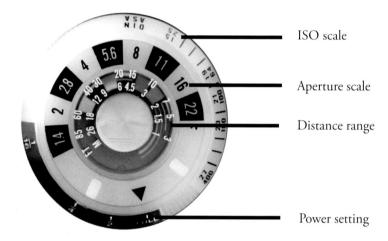

Control panel of an older style automatic flash unit

Automatic

An automatic flash unit uses a photocell mounted on the front of the unit to read the reflected light and operate an on-off switch of the fast-acting thyristor type. The metering system works independently of the camera's own metering system. If the flash unit is detached from the camera the photocell must remain pointing at the subject if the exposure is to be accurate.

Useful specifications

Perhaps the most important consideration when selecting an automatic flash unit is its ability to make use of a range of f-stops on the camera lens. Cheaper units may only have a choice of two f-stops whereas more sophisticated units will make use of at least four.

Ideally the output of a professional unit will have a high 'guide number' (an indication of the light output). The amount of time the unit takes to recharge is also a consideration. Many flash outfits have the option of being linked to a separate power pack so that the drain on the unit's smaller power supply (usually AA batteries) does not become a problem.

The flash head of a unit will ideally swivel and tilt, allowing the photographer to direct the flash at any white surface whilst still keeping the photocell pointed at the subject.

Dedicated

Dedicated flash units are often designed to work with specific cameras, e.g. Nikon 'speedlights' with Nikon cameras. The camera and flash communicate more information through additional electrical contacts in the mounting bracket of the unit. The TTL metering system of the camera is used to make the exposure reading instead of the photocell. In this way the exposure is more precise and allows the photographer the flexibility of using filters without having to alter the settings of the flash.

In addition to the TTL metering system the camera may communicate information such as the ISO of the capture medium and the focal length of the lens being used. This information may be automatically set, ensuring an accurate exposure and the correct spread of light.

Features such as automatic fill flash, slow sync, rear curtain slow sync, red eye reduction and strobe are common features of some sophisticated units. Often the manuals accompanying these units are as weighty as the manual for the camera which they are designed to work in conjunction with.

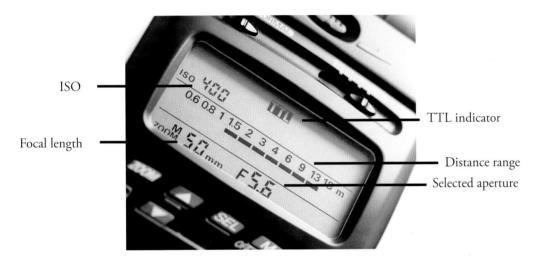

Control panel of a modern dedicated flash unit

Setting up a flash unit

- Check that the ISO has been set on either the flash or flash meter and the camera.
- Check that the flash is set to the same focal length as the lens. This may involve adjusting the head of the flash to ensure the correct spread of light.
- Check that the shutter speed on the camera is set to the correct speed (often slower than 1/250 second on a DSLR camera using a focal plane shutter).
- Check that the aperture on the camera lens matches that indicated on the flash unit. On dedicated units you may be required to set the aperture to an automatic position or the smallest aperture.
- Check that the subject is within range of the flash. On dedicated and automatic units the flash will only illuminate the subject correctly if the subject is within the two given distances indicated on the flash unit. If the flash is set incorrectly the subject may be overexposed if too close and underexposed if too far away. Check the accuracy of the flash output using a flash meter (see 'Guide numbers' in this chapter).

Guide numbers

Michael E. Stern, photographer and lecturer at Brooks Institute, talks us through the subject of guide numbers (GN) that are used to express the power of a class of electronic flash unit known as the speedlight. Speedlights are small flash units that work with DSLR 35mm cameras. Regardless of the stated guide numbers, professionals perform a guide number test to accurately measure and understand what the GN is for each speedlight unit and camera combination they work with.

Testing the guide number of a speedlight

The guide number calibration test is simple to perform and provides valuable information for photojournalists who routinely have to create images under difficult lighting conditions, and to help photographers in general who choose to make lighting ratios with multiple speedlight units. The GN formula and its two derivatives are as follows:

FSD (FSD = Flash to Subject Distance) x Aperture = GN

 $GN \div Aperture = FSD$

 $GN \div FSD = Aperture.$

The test is based on these parameters: the flash unit is set to full manual power and the zoom head is set to 50mm. The ISO is set to 100 and a camera sync speed of either 1/200, 1/250 or 1/500 second is selected. The FSD is set at 10 feet exactly.

Testing the guide number of a speedlight - Michael E. Stern

The test

- Find a dimly lit room and position the flash exactly 10 feet away from your subject wearing a white shirt (we don't want the ambient light contributing at all to the exposure value). For additional information have the subject holding either a gray card or a Macbeth Color checker. Double check the ambient light level by exposing a frame using the sync speed at f/8 (flash switched off). If the frame is black then the ambient light level is correct.
- Point the flash unit at the subject.
- Make a series of exposures beginning with f/22 and ending with f/8. Open up your aperture in 1/3 stop increments (you will have 10 exposures when completed). Alter your exposures via the aperture and not the shutter speed.

Evaluating the results

Open up the two or three images in Photoshop that look correct in the sRGB or Adobe RGB (1998) working space. Set the color picker to a 3 × 3 or 5 × 5 average. Select the image with the best detail in the white shirt, i.e. the brightest highlights in the white shirt should fall between 240 and 250 to ensure that they print with detail. Evaluation of the subject's skin tone is also an important part of this measurement process. Skin tones vary so strive for a balance between 'white with detail' numbers and good skin tone values. It is highly recommended that a gray card or Macbeth Color checker be included as part of this test. Measure the gray card and look for a value of between 105 and 130. The precise number can vary due to inconsistencies in manufacturing of gray cards. If the gray card is not parallel to the camera the numbers can vary considerably. You'll have better luck with a Macbeth Color checker but make note that its middle gray is around 121 in the sRGB and Adobe RGB color spaces. As long as emphasis is placed on 'white with detail' numbers followed by skin tone and then middle gray values, an optimum exposure will be identified.

Finishing up

To better illustrate this concept, a frame will be selected and plugged into the formula. The frame captured using an aperture of f11 is selected as the optimum frame. It has white with detail and good skin tone values. An accurate GN for the particular flash unit and camera combination can now be established. It is $10 \text{ feet} \times \text{f}/11 = \text{a GN}$ of $110 \text{ (FSD} \times \text{Aperture} = \text{GN})$.

The photographer must now be comfortable with the implications of changing either the ISO on the camera or the FSD. Changing the aperture (up or down) as the ISO changes (up or down) is known as maintaining equivalent exposures.

When the FSD changes the photographer divides the guide number by the distance to establish the most appropriate aperture to use. In our example, using the GN of 110, at just over 27 feet from the subject the photographer would have to use an aperture of f/4 (GN \div FSD = Aperture) to maintain an appropriate exposure.

Flash as the primary light source

The direct use of flash as a professional light source is often seen as unacceptable due to its harsh qualities. The light creates dark shadows that border the subject, hot-spots in the image where the flash is directed back into the lens from reflective surfaces and 'red-eye'.

Red-eye

Red-eye is produced by illuminating the blood-filled retinas at the back of the subject's eyes with direct flash. The effect can be reduced by exposing the subject's eyes to a bright light prior to exposure ('red-eye reduction') or by increasing the angle between the subject, the camera lens and the flash unit. Red-eye is eliminated by moving closer or by increasing the distance of the flash unit from the camera lens. To do this the flash must be removed from the camera's hot shoe. This is called 'off-camera flash'. Red-eye can also be removed in post-production editing software.

Off-camera flash

Raising the flash unit above the camera has two advantages. The problem of red-eye is mostly eliminated. Shadows from the subject are also less noticeable.

When the flash unit is removed from the camera's hot shoe the flash is no longer synchronized with the opening of the shutter. In order for this synchronization to be maintained the camera and the flash need to be connected via a 'sync lead'.

For cameras that do not have a socket that will accept a sync lead a unit can be purchased which converts the hot shoe on the camera to a sync lead or TTL cord socket. If a dedicated flash unit is intended to be used in the dedicated mode a dedicated sync cable is required that communicates all the information between the flash and the camera. If this is unavailable the unit must be switched to either automatic or manual mode.

Keep the photocell of an automatic unit directed towards the subject during exposure.

Hot-spots

When working with direct flash the photographer should be aware of highly polished surfaces such as glass, mirrors, polished metal and wood. Standing at right angles to these surfaces will cause the flash to be directed back towards the cameras lens, creating a hot-spot. Whenever such a surface is encountered the photographer should move so that the flash is angled away from the camera. It is a little like playing billiards with light.

Practical activity

Connect a flash unit to your camera via a sync lead and set the unit to automatic.

Position your subject close to a white wall.

Hold the flash above the camera and directed towards the subject.

Make exposures at varying distances from the subject. Keep a record of the position of the flash and distance from the subject for each image.

Repeat the exercise with the unit mounted on-camera.

Compare the results and identify the position of the flash in relation to the subject for the best images.

Diffusion and bounce

If the subject is close or the output of the flash unit is high, the photographer has the option of diffusing or bouncing the flash. This technique will soften the quality of the light but lower the maximum working distance.

Diffusion

Diffusion is affected by placing tissue, frosted plastic or a handkerchief over the flash head. Intensity of light is lowered but the quality of light is improved.

The flash can be further diffused by directing the flash towards a large, white piece of card attached to the flash head. Purpose-built attachments can be purchased.

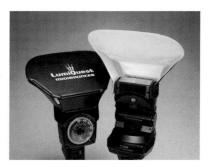

A LumiQuest MidiBouncer

Bounce flash

The most subtle use of flash is achieved by directing the flash to a much larger, white reflective surface such as a ceiling for overhead lighting, or nearby wall for side lighting. This is called bouncing the flash. To obtain this effect the flash unit must have the ability to tilt or swivel its flash head. If this is not possible the flash can be removed from the hot shoe and connected to the camera via a sync lead. If an automatic flash is being used the photographer must ensure that the photocell is facing the subject when the flash is fired.

Practical activity

Create an image of a person using either diffused flash or bounce flash. For the bounce flash technique direct the flash towards a white ceiling or white reflector positioned to one side of the subject. Vary the distances of the reflector to the subject. Compare the quality of the light in your resulting images.

Note > Ensure the thyristor of the flash unit is directed towards your subject.

Fill flash

Fill flash can be a very useful way of lowering the brightness range. Often the photographer is unable to reposition the primary subject and the addition of fill light from the camera's position is essential to the image's success.

The aim of fill flash is to reveal detail in the dark shadows created by a harsh directional light source. The aim is not to overpower the existing ambient light and remove the shadows completely. If the power of the flash is too high the light will create its own shadows, creating an unnatural effect. Mount the flash unit on the camera's hot shoe and direct the flash towards the subject. To retain the effect of the primary (ambient) light source the flash is most commonly fired at half or quarter power. The ratio of ambient to flash light is therefore 2:1 or 4:1, i.e. it is either one or two stops under the ambient level of light.

Manual - Select a smaller aperture on the camera from the one that is indicated by the flash unit or flash meter, e.g. if the meter or unit indicates f/5.6 select f/8 or f/11 on the camera. Compensate for the reduced aperture by selecting a slower shutter speed on the camera so that the ambient light exposure is still appropriate for your subject. This action will lead to correctly exposing the ambient light and underexposing the light from the flash unit.

Automatic - Many automatic flash units have the facility to fire at 1/2 or 1/4 power, making fill flash a relatively simple procedure. If this facility is unavailable set the ISO on the flash unit to double or quadruple the actual speed of the ISO set in the camera to lower the output.

Dedicated - Many sophisticated cameras and dedicated flash units have a fill flash option. This should be regarded as a starting point only and further adjustments are usually required to perfect the technique. Power often needs to be further lowered for a more subtle fill-in technique. The photographer may also wish to select a 'slow-sync' option on the camera, if available, to avoid underexposing the ambient light in some situations.

Practical activity

Create an image using the fill flash technique.

Lower the lighting contrast of a portrait lit with harsh sunlight.

Experiment to see if you can lower the flash output on your unit to half or quarter power. Compare the light quality of the resulting images.

Flash as a key light

The main light in studio photography is often referred to as the 'key light'. Using studio techniques on location is popular in advertising and corporate photography where mood is created rather than accepted. In this instance flash becomes the dominant light source and the ambient light serves only as the fill light.

When the ambient light is flat, directional light can be provided by off-camera flash. This enables the photographer to create alternative moods. The use of off-camera flash requires either the use of a 'sync lead' or an infrared transmitting device on the camera.

Slave units

Professional quality flash units come equipped with a light-sensitive trigger (optical slave) so that as soon as another flash is fired by the camera the unconnected flash or 'slave' unit responds. On location the slave unit can be fired by the use of a low powered on-camera flash (optical slave), by radio communication (wireless) or infrared. Wireless offers the most flexibility as line-of-sight is not required between the trigger and the slave unit.

Accessories

A tripod or assistant is required to either secure or direct the flash.

An umbrella or alternative means of diffusion for the flash may be considered.

Color compensating filters may also be considered for using over the flash head. A warming filter from the 81 series may be useful to create the warming effect of low sunlight.

Technique

- Check the maximum working distance of the flash.
- Ensure the key light is concealed within the image or out of frame.
- Diffuse or bounce the key light where possible.
- Consider the effects of fall-off.
- Avoid positioning the key light too close.
- Establish a lighting ratio between the key light and ambient light.
- Consider the direction of shadows being cast from the key light.

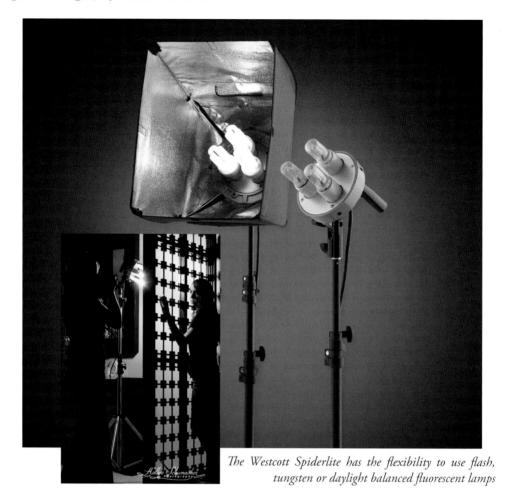

Halogen or daylight balanced fluorescent lamps on location

The availability of powerful tungsten halogen or daylight balanced fluorescent lamps (although not as powerful as flash) provides the photographer with a realistic alternative to using flash on location. The primary advantage to using tungsten halogen or daylight corrected fluorescent lamps instead of flash is that the light is constant, allowing the photographer to see the lighting effect as they move the light or lights into position.

Note > Although the modelling lights with studio style flash units may prove useful in a studio setting they are are usually rendered obsolete on location with the presence of brighter levels of ambient light.

Practical activity

Create an image using introduced light as a directional key light.

Make a record of the ambient exposure without the key light.

Compare the effects of both the key and ambient light on your subject.

Slow-sync flash

Slow-sync flash is a technique where the freezing effect of the flash is mixed with a long ambient light exposure to create an image which is both sharp and blurred at the same time. Many modern cameras offer slow-sync flash as an option within the flash program but the effect can be achieved on any camera. The camera can be in semi-automatic or manual exposure mode. A shutter and aperture combination is needed that will result in subject blur and correct exposure of the ambient light and flash. To darken the background so that the frozen subject stands out more, the shutter speed can be increased over that recommended by the camera's light meter.

- Set the camera to a low ISO setting.
- Select a slow shutter speed to allow movement blur, e.g. 1/8 second.
- Take an ambient light meter reading and select the correct aperture.
- Set the flash unit to give a full exposure at the selected aperture.
- Pan or jiggle the camera during the long exposure.

Mark Galer

Possible difficulties

Limited choice of apertures - less expensive automatic flash units have a limited choice of apertures leading to a difficulty in obtaining a suitable exposure. More sophisticated units allow a broader choice, making the task of matching both exposures much simpler.

Ambient light too bright - if the photographer is unable to slow the shutter speed down sufficiently to create blur, a slower ISO should be used or the image created when the level of light is lower.

Practical activity

Create an image using the technique slow-sync or flash blur.

Choose a subject and background with good color or tonal contrast.

Pan the camera during the exposure.

Compare the results.

First exposure - exterior ambient light - exposure: MIE less 1/2 stop

Second exposure - total darkness - interior lights on - exposure: average highlights and shadows

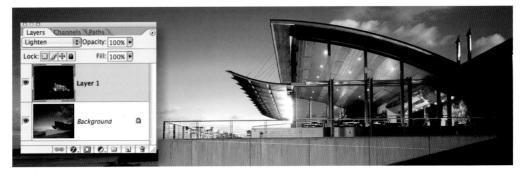

Combined exposure

Double exposures

A double exposure can be used to balance the bright ambient light and the comparatively dim interior lighting of a building. Some digital cameras allow for the multiple exposures, that are required to achieve this outcome, to be recorded in-camera. If the camera does not allow for multiple exposures to be made using a single image file, two separate exposures can be combined in post-production. To achieve this result the photographer must use a tripod and take care not to disturb the alignment whilst adjusting the camera to make the second exposure. If the camera's white balance is set to daylight the interior lighting will record as a different color temperature to the exterior daylight. If the images are combined in post-production the interior lighting is placed on a layer above the exterior lighting layer. Set the interior lighting layer to the Lighten blend mode.

High dynamic range

Contrary to popular opinion - what you see is not what you always get. You may be able to see the detail in those dark shadows and bright highlights when the sun is shining - but can your film or image sensor? Contrast in a scene is often a photographer's worst enemy. Contrast is a sneak thief that steals away the detail in the highlights or shadows (sometimes both). A wedding photographer will deal with the problem by using fill flash to lower the subject contrast; commercial photographers diffuse their own light source or use additional fill lighting and check for missing detail using the 'Histogram' when shooting with a digital camera.

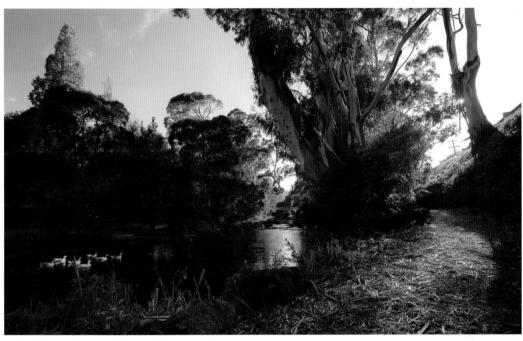

Combination of two exposures merged manually - Upper Yarra River by Mark Galer

Landscape photographers, however, have drawn the short straw when it comes to solving the contrast problem. For the landscape photographer there is no 'quick fix'. A reflector that can fill the shadows of the Grand Canyon has yet to be made and diffusing the sun's light is only going to happen if the clouds are prepared to play ball.

Ansel Adams (the famous landscape photographer) developed 'The Zone System' to deal with the high-contrast vistas he encountered in California. By careful exposure and processing he found he could extend the film's ability to record high-contrast landscapes and create a black and white print with full detail. Unlike film, however, the latitude of a digital imaging sensor (its ability to record a subject brightness range) is fixed. In this respect the sensor is a strait-jacket for our aims to create tonally rich images when the sun is shining - or is it?

Note > To exploit the full dynamic range that your image sensor is capable of, it is recommended that you capture in Raw mode. JPEG or TIFF processing in-camera may clip the shadow and highlight detail (see Adobe Camera Raw).

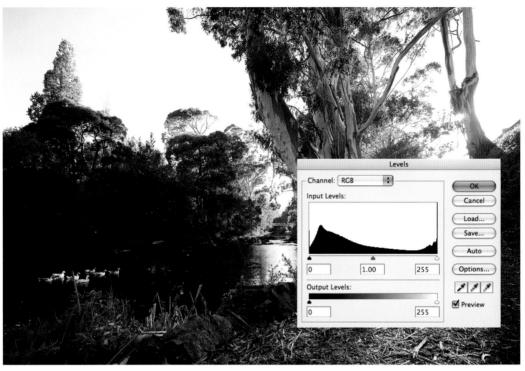

A single exposure in a high-contrast environment could result in a loss of detail in both the shadows and highlights, as can be seen by the tall spikes at Level 0 and Level 255 in the histogram of the image

If we can't fit all the goodies in one exposure, then we'll just have to take two or more. The idea is to montage, or blend, the best of both worlds (the light and dark side of the camera's not quite all seeing eye). To make the post-production easier the photographer needs to take a little care in the pre-production, i.e. mount the camera securely on a sturdy tripod. Take four exposures - two overexposing from the auto reading, and the other two underexposing from the auto reading. One or two stops either side of the meter-indicated exposure should cover most high-contrast situations.

Note > It is recommended that you use the shutter speed to bracket the exposures. This will ensure the depth of field is consistent between the different exposures.

Bracketing exposures

Setting your camera to 'auto bracket exposure mode' means that you don't have to touch the camera between the two exposures, thereby ensuring the first and second exposures can be exactly aligned with the minimum of fuss (the Auto-Align Layers feature in the full version of Photoshop does not work when your layers are Smart Objects). Use a remote release or the camera's timer to allow any camera vibration to settle. The only other movement to be aware of is something beyond your control. If there is a gale blowing (or even a moderate gust) you are not going to get the leaves on the trees to align perfectly in post-production. This also goes for fast-moving clouds and anything else that is likely to be zooming around in the fraction of a second between the first and second exposures.

Merge to HDR

Merge to HDR is a semi-automated feature in the full version of Photoshop for combining detail from a range of differnt exposures. A series of bracketed exposures can be selected and the Merge to HDR feature then aligns the images automatically. The Merge to HDR dialog box then opens and the user is invited to select a bit depth and a white point. It is recommended to save the file as a 32-bit image. This allows the exposure and gamma to be fine-tuned after the image is opened into Photoshop by going to Image > Adjustments > Exposure. As editing in 32 Bits/Channel is exceptionally limited the user will inevitably want to drop the bit depth to 16 or 8 Bits/Channel at some stage to make use of the full range of adjustment features.

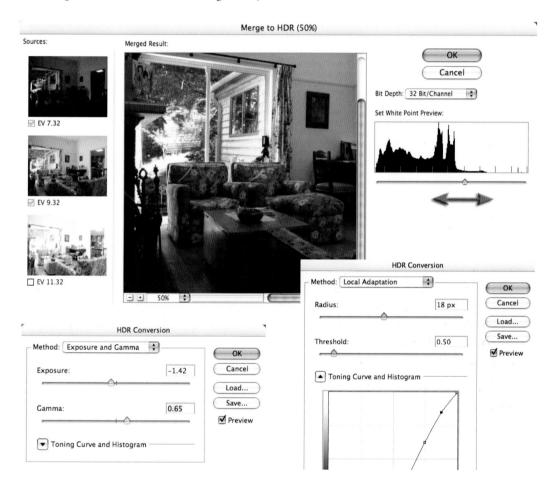

When the Photoshop user converts an HDR 32-bit image to 16 or 8 Bits/Channel the user can choose a conversion method that allows the best tonal conversion for the job in hand. With very precise working methods HDR images can provide the professional photographer with a useful workflow to combat extreme contrast working environments. For situations where HDR is required but people or animals are likely to move between exposures a manual approach to merging the exposures is highly recommended.

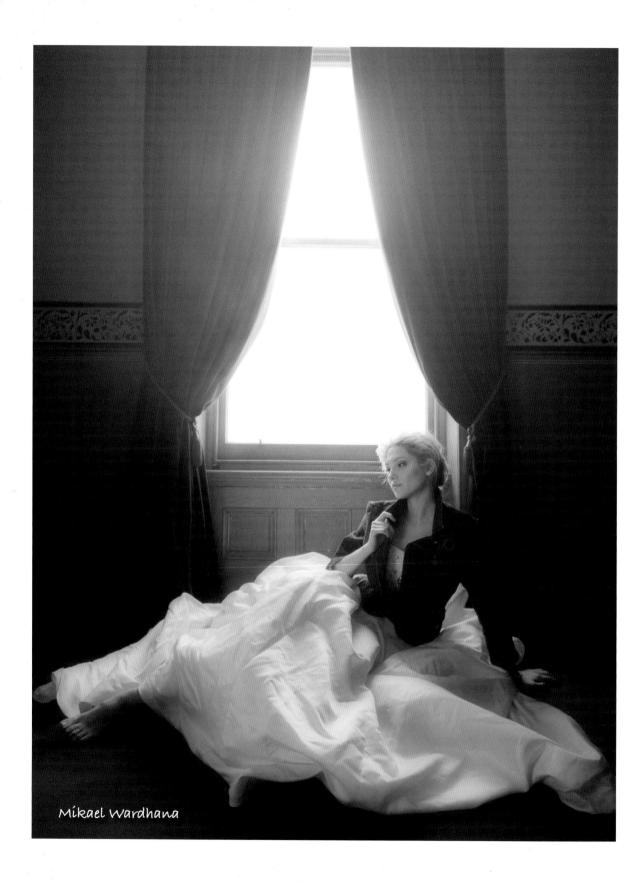

post-production editing

Mark Galer

essential skills

- Enhance and optimize digital files for maximum impact.
- · Optimize the white point and dynamic range of digital images.
- Optimize image contrast and saturation.
- Convert an image from RGB to black and white in Photoshop Lightroom.
- Split tone an image in Photoshop Lightroom.
- Sharpen an image in Photoshop Lightroom.
- Create localized adjustments to control communication and enhance design

Introduction

Images captured by the camera are an interpretation of the scene that you have photographed. The mood, contrast and color may differ from how you remember the scene when it was first captured. Image-editing software can be used to either optimize and enhance the image so that it communicates a faithful rendition of how you saw the original subject or it can be used to manipulate the subject matter so that it communicates an entirely different mood. The most popular software to carry out this editing is one of the products from the Photoshop family.

Optimizing photos using Photoshop Lightroom

Lightroom is the perfect place to optimize your images as you sift and sort through the shoot on location. This process of optimizing or 'developing' your images in Lightroom allows you to assess the potential quality of each and every image quickly and efficiently and then apply or 'synchronize' these settings across multiple images from the shoot, or indeed the entire shoot.

The photographer has the control to optimize the exposure, white balance and perfect the color and tonality. Lightroom is not, however, intended to replace the Photoshop or Photoshop Elements software that have greater capabilities for localized editing and montage work (constructing multilayered composite images). All adjustments that you may make to the visual appearance of photos in a Photoshop Lightroom catalog are non-destructive, i.e. the images can be returned to their original states or any intermediate states in the development process at any time. Even though the visual appearance of the image changes on screen the pixel values are not actually modified until the image is exported from Lightroom (for screen or print viewing or further post-production editing in Photoshop or Photoshop Elements).

Quick Develop

Note > When reading through this chapter it is recommended that you have Photoshop Lightroom open so that you can follow along with the sequence of steps.

1. The appearance of the image can be optimized in the Library module using the 'Quick Develop' panel on the right-hand side. Click the forward or back arrow to increase or decrease the adjustment in 5% increments. Click on the double arrows to make adjustments in 20% increments.

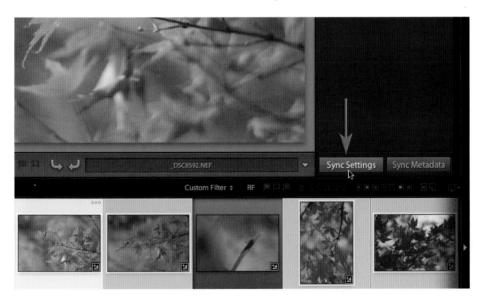

2. Select additional images in the Filmstrip that require the same level of adjustment and click on the 'Sync Settings' button. Hold down the Ctrl key (PC) or Command key (Mac) as you select additional images in the Filmstrip. Hold down the Shift key to select all of the images between the first and second clicks.

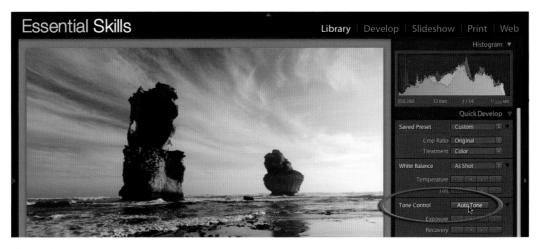

Auto Tone

3. In the Import panel (Preferences > Import) there is an option for applying auto corrections as the images are being imported into the Catalog. My personal preference is to have this option switched off so that I can see my photos in their original state prior to applying any adjustments. If you have switched this option off you will still able to apply the auto adjustments by clicking on the 'Auto Tone' button in the 'Quick Develop' panel to one or more images. This will enable you to see Lightroom's best guess at how this image could appear if it was optimized. This may 'fix' the image or give you a better starting point for subsequent adjustments.

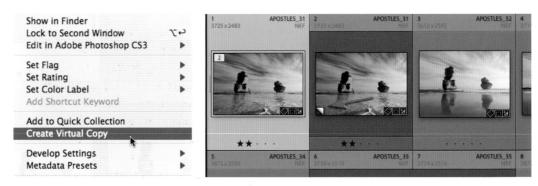

Virtual Copy

4. When editing the appearance of an image in Lightroom it is important to remember that Lightroom does not edit or change the actual pixels. Lightroom keeps a record of any changes to the visual appearance in the metadata for any file that is modified. It is possible to keep multiple sets of metadata to descibe a different visual interpretation of the same image file, e.g. one version in color and another in black and white. The photographer can go to Create Virtual Copy if they want to preserve a preview of the original image. Go to 'Photo > Create Virtual Copy'. Creating a virtual copy is like creating an 'alias' and does not duplicate the original file. Creating one or more virtual copies allows you to modify the visual appearance of the image in a number of different ways. One or all of these previews can be reset to the original appearance at any time.

Develop module

White Balance

The Develop module offers an extensive range of controls for optimizing the image for precise control over color and tonality. Photographers will gravitate to this module after first knocking the images into better shape in the Quick Develop panel, or just move straight to this module for images that require precise adjustments. The Filmstrip still gives the photographer who is working in the Develop module immediate access to the other images in the folder without having to return to the Library module. There is no precise order or sequence for the image adjustments to be applied in the Develop module, but most photographers usually find they start with the adjustments in the 'Basic' panel and work their way down.

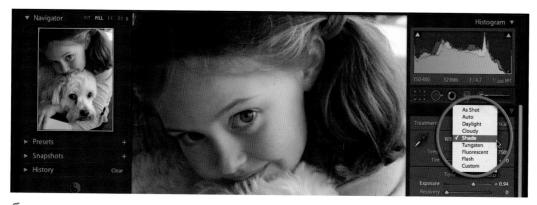

5. The first adjustment in the 'Basic' panel is the White Balance adjustment. Most amateur photographers use an 'Auto White Balance' setting in-camera, and, if the camera had done a good job the image will not require further adjustment. The reality is, however, that the auto features in-camera often get it wrong and the white balance can be further optimized using the 'White Balance Presets', 'Temp and Tint' sliders or the 'White Balance Selector' tool. When the White Balance preset is set to 'As Shot' the white balance that was assigned by the camera at the time of capture will be used. If you think the image appears either too warm or too cool an alternative white balance setting can be applied using one of the alternative presets. In the illustration above the auto white balance has created an image with a blue cast. This has been rectified to some extent by selecting the 'Shade' preset in the White Balance presets menu. The presets offer an approximate adjustment only. You need to create a custom white balance setting in-camera or present Lightroom with a neutral tone from which to take a measurement in order to create a more accurate white balance setting. Move the Temp or Tint sliders to fine-tune the color rendition. Increasing or decreasing the warmth of an image after it has already been corrected can change the mood of an image to suit the needs of the photographer or client.

Note > It is recommended to create a custom white balance setting in-camera when using the JPEG file format in order to preserve image quality. A custom white balance when using the Raw file format, although useful, serves only as a reference point that can be used by Lightroom to indicate the color temperature of the light source at the time of capture. The white balance is not applied to the Raw data of the image but is stored in the file's metadata.

6. The White Balance Selector tool (the eyedropper from the 'Basic' tab) can be used to color-correct your images. Click on the tool in the Basic panel to select it. Then click on a neutral tone in the image preview to set the White Balance for the photo. This can be a fast and effective way of color-correcting images. Not all images, however, are blessed with a neutral tone such as the white piece of paper this girl is holding.

White Balance - Reference image

7. A custom white balance can be set in-camera by placing a neutral tone in front of the lens. Taking a reference image using a white piece of paper, a photographic gray card or a product such as the 'WhiBal' makes this an easy task. The WhiBal can be placed in the first image of the shoot and then removed for the subsequent shots captured using the same light source. The white balance setting used in Lightroom to correct the reference image can then be applied to all subsequent images in the shoot by selecting multiple images from the Filmstrip and then clicking on the Sync button.

8. The Expodisc does not require the photographer to place a reference card in the image. The photographer simply captures an image with the Expodisc in front of the lens while pointing the camera back towards the light source. This creates a gray image that can be corrected using the White Balance Selector tool. After correcting the white balance of the reference image the photographer selects multiple images in the Filmstrip and then clicks on the 'Sync' button. Select the White Balance option and then select 'Synchronize'.

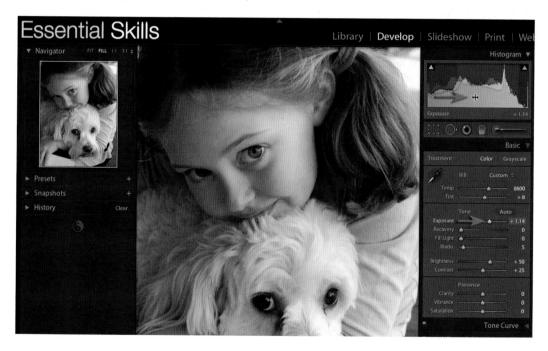

9. Adjust the exposure of the image by either dragging the Exposure slider to the left or right or positioning your cursor in the central portion of the histogram and dragging left or right to darken or lighten the image. Moving the Exposure slider to the right or left will not only lighten or darken the image but it will also assign a white point (set how bright the lightest tones in the image will appear). Moving the Exposure slider too far to the right will cause the brightest tones to become white and lose any tone that they may have had (often referred to as 'clipping the highlights'). Moving the Exposure slider to the left can restore lost detail in the highlights in many, but not all, photos.

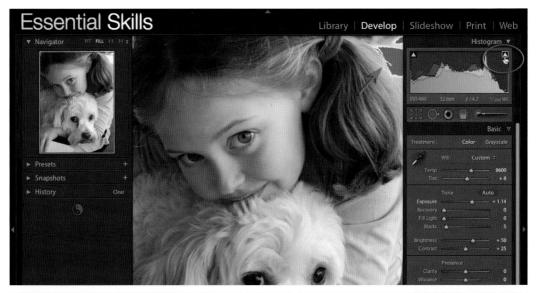

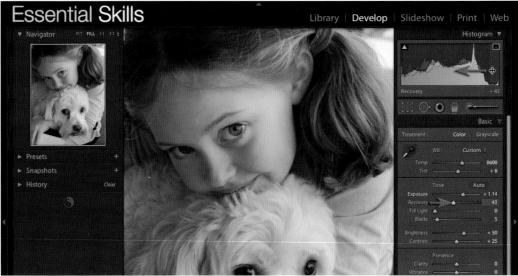

10. Move your mouse cursor over the 'Show Clipping' triangle above the right-hand side of the histogram to see when clipping (loss of detail) occurs in the highlights. Areas of the highlights that now appear solid red will be clipped using the current settings. Ideally only the light source or the reflection of the light source (a specular highlight) should appear devoid of texture or tone. All other surfaces should appear bright but with some tonal information. Click on the 'Show Clipping' triangles to leave the clipping warning on as you make further adjustments. Moving the Exposure slider to the left will reduce or eliminate the clipping in the highlights but may render the image too dark in the midtones. If this is the case move the Recovery slider to the right. This will restore highlight detail but leave midtones bright. The 'Recovery' slider can restore highlight detail that has been clipped by generous use of the Exposure slider or by small amounts of overexposure in-camera.

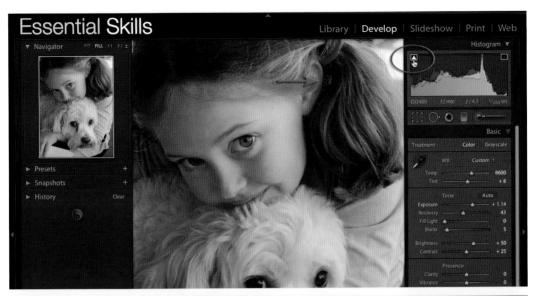

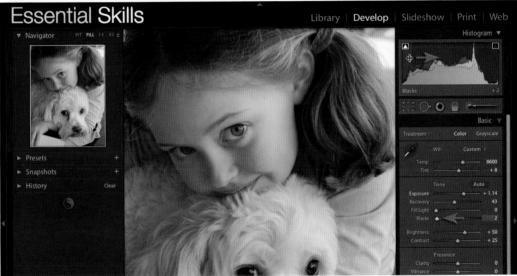

1 1. Shadow tones that are banked up against the left-hand wall of the histogram will not render visible detail on screen or in print. Moving the mouse cursor over the 'Show Clipping' triangle (above the left-hand side of the histogram) will show the dark tones in the image that are clipped as blue. Click on the triangle or hold down the Alt/Option key as you drag the Blacks slider to the left or right to set the optimum black point in the image (the darkest blacks possible before clipping occurs). The 'Blacks' slider controls the black point of the histogram. In this image the Blacks slider is moved to 0 from its default value of 5 to preserve fine detail in the blacks (alternatively click and drag the left side of the histogram). Note how the shape of the histogram now rises as a gentle gradient after the blacks have been adjusted in this image. Adjusting the Blacks slider, however, may not lighten the shadow tones enough to enable the shadows to print with detail in every image. The shadow tones may still be banked up on the left-hand wall of the histogram if there was underexposure in-camera. In this instance we can use the 'Fill Light' slider.

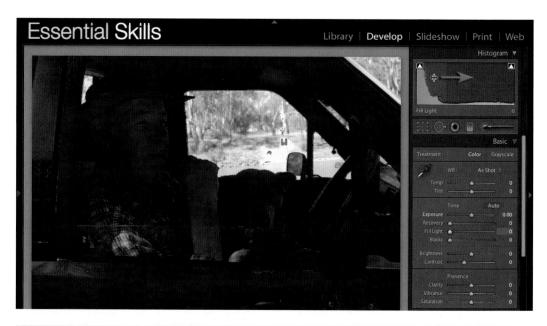

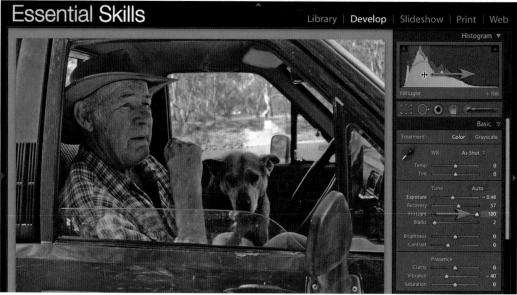

12. The 'Fill Light' slider can raise the dark shadow tones to reveal the detail that would otherwise be hidden. Localized contrast and saturation is also increased in these shadow areas to maintain depth in these rescued tones.

Note > Dark tones in a digital file can be of very poor quality (noise and banding) so care needs to be taken when using this slider. The Fill Light slider is no replacement for using 'real' fill light (a reflector of fill flash) at the time when an image is captured. The image above was taken with a CCD sensor (a Sony CCD sensor noted for its low noise at very low ISO settings).

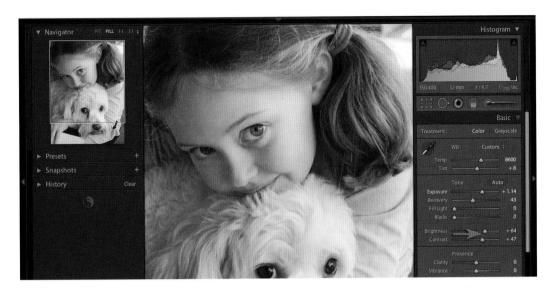

13. The 'Brightness' and 'Contrast' sliders are non-destructive (unlike their namesakes in older versions of Photoshop, CS and CS2) so can enhance midtone values without too much risk of clipping the white and black points set by the previous tone controls.

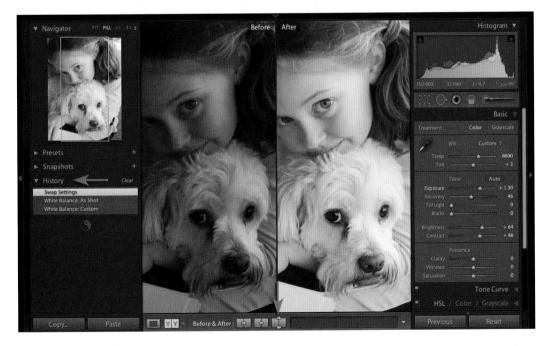

Before & After

14. At any time during the development process you can click on the 'Before & After' button in the Toolbar (press T if the Toolbar is not visible or go to View > Before/After). Press on the 'Before & After' button again to cycle through the different ways Lightroom can display the before and after views (a fly-out menu is also available to take you through to your preferred view).

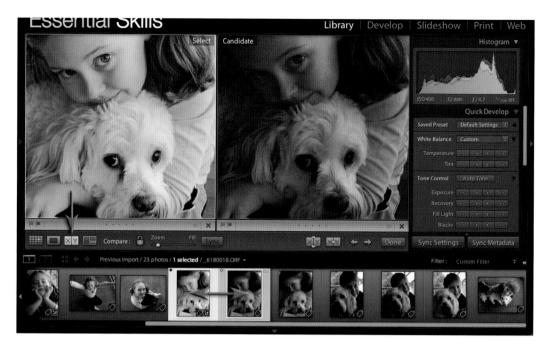

Compare View

15. In the Library module you can see a comparison between the modified version and the original by selecting the original file and the virtual copy (hold down the Ctrl key [PC] or Command key [Mac] to select a second file in the Filmstrip) and then click on the 'Compare View' button in the Toolbar (View > Compare).

Sync Settings

16. To apply these settings to additional images in the catalog select photos in the Filmstrip or from the Grid view in the Library module one by one (Command/Ctrl + click each image) or select a range of images (Shift + click from first to last) and click on the Sync Settings button.

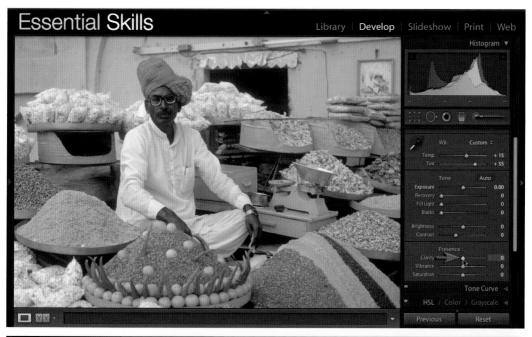

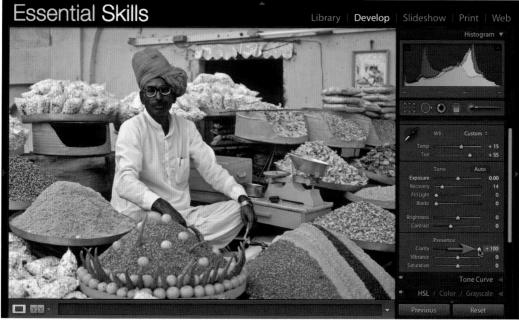

Presence

17. The 'Clarity' slider increases midtone contrast by finding edges within the image and then modifying the luminosity either side of the edge. Observe how the tones appear darker as they approach the white shirt the man is wearing in the image above. The changes are mainly restricted to the midtones so there is little risk of clipping tones along edges that are already very bright or very dark. So the adjustment is not too obvious it is recommended to back the slider off until the light and dark haloes are very subtle.

In Lightroom 2 we now have the option to use a negative Clarity setting. This is useful to soften and suppress detail and texture. In the example above the Clarity slider has been dropped to -100 to illustrate how the filter can be used to reduce the excessive detail in the model's skin. Note also how the Clarity slider creates a light halo around the face.

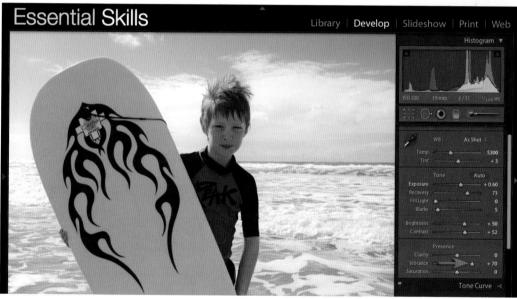

18. The 'Vibrance' slider increases the overall saturation of the colors. The Vibrance slider is less destructive than the Saturation slider as it primarily targets colors of lower saturation more than colors of a higher saturation (it is less likely to push saturated colors 'out of gamut'). In the examples above the Saturation and then the Vibrance sliders have been raised to +70 to highlight the differences between these two controls. The Vibrance slider targets colors of lower saturation rather than rasing the saturation of all colors equally (notice how the saturation level of the blue sky has been raised more than the yellow of the body-board when using the Vibrance slider). Notice also how in the second image that uses the Vibrance slider that the skin tones have been protected from an excessive rise in saturation.

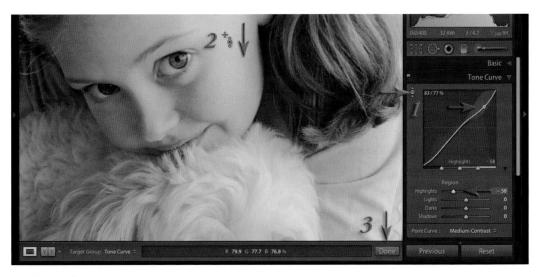

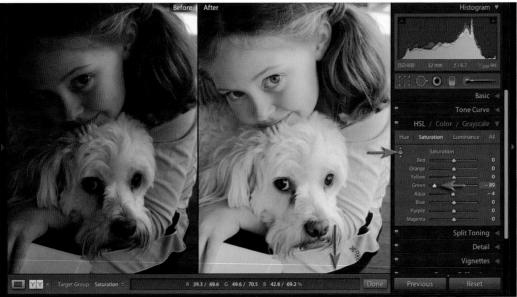

Tone Curve and HSL and Grayscale

19. For more precise control over tonality open the 'Tone Curve' panel. Click on the 'TAT' (targeted adjustment tool) button in the top left-hand corner of the panel and then click in the image preview and drag up or down on the target tone you would like to brighten or darken. This is a global and not a localized adjustment, i.e. all the tones that are similar to the one you clicked on within the image will also be adjusted. As the curve gets steeper the contrast increases. The 'HSL' (Hue, Saturation and Luminance) tab can target a specific color range to adjust. Click on the TAT tool and drag color values up or down to adjust them. All colors of a similar hue within the image will aslo be adjusted.

Note > Remember to hit the 'Done' button after the adjustment has been completed, otherwise this adjustment feature will remain switched on when you move on to the next adjustment.

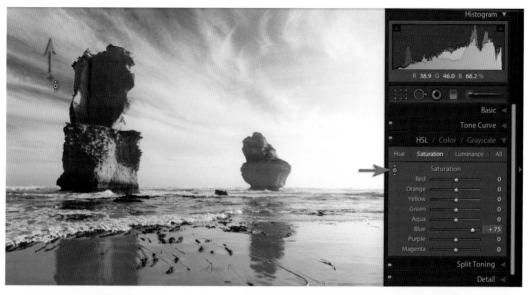

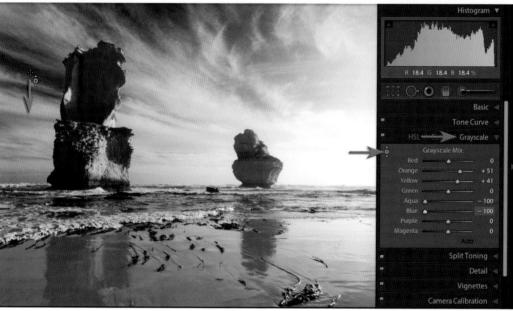

20. Excessive adjustments using the HSL sliders can introduce image artifacts that degrade image quality, e.g. lowering the blue luminance slider to -100 or increasing the blue saturation slider to +100 to modify a sky may introduce banding and noise (see the effects on a 100 ISO image above). Click on the word 'Grayscale' on the right side of the panel if you wish to remove the color from the image in order to create a black and white image. You can continue to modify or 'mix' the luminance values of the individual colors even though they are rendered as gray.

Note > If you do notice excessive artifacts as a result of using these sliders you should zoom in to the 1:1 view and reduce the artifacts by going to the Detail tab and then use the noise reduction sliders (see step 22).

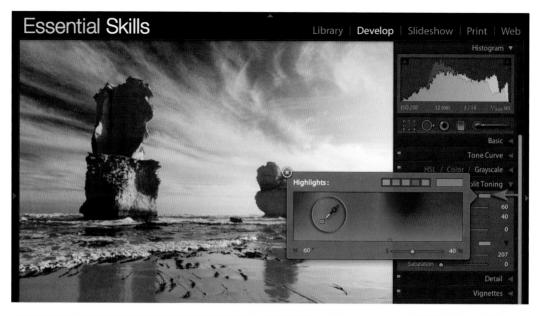

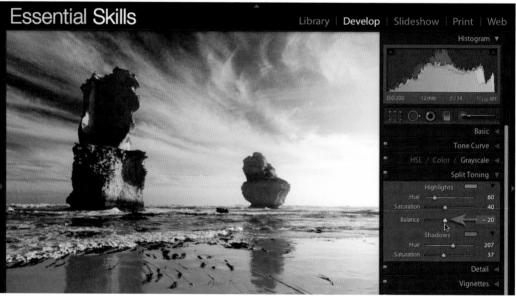

Split Toning

21. An image can be toned if it is a color photo or a color photo that has been converted to grayscale. It is easier to select the precise colors for toning, however, if the photo is first converted to grayscale in the HSL/Color/Grayscale panel. In the 'Split Toning' panel click on the Highlight color swatch next to the word Highlights. Choose a color for the highlights and then close this window. Repeat the process with the Shadows color and then move the Balance slider to change the midpoint between highlight and shadow colors (the threshold where a shadow becomes a highlight). Click on HSL to revert the image back to color if you wish to split tone a color image.

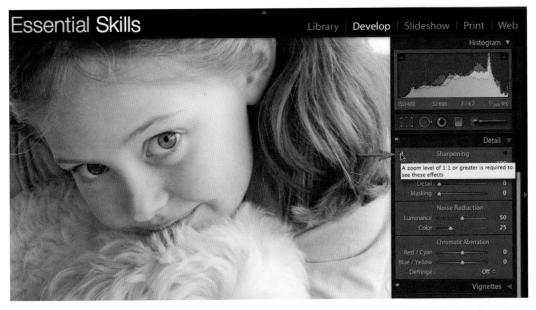

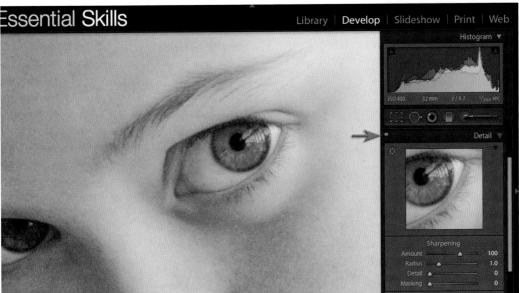

Detail

22. Images captured using the Raw format have no noise reduction or sharpening applied in-camera. Go to the Detail tab and zoom in to view the image at 1:1 (click on the warning triangle to zoom in) to see the effect of the noise reduction and sharpening controls or use the samll preview window. Turn off the switch on the top left-hand corner of the panel to see a preview of what the image looks like without any noise reduction or sharpening at all (the default settings in this panel usually reduce color noise and apply a small amount of sharpening). Raise the Color slider just enough to eliminate the colored speckles within the image. Typically a setting of 25 will remove the color noise from most DSLR cameras.

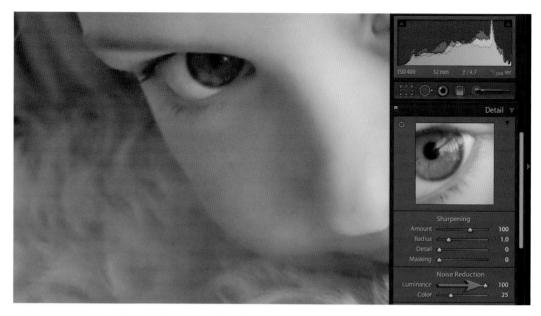

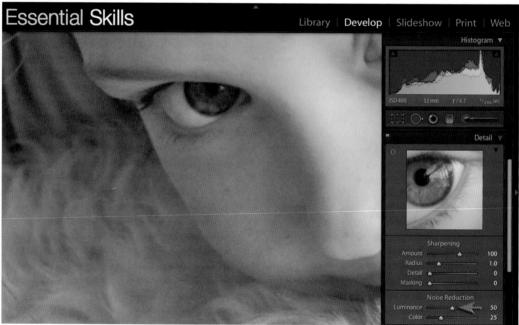

23. Luminance noise in this image (captured at a higher ISO setting on a budget DSLR) is not removed until the slider is at its maximum setting. This setting, however, creates excessive softening of detail. Luminance noise can often be suppressed, or reduced, but not totally eliminated without damaging the image quality. A compromise often has to be reached between image noise and excessive blurring. In the example above the slider is pulled back to 50 to reclaim some of the detail in the image.

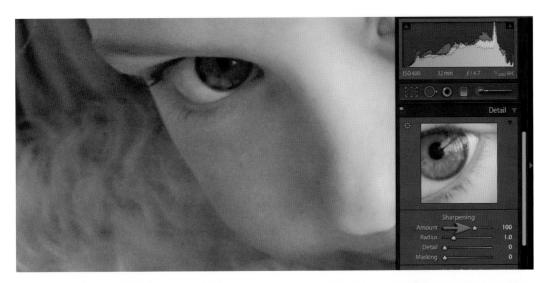

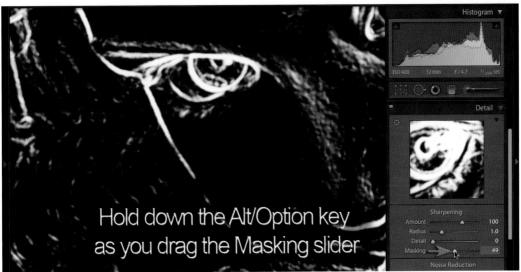

24. Images captured using the Raw format have no sharpening applied in-camera. Sharpening in Lightroom is performed in the Detail tab. View the image at 1:1 (actual pixels) to see the effect of the sharpening controls. Leave the Radius slider at the default setting of 1.0 for most images. Raise the Detail slider to accentuate fine detail within the image or reduce to 0 to retain areas of smooth continuous tone such as skin. Hold down the Alt/Option key and drag the 'Masking' slider to the right. The preview will change to a 'Threshold' or black and white view. The darker areas that appear as you drag the slider to the right are the areas of smooth continuous tone that will be masked and not subjected to the sharpening process. This will ensure only the higher contrast edges are sharpened.

Note > Increasing the contrast at the edges of tone or color creates a visually sharper image. If the radius is too high the haloes around the edges will be visible and the image will appear over-sharpened.

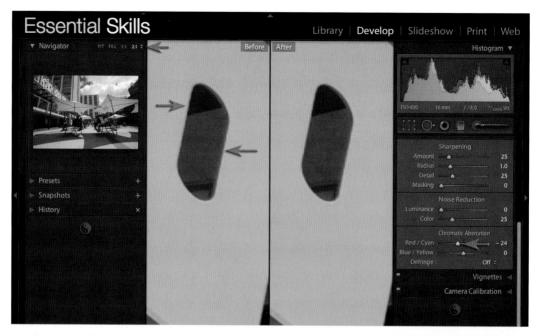

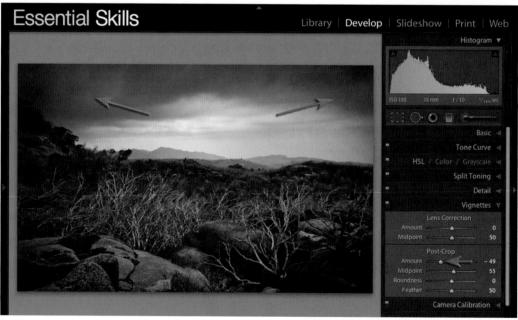

25. Zoom in to 1:1 (100%) or 2:1 (200%) when using the Chromatic Aberration sliders. Chromatic aberration, if present, is most visible in the corners of the image. Adjust the sliders to reduce or eliminate any color fringing that may be apparent around high-contrast edges. The images created by some lenses have a tendency to appear lighter in the corners. A vignette can be removed or added (for increased drama) using the 'Amount' and 'Midpoint' sliders in the 'Lens Corrections' tab. Use the 'Post Crop' vignette sliders for adding a vignette to cropped images.

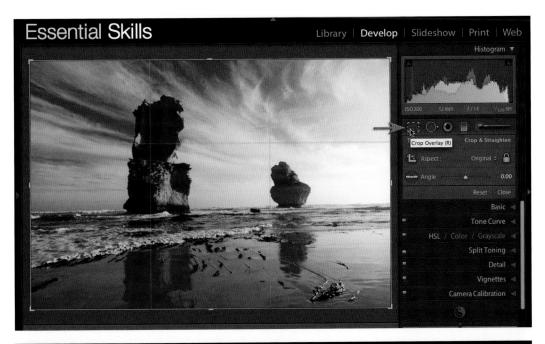

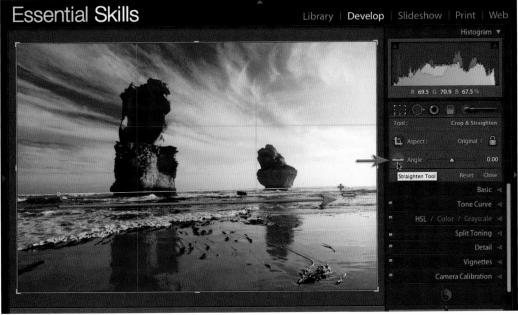

Tool Strip

Crop tool

26. If an image is not straight click on the 'Crop Overlay' icon and then click on the 'Straighten' tool. Click and drag from one end of a horizontal or vertical line within the image preview to the other end and then let go of the mouse button. The horizon line in this image offers the perfect reference point for alignment.

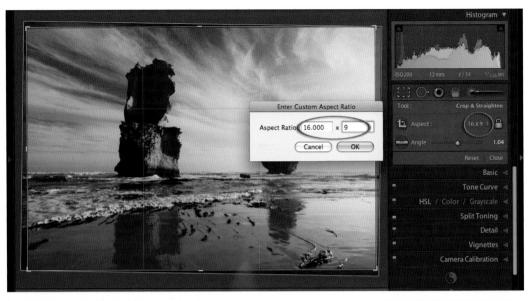

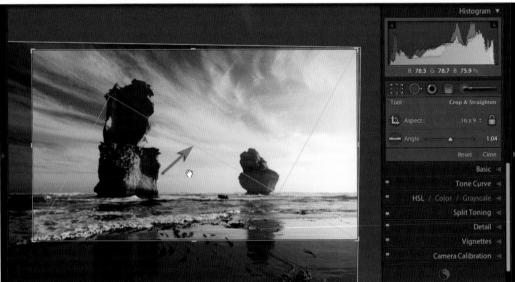

27. You can crop to a specific 'Aspect Ratio' or shape by selecting an Aspect Ratio preset or by creating your own. Enter specific values in the dialog box if you know the aspect ratio of the screen or printing paper where the image is destined to be output to (in this example a custom 16:9 aspect ratio is created for a widescreen TV display). It is important to note that cropping in Lightroom is not destructive. The pixels outside of the crop area are hidden from view rather than discarded. With the aspect ratio locked the bounding box can be adjusted to frame a different area of the image while the 16:9 aspect ratio is maintained. Click on the closed lock icon to unlock the aspect ratio so that you can crop to a custom aspect ratio.

Note > Pressing the letter 'O' on the keyboard will cycle through the crop overlays that may help in framing the image (see 'Framing the image') .

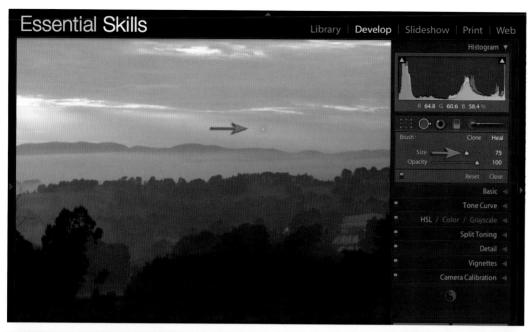

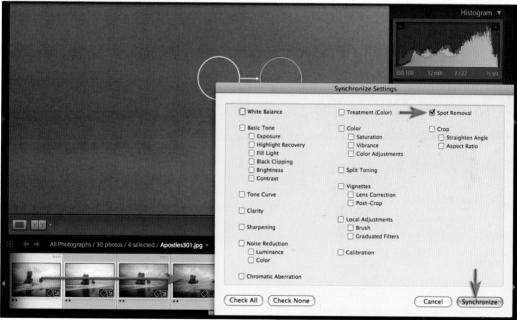

Remove Spots tool

28. Remove dust spots on the sensor using the 'Remove Spots' tool. Click on each spot and adjust the cursor size to cover the area to be repaired. For each spot that is repaired there is a corresponding source area that can be moved by dragging it to a new location. Select multiple images in the Filmstrip and click on the 'Sync' button. If spot removal is the only adjustment you are synchronizing select the 'Check None' button and then select the 'Spot Removal' option before hitting the 'Synchronize' button in the 'Synchronize Settings' dialog box.

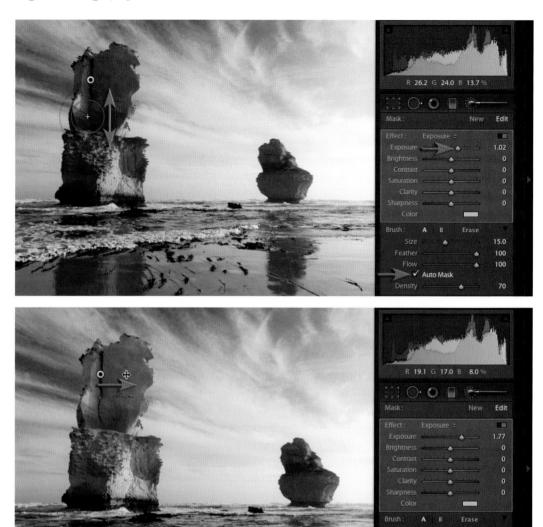

Retouch tool

29. In Lightroom 2 a 'Retouch' tool was added in order to allow the user to adjust the exposure, brightness, saturation, clarity and tint in localized areas of the image. The user must first select the paint option, the effect (negative or positive amount or tint color) and the brush settings they would like to use. Two brush presets are available including a small hard brush and a large soft one but these settings can be modified to suit the user's preferences. Checking the Auto Mask option will ensure the brush will detect edges within the subject and ensure the adjustments do not flow over adjacent subjects. After making an adjustment the user can move the mouse cursor over the target and then pull left or right to increase or decrease the retouch amount.

100

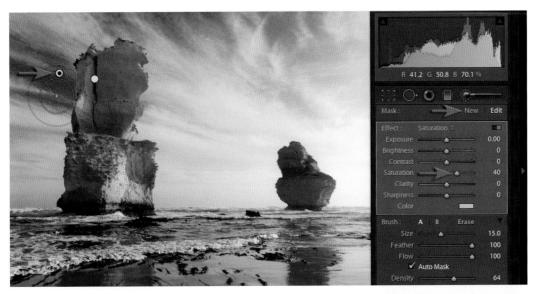

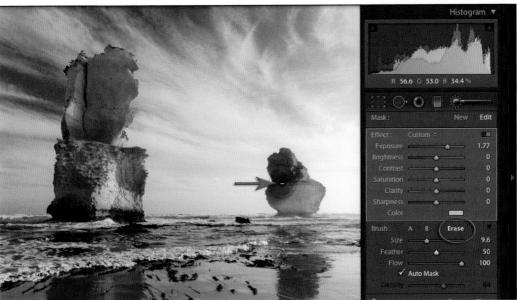

30. To paint with a different effect click on the New button, select a different paint option and then target either the same location or another location to adjust. To modify a previous adjustment click on the target to make the area active and then modify the amount of the previous adjustment or modify the adjustment settings by clicking on the Edit button. It is possible to readjust the painting area by painting again to increase the adjustment or 'mask' area or to subtract from a previous painting mask by holding down the Alt/Option key or clicking on the Erase option in the Brush section and then painting.

printing

Dorothy Connop

essential skills

- Control the color accuracy between monitor preview and print.
- Understand the procedures involved with producing a digital print.
- Print a color-managed digital image using a desktop inkjet printer.
- Compensate for visual differences between the monitor preview and print

Introduction

The secret to successful printing is to adopt a professional print workflow that takes the frustration out of seeing the colors shift as your image moves from camera to monitor, and from monitor to print. Color consistency has never been more easy and affordable to implement for the keen amateur and professional photographer. This project guides you along the path to ultimate print satisfaction, so that you will never say those often heard words ever again - 'why do the colors of my print look different to my monitor?'

The reward for your effort (a small capital outlay and a little button pushing) is perfect pixels — color consistency from camera to screen to print. Once the initial work has been carried out predictable color is a real 'no-brainer', as all of the settings can be saved as presets. As soon as you start printing using your new color-managed workflow you will not only enjoy superior and predictable prints, but you will also quickly recover the money you outlaid to implement this workflow (no more second and third attempts).

Note > The color-managed workflow must be established using Photoshop or Photoshop Elements but can then be implemented for printing from Photoshop Lightroom.

The range or 'gamut' of colors that each output device is capable of displaying can vary enormously. The Adobe RGB monitor space (shown in white) is able to contain the gamut of a typical inkjet printer and so offers a better alternative to editing in sRGB which is primarily a monitor space

The problem and the solution

Have you ever walked into a TV shop or the cabin of an aircraft and noticed that all the TVs are all showing exactly the same TV program but no two pictures are the same color? All of the TVs are receiving exactly the same signal but each TV has its own unique way of displaying color (its own unique 'color characteristics'). Different settings on each TV for brightness, contrast and color only make the problem worse.

One signal - different pictures (image courtesy of iStockphoto.com)

In the perfect world there would be a way of making sure that all of the TVs could synchronize their settings for brightness, contrast and color, and the unique color characteristics of each TV could be measured and taken into account when displaying a picture. If this could be achieved we could then send 10 different TVs the same picture so that the image appeared nearly identical on all TVs, irrespective of make, model or age. In the world of digital photography, Adobe has made the elusive goal of color consistency possible by implementing a concept and workflow called Color Management. Color Management, at first glance, can seem like an incredibly complex science for the keen amateur to get their head around, but if just a few simple steps are observed and implemented then color consistency can be yours.

Don't position your monitor so that it faces a window and lower the room lighting so that your monitor is the brightest thing in your field of vision (image courtesy of iStockphoto.com)

Step 1 - Preparing your print workshop

The first step is to optimize the room where your monitor lives. Ideally, the monitor should be brighter than the daylight used to light the room and positioned so the monitor does not reflect any windows or lights in the room (the biggest problems will all be behind you and over your shoulders as you sit at the monitor). Professionals often build hoods around their monitors to prevent stray light falling on the surface of the monitor but if you carefully position the monitor in the room you should be able to avoid this slightly 'geeky' step. Stray light that falls on your monitor will lower the apparent contrast of the image being displayed and could lead you to add more contrast when it is not required. The color of light in the room (warm or cool) is also a critical factor in your judgement of color on the screen. It is advisable to light the room using daylight but this should not be allowed to reflect off brightly colored surfaces in the room, e.g. brightly painted walls or even the brightly colored top you may be wearing when you are sitting in front of your monitor. If the room is your own personal space, or your partner supports your passion/obsession/ addiction for digital imaging, then you could go that bit further and paint your walls a neutral gray. The lighting in the room should be entirely daylight - without the possibility of warm sunlight streaming into the room at certain times of the day. The brightness of the daylight in the room can be controlled with blinds or you can introduce artificial daylight by purchasing color corrected lights, e.g. Solux halogen globes or daylight fluorescent lights. If the above recommendations are difficult to achieve - lower the level of the room lighting significantly.

Overview of step 1 > Position your computer monitor so that it does not reflect any windows, lights or brightly colored walls in the room (when you sit at the monitor a neutral colored wall, without a window, should be behind you). Use daylight or daylight globes to light the room and make sure the room lighting is not as bright as the monitor (the monitor should be the brightest thing in your field of view).

Step 2 - Preparing the monitor

Purchase a monitor calibration device (available for as little as US\$100 from X-Rite, ColorVision or Pantone) and follow the step-by-step instructions. The calibration process only takes a few minutes once you have read through the instructions and adjusted a few settings on your monitor. It is now widely accepted that photographers should choose a D65 whitepoint (how cool or warm tones appear on your monitor) and a Gamma of 2.2 (this controls how bright your midtones are on your monitor). The next time you use your calibrated and profiled monitor, Photoshop will pick up the new profile to ensure you are seeing the real color of the image file rather than a version that has been distorted by the monitor's idiosyncrasies and inappropriate default settings.

MONITOR CALIBRATOR RECOMMENDATIONS

If you are on a budget I recommend the ColorVision Spyder 2 Express or the Pantone Huey. If you have a little more money and are looking for a really professional tool, then the Eye One Display 2 is my personal favorite, although it costs a little more. If you decide on the Spyder 2 Express I found the only hiccup in an otherwise easy-to-follow guide was the instruction on how to decide whether your LCD monitor had a 'brightness' or 'backlight' control. As the vast majority of LCD monitors use a 'backlight' to control brightness I think this information is a possible source of confusion. The tiny Pantone Huey is really easy to use, completes the process in just a few minutes, and has an option to measure the brightness of the room and then adjust the brightness of the monitor accordingly. I would recommend that you lower the brightness of the LCD monitor to a setting of between 50% and 75% before calibrating an LCD screen with the Huey. The automatic brightness adjustment of the monitor is only useful if you can't maintain a standard level of illumination in your room. If you think small is cute, then the Huey will do an admirable job and you can put it in your shirtpocket when you're done.

Step 3 - Preparing to print to your own inkjet printer

Just as the color characteristics of the monitor had to be measured and profiled in order to achieve accurate color between camera and monitor, a profile also has to be created that describes the color characteristics of the printer. This ensures color accuracy is maintained between the monitor and the final print. When an accurate profile of the printer has been created Photoshop, rather than the printer, can then be instructed to manage the colors to maintain color consistency. Photoshop can only achieve this remarkable task because it knows (courtesy of the custom profile) how the printer skews color.

If you hope to achieve optimum print quality at home it is recommended that you use a photo-quality printer (one with six or more inks), one that will let Photoshop manage the colors for the best results. A custom profile is only accurate so long as you stick to the same ink and paper. Additional profiles will need to be created for every paper surface you would like to use. Printers come shipped with profiles, but these are of the 'one size fits all' variety, affectionately known as 'canned profiles'. For optimum quality, custom printer profiles need to be made for the unique characteristics of every printer (even if they are of the same brand and model number).

Note > Canned profiles for different paper stocks are also available on the web so check that you have the latest versions if you intend to proceed without making a custom profile.

PERFORMANCE TIP

In an attempt to make the first time not too memorable, for all the wrong reasons, check that your ink cartridges are not about to run out of ink and that you have a plentiful supply of good quality paper (same surface and same make). Refilling your ink cartridges with a no-name brand and using cheap paper is not recommended if you want to achieve absolute quality and consistency. I would recommend that you stick with the same brand of inks that came shipped with your printer and use the same manufacturer's paper until you have achieved your first successful workflow.

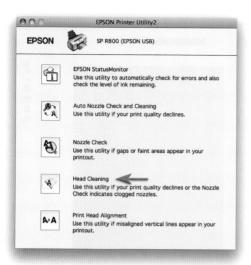

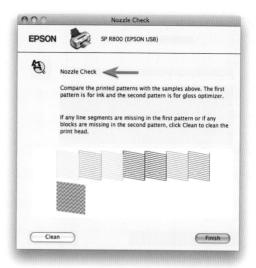

Before proceeding to create a custom profile for your printer it is important to check that all the inks nozzles are clean. Open your printer utility software and run a Nozzle check. This will print out a pattern on plain paper so that you can check all of the inks are running cleanly. If one or more of the inks are not printing or some of the pattern is missing then proceed to select the option to clean the heads in the Utility software.

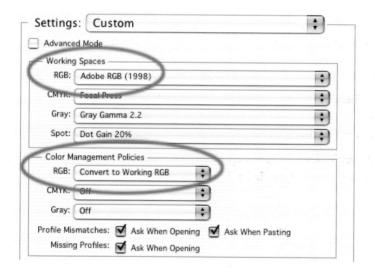

Step 4 - Select an appropriate color setting for the software Select a 'working space' for Photoshop that is sympathetic to the range of colors that can be achieved by your inkjet printer using good quality 'photo paper'. The most suitable working space currently available is called 'Adobe RGB (1998)'. To implement this working space choose 'Color Settings' in Photoshop and set the workspace to 'Adobe RGB (1998)' from the RGB pull-down menu. In the 'Color Management Policies' section, select 'Convert to Working RGB' from the 'RGB' pull-down menu and check the 'Ask When Opening' boxes. When using Photoshop Elements select the 'Allow Me to Choose' option.

Step 5 - Download a profile target

You can profile your printer, but the equipment is expensive. You can, however, print out a test chart and mail it to a company that has the equipment and will make the profile for you. Download a profile target from the website of the company who will create your custom printer profile. The target print can be mailed back to the company and your profile can be emailed back to you once it has been created by analyzing the test print you created.

Step 6 - Open the profile target file in Photoshop

Open the target print you have downloaded from your profile service provider and select 'Leave as is' in the 'Missing Profile' dialog box. If the file opens and no dialog box appears then close the file and check that you have changed the Color Settings as outlined in step 4. The color swatches on the target print must remain unchanged by the color management mechanisms for this process to be effective.

Note > Do not attempt to print a profile target file or test chart using Photoshop Lightroom as Lightroom cannot leave a file 'as is', i.e. switch off the color management.

Step 7 - Print settings in Photoshop

When the target image is open in Photoshop proceed to 'File > Print'. In order to measure the unique characteristics of the printer the colors on the test chart must be printed without any color management, i.e. Photoshop must NOT change the RGB numbers, hence the recommendation to select No Color Management in this step.

- 1. Select your printer from the 'Printer' menu.
- Click on the 'Page Setup' to choose the size of your printing paper (large enough to print the
 target image at 100%). Note > You can also rotate the image or rotate the paper orientation
 within the Page Setup dialog box.
- 3. Make sure that the scale is set to 100%.
- 4. In the 'Color Management' section of the dialog box choose 'No Color Management' for the Color Handling option. The Source Space should read 'Untagged RGB' and there will be a reminder to switch off the color management in the Printer Preferences dialog which we will do in the next step.

The printer driver of an Espon R800 - the layout and naming of the various options will vary between different makes and models of printers

Step 8 - Printer Preferences

Click on Printer Preferences in Photoshop's printer dialog box (in the Color Management section) and then choose the 'Advanced' options in your printer driver if available. In the printer driver dialog box choose the paper or media type (1), photo print quality (2) and switch off the color management (3), any Auto settings, a 'Gloss' option (4) if available and, for owners of Canon printers, make sure the 'Print Type' is set to 'NONE'. The precise wording for switching off the color management in the printer driver will vary depending on the make of the printer and the operating system you are using. When using an Epson or Canon printer you may see that color management is referred to as ICM or ICC. Other manufacturers may refer to letting the software (Photoshop) manage the color. When you print this target print, the colors are effectively printed in their raw state. In this way the lab that creates your profile can measure how the colors vary from one printer to another and they can then create a unique profile that best describes what your printer does with standard 'unmanaged' color.

Step 9 - Install your custom profile

Send the target print to the profiling company so that it can be measured using the sophisticated and expensive profiling hardware and software that is best left to the experts. They will email you the profiles after just a few days as an attachment. Right-click the profile and choose Install, and Windows will install it in the correct location.

Step 10 - Tag your images with the Adobe RGB profile

When you have installed your custom printer profile make sure that most of your images destined for print are tagged with the Adobe RGB profile. Select the Adobe RGB profile in the camera if possible (digital SLR cameras and many prosumer fixed-lens digicams allow the photographer to choose this setting). Change the Color Settings in Photoshop Elements (Edit > Color Settings) to 'Always Optimize for Printing' (changing the 'Color Settings' to Always Optimize for Printing in Photoshop Elements will ensure any files being opened from Adobe Camera Raw will automatically be tagged with the Adobe RGB profile rather than the sRGB profile). In the full version of Photoshop you must click on the blue writing at the base of the ACR dialog box Workflow Options. Select Adobe RGB (1998) from the Space menu.

Step 11 - Select Photoshop Manages Colors

It is recommended that the first print you make using your custom profile is a test image - one that has a broad range of colors and tones. A test image with skin tones can be very useful for testing the accuracy of your new print workflow. When you next open the 'Print' dialog box make sure you change the previous setting used to print the profile target from 'No Color Management' to 'Photoshop Manages Colors'. Select your new custom profile from the Printer Profile menu and in the Rendering Intent options choose either 'Perceptual' or 'Relative Colorimetric'. Select 'Print'.

Step 12 - Making printer presets for quick and easy printing

From the Printer Preferences menu select the same settings that were used to print the profile target (don't forget to ensure the color management is turned 'OFF'). Save a 'Preset' or 'Setting' for all of the printing options so that you only choose this one setting each time your revisit this dialog box. View your first print using bright daylight and you will discover, if you have followed these directions to the letter, that you have almost certainly found a solution to one of the mysteries of digital color photography - the search for predictable color.

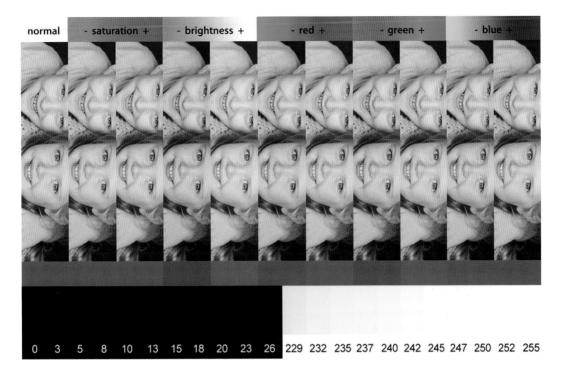

Use the test file on the supporting website to help you target the perfect color balance quickly and efficiently

Step 13 - Assessing the test print for accuracy

View the print using daylight (not direct sunlight) when the print is dry, and look for differences between the print and the screen image in terms of hue (color), saturation and brightness.

- Check that the colors are saturated and printing without tracking marks or banding. If there
 is a problem with missing colors, tracking lines or saturation, clean the printer heads using the
 available option in the printer driver.
- 2. View any skin tones to assess the appropriate level of saturation.
- 3. View any gray tones to determine if there is a color cast present in the image. If these print as gray then no further color correction is required.

PERFORMANCE TIP

Any differences between the monitor and the print will usually now be restricted to the differences in color gamuts between RGB monitors and CMYK printers. The vast majority of colors are shared by both output devices but some of the very saturated primary colors on your monitor (red, green and blue) may appear slightly less saturated in print. Choose a printer with an inkset that uses additional primary inks if you want to achieve the maximum gamut from a printer.

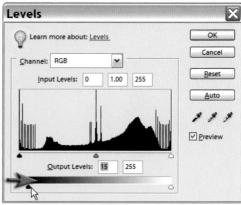

Step 14 - Maximizing shadow and highlight detail

If the dark shadow tones that are visible on screen are printing as black then you could try switching from the 'Relative Colorimetric' rendering intent to the 'Perceptual' rendering intent, try choosing an alternative media type in the printer driver or establish a Levels adjustment layer to resolve the problem in Photoshop. The bottom left-hand slider in the Levels dialog box should be moved to the right to reduce the level of black ink being printed (raise it to a value of no higher than 10 if you wish to preserve your black point). This should allow dark shadow detail to be visible in the second print.

Note > It is important to apply these Output level adjustments to an adjustment layer only as these specific adjustments apply only to the output device and media you are currently testing.

PERFORMANCE TIP

Materials

Start by using the printer manufacturer's recommended ink and paper.

Use premium grade 'photo paper' for maximum quality.

Monitor

Position your monitor so that it is clear of reflections.

Let your monitor warm up for a while before judging image quality.

Calibrate your monitor using a calibration device.

Adobe

Set the Color Settings of the Adobe software to allow you to use the Adobe RGB profile.

Select 'Photoshop Elements Manages Color'.

Use a six-ink (or more) inkjet printer or better for maximum quality.

Select the 'Media Type' in the Printer Software dialog box.

Select a high dpi setting (1440 dpi or greater) or 'Photo' quality setting.

Use a custom printer profile.

Proofing

Allow print to dry and use daylight to assess color accuracy of print.

Printing from Photoshop Lightroom

Once the effectiveness of the color-managed printing workflow has been established you can then print from Photoshop Lightroom using the custom printer profiles you created in Photoshop or Photoshop Elements for your inkjet printer.

In the Print module go to the Print Job panel and then click to open the 'Profile' pop-up menu. Choose 'Other' from the pop-up menu to access the profiles you would like to appear in this menu. Check any boxes for the custom profiles you have created and then select OK. You will now be able to print using the color-managed workflow you established in Photoshop or Photoshop Elements. A warning note will appear when you select a custom profile to remind you to switch off the color management in your printer driver.

Note > Unfortunately it is not possible to print out a test print or test chart from Lightroom for profiling purposes as color management cannot be disengaged in Lightroom. It is possible, however, to print using a color-managed workflow once you have established a custom profile for your printer.

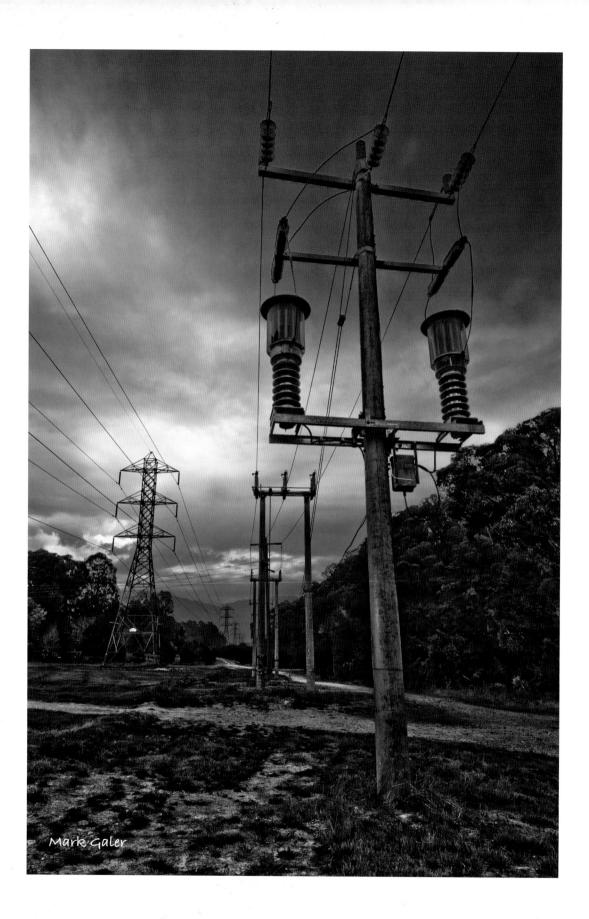

landscape

Mark Galer

essential skills

- Increase knowledge of the historical development of the landscape image.
- · Express ideas, convictions or emotions through landscape images.
- Develop an understanding of how different techniques can be employed to aid personal expression.
- Produce photographic images exploring expressive landscape photography in response to the activity and assignment briefs in this chapter.

Introduction

Picture postcards, calendars and travel brochures show us glimpses of romantic, majestic and idyllic locations to be admired and appreciated. The beautiful and wonderful are identified, observed, recorded and labelled repeatedly by professionals, tourists and travellers. Mankind is responding to the basic social needs and expectations to capture, document and appreciate. I came, I saw, I photographed. Photography allows the individual to pay homage to beauty and achievement as if in some religious ritual. We mark the occasion of our endeavor and our emotional response by taking a photograph.

'Most tourists feel compelled to put the camera between themselves and whatever is remarkable that they encounter. Unsure of other responses they take a picture. This gives shape to experience: stop, take a photograph, and move on.'

Susan Sontag - On Photography

In order to avoid a stereotypical representation it is important to connect emotionally with the environment in order to express something personal. How do you as an individual feel about the location and what do you want to say about it?

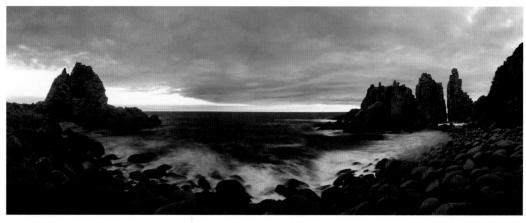

Orien Harvey

History

Early landscape images were either created as factual records or looked to the world of painting for guidance in such things as composition and choice of content. Fox Talbot described his early photographs as being created by the 'pencil of nature'. On the one hand the medium was highly valued because of the great respect for nature at this time. On the other hand the medium was rejected as art because many perceived photography as a purely objective and mechanical medium. The question was asked: 'Can photography be considered as an artistic medium?' Although it is the camera that creates the image, it is the photographer who decides what to take and how to represent the subject. This subjective approach enables individuals to express themselves in unique ways whether they use a brush or a camera.

Pictorial photography

The practice of recording the environment as the principal subject matter for an image is a fairly modern concept. Prior to the 'Romantic Era' in the late 18th century, the landscape was merely painted as a setting or backdrop for the principal subject. Eventually the environment and in particular the natural environment began to be idealized and romanticized. The picturesque aesthetic of beauty, unity and social harmony was established by painters such as John Constable and William Turner working just prior to the invention of photography. The first photographic movement was born and was known as 'pictorial photography'. Pictorial photographers believed that the camera could do more than simply document or record objectively. The pictorial approach was not so much about information as about effect, mood and technique. Pictorial photographers often felt, however, that the photographic lens recorded too much detail. This led to photographers employing techniques to soften the final look of the image. These techniques included taking the images slightly out of focus or using print manipulation to remove detail. The aim was to create an image which looked more like a drawing or painting and less like a photograph.

Pictorial style image - Itti Karuson

Naturalism

Dr Peter Henry Emerson promoted photographic 'Naturalism' in 1889 in his book *Naturalistic Photography for Students of Art*. Emerson believed that photographers shouldn't emulate the themes and techniques of the painters but treat photography as an independent art form. He encouraged photographers to look directly at nature for their guidance rather than painting. He believed that photography should be true to both nature and human vision. Emerson promoted the concept that each photographer could strive to communicate something personal through their work.

Realism

In 1902 a photographer named Alfred Stieglitz exhibited under the title 'Photo-Secessionists' with nonconformist pictorial photographs, choosing everyday subject matter taken with a hand-held camera. These images helped promote photography as an aesthetic medium.

Dunes, Oceano, California 1963 - Ansel Adams © Ansel Adams Publishing Rights Trust/Corbis

F64

Another member of the group, Paul Strand, pioneered 'straight photography', fully exploring the medium's strengths and careful observation of subject matter. Strand believed that the emphasis should lie in the 'seeing' and not the later manipulation in order to communicate the artist's feelings. The work and ideas influenced photographers such as Edward Weston and Ansel Adams who decided to take up this new 'Realism'. They formed the group F64 and produced images using the smallest possible apertures on large-format cameras for maximum sharpness and detail. Straight photography heralded the final break from the pursuit of painterly qualities by photographers. Sharp imagery was now seen as a major strength rather than a weakness of the medium. Photographers were soon to realize this use of sharp focus did not inhibit the ability of the medium to express emotion and feeling.

Documentary

Photography was invented at a time when the exploration of new lands was being undertaken by western cultures. Photography was seen as an excellent medium by survey teams to categorize, order and document the grandeur of the natural environment. A sense of the vast scale was often established by the inclusion of small figures looking in awe at the majestic view. These majestic views and their treatment by American photographers contrasted greatly with European landscape photographs. Landscape painters and photographers in Europe did not seek isolation. Indeed seeking out a sense of isolation is problematic in an industrialized and densely populated land.

Bethlehem, Graveyard and Steel Mill - Walker Evans 1935 © Walker Evans Archive, 1994, The Metropolitan Museum of Art

In the 1930s Roy Stryker of the Farm Security Administration (FSA) commissioned many photographers to document life in America during the depression. Photographers such as Arthur Rothstein, Dorothea Lange and Walker Evans produced images which not only documented the life of the people and their environment but were also subjective in nature.

Practical activity

View the image by Walker Evans on this page and describe what you can actually see (objective analysis) and what you think the image is about (subjective analysis).

How effective has Walker Evans been in using a landscape image to communicate a point of view. Can this photograph be considered as Art?

Personal expression

The image can act as more than a simple record of a particular landscape at a particular moment in time. The landscape can be used as a vehicle or as a metaphor for something personal the photographer wishes to communicate. The American photographer Alfred Stieglitz called a series of photographs he produced of cloud formations 'equivalents', each image representing an equivalent emotion, idea or concept. The British landscape photographer John Blakemore is quoted as saying:

'The camera produces an intense delineation of an external reality, but the camera also transforms what it "sees". I seek to make images which function both as fact and as metaphor, reflecting both the external world and my inner response to, and connection with it.'

Rocks and Tide, Wales - John Blakemore

'Since 1974, with the stream and seascapes, I had been seeking ways of extending the photographic moment. Through multiple exposures the making of a photograph becomes itself a process, a mapping of time produced by the energy of light, an equivalent to the process of the landscape itself.'

John Blakemore, 1991

Communication of personal ideas through considered use of design, technique, light and symbolic reference is now a major goal of many landscape photographers working without the constraints of a commercial brief. Much of the art world now recognizes the capacity of the photographic medium to hold an emotional charge and convey self-expression.

Alternative realities

There is now a broad spectrum of aesthetics, concepts and ideologies currently being expressed by photographers. The camera is far from a purely objective recording medium. It is capable of recording a photographer's personal vision and can be turned on the familiar and exotic, the real and surreal. This discriminating and questioning eye is frequently turned towards the urban and suburban landscapes the majority of us now live in. It is used to question the traditional portrayal of the rural landscape (romantic and idyllic) as a mythical cliché. It explores the depiction of the natural landscape for many urban dwellers as a mysterious location, viewed primarily through the windscreen of the car and from carefully selected vantage points. Photographers such as Martin Parr now present different views of familiar locations and offer alternative realities. Landscape is used frequently as a political tool, reflecting the values of society. The landscape traditionally portrayed as being unified and harmonious may now be portrayed as confused and cluttered and in turn express the conflict between expectation and reality.

Dreams will come true - Matthew Orchard

Photographers also explore their personal relationship with their environment using the camera as a tool of discovery and revelation. To make a photograph is to interact and respond to the external stimuli that surround us. We may respond by creating images that conform to current values and expectations or we may create images that question these values. To question the type of response we make and the type of image we produce defines who we are and what we believe in.

Practical activity

Find two landscape photographs that question social values or act as a metaphor for personal issues that the photographer is trying to express. Is the communication clear or ambiguous and how is this communication conveyed.

Expressive techniques

Sweeping panoramas are not caught by the frame of a standard lens. When a wide-angle lens is attached to include more of the panorama the resulting images may be filled with large areas of empty sky and foreground. This does little for the composition and can make the subject of interest seem far away and insignificant. The lens does not discriminate, recording everything within its field of vision. Painters recording a landscape have the option of eliminating information that would clutter the canvas or detract from the main subject matter. Unlike the painter, a photographer can only remove superfluous detail by using a carefully chosen vantage point or by moving in closer to reduce the information that is contained within the frame. If the photographer moves in too close, the feeling of the broader landscape is lost.

The Apostles - Mark Galer

Although it is difficult to communicate personal ideas or feelings and capture the mood of a location it is nevertheless possible and, when achieved, can be one of the most rewarding photographic experiences. Through increased awareness, careful observation and knowledge of the elements that create a successful landscape photograph the photographer can learn to achieve expressive and effective results consistently.

Practical activity

Compare and contrast a landscape photograph with a landscape painting. What are the expressive possibilities of each medium? Choose your examples carefully as representative of the medium.

Light

As previously stated in the chapter on light the use of low-light is essential to increase the range of moods. The changes in contrast, hue and color saturation found in low-light conditions can all be used to extend the expressive possibilities for the photographer.

Extreme brightness range

With an extreme brightness range the exposure between land and sky is often a compromise. Sky may become overexposed when detail is required in the land, land may become underexposed when detail is required in the sky. The brightness range can be controlled by filtration, shooting at an appropriate time of day and by using the Camera Raw format. It is also possible to bracket exposures and merge the images in post-production (see *Photoshop CS3/CS4: Essential Skills* or *Photoshop Elements Maximum Performance*).

Note > It is recommended to capture in Raw mode to exploit the full dynamic range that your image sensor is capable of as JPEG or TIFF processing in-camera may clip the shadow and highlight detail.

Mark Galer

Merge to HDR

In the full version of Photoshop there is the merge to HDR (High Dynamic Range) automated feature. A series of bracketed exposures can be selected and the Merge to HDR feature then aligns the images automatically. It is recommended that the photographer brackets the exposures using the shutter speed rather than the aperture for optimum results. This will eliminate the possibility of creating exposures where the depth of field varies (this would make registering the images difficult or impossible).

Composition

Composing subject matter is more than an aesthetic consideration. It controls the way we read an image and the effectiveness of the photographer's communication.

Format and horizon line

The most powerful design elements landscape photographers have to work with are choice of format and positioning of the horizon line. Most landscape images are horizontal or landscape format. The use of this format emulates the way we typically view the landscape. To further emulate the human vision we can crop to a wider image to reduce the viewer's sensation of viewing a truncated image. Many photographers make the mistake of overusing the vertical or portrait format when faced with tall subject matter. The placement of the horizon line within the frame is also critical to the final design. A central horizon line dividing the frame into two halves is usually best avoided. The photographer should consider whether the sky or foreground is the more interesting element and construct a composition according to visual weight and balance.

Mark Galer

Open or closed landscape

By removing the horizon line from the image (through vantage point or camera angle) the photographer creates a closed landscape. In a closed landscape a sense of depth or scale may be difficult for the viewer to establish.

Practical activity

Capture two photographs in a location with tall buildings or trees using both formats.

Create a closed and open landscape at one location.

Compare the effectiveness of the resulting images.

Depth

Including foreground subject matter introduces the illusion of depth through perspective and the image starts to work on different planes. Where the photographer is able to exploit lines found in the foreground the viewer's eye can be led into the picture. Rivers, roads, walls and fences are often used for this purpose.

By lowering the vantage point or angling the camera down, the foreground seems to meet the camera. A sense of the photographer in, or experiencing, the landscape can be established. In the photograph below the beach and cliff walls are included along with the author's own footsteps to establish a sense of place.

Mark Galer

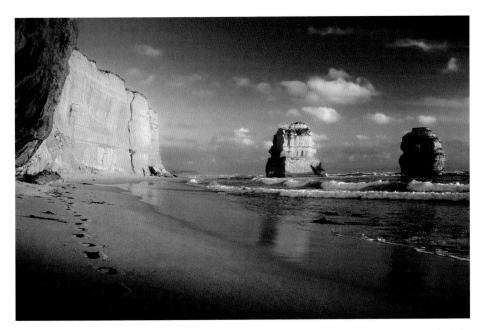

Mark Galer

Practical activity

Create a landscape utilizing foreground subject matter to create a sense of depth. How will the resulting image be read by the viewer?

Panoramic images

The ability to combine or stitch images seamlessly in Photoshop greatly improved with the release of Photoshop CS3 and Elements 6. The Photomerge feature is now capable of aligning and blending images without any signs of banding in smooth areas of transition. The quality will be even better if the component images are captured vertically with a 50% overlap, using manual exposure, manual focus and a custom white balance setting (or the images processed identically in Camera Raw). The results are now truly seamless and provide an excellent way of extending the capabilities of the wide-angle lens.

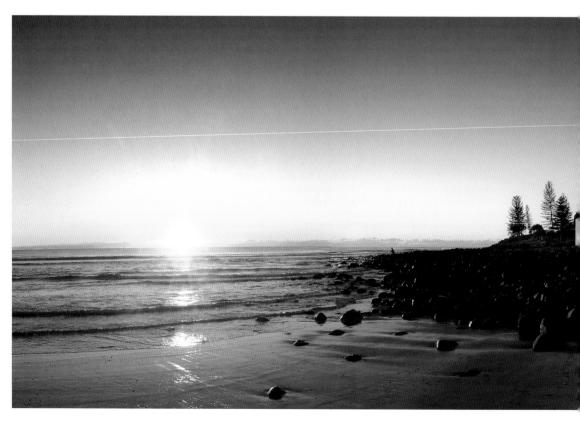

Mark Galer

Now the only limitation you may run up against is Photoshop's ability to align and blend strong geometric lines that come close to the camera lens. If the camera is hand-held to capture the component images (you have not used a specialized tripod head designed for professional panoramic stitching work) then the problem of aligning both foreground and distant subject matter is a big problem for any software (Photoshop handles it better than the rest). The camera should ideally be rotated around the nodal point of the lens to avoid something called parallax error. You willl probably not encounter any problems with the new Photomerge feature unless you are working with strong lines in the immediate foreground. Notice how the curved lines in the image above are slightly crooked due to the fact that these images were shot with an 18mm focal length and these lines are very close to the lens.

Scale

Where the photographer is unable to exploit foreground interest it is common to include subject matter of known size. This gives the viewer a sense of scale which can often be lost in images that seemingly exist on only one plane. The lone figure on the summit of an active volcano in the photograph below adds not only a focal point of interest but also scale.

Mark Galer

Focal length

A wide-angle lens is a favorite tool of the landscape photographer. It has the potential to create images with exaggerated perspective and greater depth of field. Foreground detail is vital to prevent empty images.

The telephoto lens is often overlooked when photographing landscape images. The photographer Andreas Feininger made a series of dramatic images of New York using very long telephoto lenses. Feininger did not like the distortion of scale when using wide-angle lenses close to the subject matter. He preferred to photograph the correct relationship of scale by shooting at a distance with a longer lens.

Where a high vantage point has been found the compression of detail and subject matter can be used to create dramatic designs. Photographers working at a distance with long lenses should take precautions against overexposure due to excessive UV light. Slight underexposure and use of UV or Skylight filters is strongly recommended.

Practical activity

Create a landscape image with a wide-angle lens or telephoto lens.

Compare the differences in communication and design with an image captured using a standard lens.

Detail

The photographer can communicate more about the natural environment than just with images of the broad landscape. With more than one image capable of being stored on a memory card the photographer is not restricted to making a single carefully chosen statement about a natural landscape on a particular day. With keen visual awareness and close observation the photographer is able to move in close, isolate particular features and build a more detailed impression of a location. By moving in close, depth of field is reduced, so aiding the photographer's attempt to isolate single features within a complex environment.

Matthew Connop-Galer

Macro

Very small features may be photographed with the aid of a macro lens or a relatively inexpensive close-up lens. The close-up lens is screwed onto the front of an existing lens like a filter and is available in a range of dioptres. The photographer using macro capabilities to capture nature should be aware of the very shallow depth of field when shooting at wide apertures. Photographers using the smaller apertures can incur a number of problems. Extended shutter speeds may require the use of a tripod or monopod and any wind may cause the subject to blur.

Monopods are preferred by many who find the speed advantage over a tripod invaluable. An insect visiting a flower is often gone by the time the legs of a tripod are positioned. Many photographers specializing in this area of photography often resort to using wind-breaks to ensure that the subject remains perfectly still during an extended exposure. These wind-breaks can be constructed out of clear polythene attached to three or four wooden stakes so that a natural background can be retained. One or more of the sides can be a white translucent material that can act as a reflector or a diffuser to lower the contrast of harsh direct sunlight.

Night photography

One of the best times to take night photographs is not in the middle of the night but at dusk, before the sky has lost all of its light. The remaining light at this time of day helps to delineate the buildings and trees from the night sky.

Night photography is often seen as a technically demanding exercise. With a little extra equipment and a little knowledge, however, the pitfalls can easily be avoided. Use a tripod to brace the camera, a cable release to release the shutter (optional if using the self-timer) and a flashlight to set controls of the camera. Raising the ISO and the use of very long exposures (over 1 second) can present 'noise' problems for prosumer cameras using smaller CCD sensors and some of the budget DSLRs.

Michael Wennrich

Using the camera's meter and histogram to calculate exposure Set the camera to manual exposure mode. Frame part of the scene where the artificial lights will not overly influence the meter (avoid lights directed towards the camera and/or in the center of the frame). If the reading is off the meter's scale try opening the aperture or extending the shutter speed to establish a reading. Review the preliminary exposures using the camera's LCD screen and histogram. Bracket several exposures using the shutter speed. This will allow you to merge separate exposures using Photoshop's Merge to HDR feature if the contrast exceeds the latitude or dynamic range of the sensor.

Practical activity

Create an image at an urban location during the twilight hour. Bracket your exposures. Create an image where the twilight delineates the buildings and trees from the night sky.

The constructed environment

When Arthur Rothstein, FSA photographer, moved a skull a few feet for effect he, and the FSA, were accused of fabricating evidence and being dishonest. A photograph, however, is not reality. It is only one person's interpretation of reality. Rothstein perceived the skull and the broken earth at the same time and so he included them in the same physical space and photograph to express his emotional response to what he was seeing. Is this dishonest?

The photograph can act as both a document and as a medium for self-expression. Truth lies in the intention of the photographer to communicate visual facts or emotional feelings. Sometimes it is difficult for a photograph to do both at the same time.

Andy Goldsworthy

The majority of photographers are content with responding to and recording the landscape as they find it. A few photographers, however, like to interact with the landscape in a more concrete and active way. Artists such as Andy Goldsworthy use photography to record these ephemeral interactions. Goldsworthy moves into a location without preconceived ideas and uses only the natural elements within the location to construct or rearrange them into a shape or structure that he finds meaningful. The day after the work has been completed the photographs are often all that remain of Goldsworthy's work. The photograph becomes both the record of art and a piece of art in its own right.

Practical activity

Make a construction or arrangement using found objects within a carefully selected public location. Create an image showing this structure or arrangement in context with its surroundings. Consider framing, camera technique and lighting in your approach.

What do you think your construction communicates about your environment?

Assignments

Produce six images that express your emotions and feelings towards a given landscape.

Each of the six images must be part of a single theme or concept and should be viewed as a whole rather than individually.

People may be included to represent humankind and their interaction with the landscape. The people may become the focal point of the image, but this is not a character study or environmental portrait where the location becomes merely the backdrop.

- 1. Wilderness.
- 2. Seascape.
- 3. Suburbia.
- 4. Sandscape.
- 5. Inclement weather.
- 6. The city or city at night.
- 7. Mountain.
- 8. Industry.
- 9. Arable land.

Resources

A Collaboration with Nature - Andy Goldsworthy. Harry N Abrams. New York. 1990.

Ansel Adams: 400 Photographs - Ansel Adams. 2007.

On Photography - Susan Sontag. Picador. 2001.

FSA: The American Vision - Beverley Brannan and Gilles Mora. Harry N Abrams. 2006

Naturalistic Photography for Students of the Art - P. H. Emerson. Arno Press. NY. 1973.

Small World - Martin Parr. Dewi Lewis Publications. 2007.

The History of Photography: An overview - Alma Davenport. University of New Mexico Press. 1999.

The Story of Photography - Michael Langford. Focal Press. Oxford. 1998.

Walker Evans: Masters of Photography. Aperture New Ed Edition. 2005.

Landscape Photography - Tim Fitzharris. Firefly Books. 2007

Mastering Landscape Photography: The Luminous Landscape Essays - Alain Briot. Rocky Nook. 2006.

Websites

Ansel Adams: http://www.anseladams.com/

John Blakemore: http://collection.britishcouncil.org

Martin Parr: http://www.martinparr.com/

UK Landscape: http://www.uklandscape.net/

George Eastman House: http://www.geh.org/photographers.html

Luminous Landscape: http://www.luminous-landscape.com

environmental portraits

Mark Galer

essential skills

- Develop an increased awareness of the actions and interactions of a broad spectrum of people.
- Develop personal skills in directing people.
- Develop essential technical skills to work confidently and fluently.
- Produce images through close observation and selection that demonstrate both
 a comfortable working relationship with people at close range and appropriate

Introduction

The craft of representing a person in a single still image or 'portrait' is to be considered a skilled and complex task. The photographic portrait (just like the painted portrait that influenced the genre) is not a candid or captured moment of the active person but a crafted image to reveal character. The person being photographed for a portrait should be made aware of the camera's presence even if they are not necessarily looking at the camera when the photograph is made. This requires that the photographer connects and communicates with any individual if the resulting images are to be considered portraits. Portraits therefore should be seen as a collaborative effort on the part of the photographer and subject. A good photographic portrait is one where the subject no longer appears a stranger.

Mikael Wardhana

The physical surroundings and conditions encountered on location whilst making a portrait image offer enormous potential to extend or enhance the communication. Just as facial expression, body posture and dress are important factors, the environment plays a major role in revealing the identity of the individual. The environmental portrait for this reason has become a genre in its own right. Environmental portraits are produced commercially for a number of reasons. The environmental portrait may be produced to stand alone to illustrate an article about a person that is of public interest. It may also be the central or key image of a collection of images that together form a photo-essay or social documentary.

Practical activity

Look through assorted publications and collect images where the environment plays an important role in determining an aspect of the subject's character or identity. Observe how the subject relates to the environment in each image.

Design

In order for the photographer to reveal the connection between the subject and the environment the photographer must carefully position or frame the two elements together. Vantage point, cropping and choice of scale become critical factors in the design. The relationship and connection between foreground and background becomes a major design consideration for an environmental portrait.

Orien Harvey

Format

The choice of vertical or horizontal framing and the placement of the subject within the frame will affect the quantity of environmental information that can be viewed in the resulting image. A centrally placed subject close to the camera will marginalize the environmental information. This framing technique is more difficult to utilize but should not be ruled out for creating successful environmental portraits. Using the portrait format for environmental portraits usually requires the photographer to move further back from the subject so that background information is revealed.

Practical activity

Find environmental portraits that demonstrate the different ways a photographer has framed the image to alter meaning or content. Observe the photographer's vantage point, use of scale, depth of field and subject placement in all of the images.

Composing two or more people

Composing two or more people within the frame for an environmental portrait can take considerable skill. People will now relate with each other as well as with the environment. The physical space between people can become very significant in the way we read the image. For a close-up portrait of two people the space between them can become an uncomfortable design element. Careful choice of vantage point or placement of the subjects is often required to achieve a tight composition, making optimum use of the space within the frame.

Mark Galer

The situation most often encountered is where two people sit or stand side by side, shoulder to shoulder. If approached face on (from the front) the space between the two people can seem great. This can be overcome by shooting off to one side or staggering the individuals from the camera. The considerations for design are changed with additional subjects.

Practical activity

Collect environmental portrait images with two to five subjects.

In at least one image the subject should have been placed in the foreground.

Observe the arrangement of the subjects in relation to the camera and the effectiveness of the design.

Depth of field

Sophisticated digital cameras usually provide a 'Portrait Mode'. When this program mode is selected a combination of shutter speed and aperture is selected to give the correct exposure and a visual effect deemed suitable for portrait photography by the camera manufacturers. The visual effect aimed for is one where the background is rendered out of focus, i.e. shallow depth of field. This effect allows the subject to stand out from the background, reducing background information to a blur. Although this effect may be pleasing for some portrait images it is not suitable for most environmental portraits where more information is required about the physical surroundings and environment. The photographer intending to shoot environmental portraits is recommended to use aperture priority or manual in most situations so that maximum control is maintained.

Mark Galer

Portrait lenses

Some lenses of a certain focal length are often referred to as 'portrait lenses'. The 'ideal' portrait lens is considered by the manufacturers to be a medium telephoto lens such as a 135mm lens (or equivalent) for a DSLR camera. This lens provides a visual perspective that does not distort the human face when recording head and shoulder portraits. The problem of distortion, however, is not encountered with shorter focal length lenses if the photographer is not working quite so close to the subject. To record environmental portraits with a telephoto lens would require the photographer to move further away from the subject and possibly lose the connection with the subject that is required. Standard and wide-angle lenses are suitable for environmental portraiture.

Practical activity

Photograph the same subject varying both the depth of field and focal length of lens. Compare the visual effects of each image.

Revealing character

Significant and informative details can be included within the frame with the subject. These details may naturally occur in the environment or be introduced for the specific purpose of strengthening the communication. Connections may be made through the 'tools of the trade' associated with the individual's occupation. Informative artifacts such as works of art or literature may be chosen to reflect the individual's character. Environments and the lighting may be chosen to reflect the mood or state of mind of the subject.

Ann Ouchterlony

The objects or subject matter chosen may have symbolic rather than direct connection to the subject. In the above image the bent walking stick of the old man and the path travelled could be seen to represent the journey of life.

Practical activity

Compose an image considering carefully the inclusion or juxtaposition of significant or informative detail.

Describe the importance of the additional information and how it is likely to be read by the viewer.

Connecting with new people

The shift from receptive observer to active participant can sometimes be awkward and difficult for both the potential subject and the photographer. These feelings of awkwardness, embarrassment or even hostility may arise out of the subject's confusion or misinterpretation over the intent or motive behind the photographer's actions. The photographer's awkwardness or reticence to connect often comes from the fear of rejection.

Mark Galer

The initial connection with the subject is crucial for a successful environmental portrait. If the photographer is taking images at an event or activity the photographer must be very aware when someone within the frame makes eye contact with the camera. At this decisive moment the posture and facial expression usually remain unchanged from where the subject's attention was previously engaged. The photographer should be able to capture a single frame at this moment before lowering the camera. There is no time for re-focusing, re-framing and adjusting exposure. The camera should be lowered and a friendly and open response offered by the photographer. If the photographer continues to observe the subject after having been noticed the subject's sense of privacy can be invaded and the photographer's chance for an amicable contact can be lost. Most people will gladly cooperate if a friendly connection has first been established.

Contact

The first verbal connection with the subject should be considered carefully. Asking people for their permission to be photographed requires a considered response on the subject's behalf ('What are they selling?' and 'Who will see the picture?' etc.). Unsure of the implications of consenting to be photographed many people will refuse their permission. Once refused it is not always possible to persuade someone that their acceptance to be photographed would have no further implications, i.e. they would not be required to purchase the photograph, give consent for publication, etc. The first verbal connection should simply be who you are.

Familiarity

Many photographers will arrange a preliminary visit to a location if there is time available. This will allow individuals present at the location to get used to the photographer's presence and feel comfortable being photographed. This is especially useful at small or enclosed events, as it may be difficult for the photographer to work unnoticed. If introductions haven't first been made the photographer may cause some disruption at the event or activity. Successful environmental portraits are often dependent on the initial interactions the photographer has with the potential subject.

Interaction

Putting a subject at ease in front of the camera is dependent on two main factors:

- 1. The subject is clear about the photographer's motive.
- 2. The subject sees value in the photographs being made.

Motive

Many people view an unknown photographer with curiosity or suspicion. Who is the photographer and why are they taking photographs? It is essential that the photographer learns to have empathy with the people he/she intends to photograph. A brief explanation is therefore necessary to help people understand that the photographer's intentions are harmless.

Value

Many people see the activity or job that they are doing as uninteresting or mundane. They may view their physical appearance as non-photogenic. The photographer needs to explain to the subject what it is that he/she finds interesting or of value and why. If the activity the subject has been engaged in appears difficult or demanding and requires skill, patience or physical effort, the photographer should put this view forward. The photographer should continue to ask questions whilst photographing so that the subject is reassured that the interest is genuine.

Directing the subject

The photographer should display an air of confidence and friendliness whilst directing subjects. Subjects will feel more comfortable if the photographer clearly indicates what is expected of them. There can be a tendency for inexperienced photographers to rush an environmental portrait. The photographer may feel embarrassed, or feel that the subject is being inconvenienced by being asked to pose. The photographer should clarify that the subject does have time for the photograph to be made and indicate that it may involve more than one image being created. A subject may hear the camera shutter and presume that one image is all that is required.

Passive subject

Subjects should be directed to pause from the activity that they were engaged in. The photographer can remain receptive to the potential photographic opportunities by keeping the conversation focused on the subject and not oneself.

Expression and posture

Often a subject will need reminding that a smile may not be necessary. Subjects may need guidance on how to sit or stand, what they should do with their hands and where to look. It may be a simple case of just reminding them how they were standing or sitting when you first observed them.

Shooting decisively

As a photographer takes longer to take the picture the subject will often feel more and more uncomfortable about their expression and posture. To freeze human expression is essentially an unnatural act. Exposure, framing and focus should all be considered before raising the camera to the eye.

Dorothy Connop

Practical activity

Connect with someone new and create three environmental portraits. Direct them towards a relaxed expression and body posture. Reflect on the process of directing your subject.

Character study

Environmental portraits often stand alone in editorial work but can also form part of a larger body of work. A series of environmental portraits may be taken around a single character, or characters, connected by profession, common interest or theme.

With additional images the photographer is able to vary the content and the style in which the subject is photographed to define their character within the study. The photographer may choose to include detail shots such as hands or clothing to increase the quality of information to the viewer. The study may also include images which focus more on the individual (such as a straight head and shoulders portrait) or the environment to establish a sense of place.

Sean Killen

The images above show the diversity of approach to present the character of a single individual. The images are of Martin, a homeless individual who lived under a bridge in Melbourne and who sold copies of *The Big Issue* to support himself.

Practical activity

Fine a photographic essay where the photographer has varied the content of the images to define the character or characters of the individual or individuals.

How effective are the supporting images that are not environmental portraits?

Assignments

Produce six environmental portraits giving careful consideration to design, technique and communication of character. At least one of the images should include more than one person. Choose one category from the list below.

- 1. Manual laborers dockers, builders, mechanics, bakers, etc.
- 3. Craftsmanship...... potters, woodworkers, violin makers, etc.
- 4. Club or team members footballers, golfers, scouts, etc.
- Corporate image...... business consultants, bankers, etc.
 This study should include three environmental portraits,
 two images of close-up detail and one portrait.
- 6. Character study celebrity, politician, busker, etc.
 This study should include three environmental portraits,
 two images of close-up detail and one close-up portrait.

Resources

Editorial:

National Geographic

Newspapers and magazines

Books:

Arnold Newman - Poul Tojner and Diana Thater. Louisiana Museum of Modern Art. 2004.

August Sander (Aperture Masters of Photography). 2005.

Bill Brandt (Photofile) - Ian Jeffrey. Thames & Hudson. 2007.

East 100th Street - Bruce Davidson. St Ann's Press. 2003.

Immediate Family - Sally Mann. Aperture. 2005.

Karsh: A Biography in Images. MFA Publications. 2004.

Portraits - Steve McCurry. Phaidon Press Inc. 1999.

Nicholas Nixon Photographs. tf. editores 2003.

Richard Avedon Portraits. Harry N. Abrams. 2002.

The Brown Sisters - Nicholas Nixon. Museum of Modern Art. New York. 2007.

Dorothea Lange: The Photographs of a Lifetime. Aperture. 2005.

A Photographer's Life - Annie Liebowitz. Random House. 2006.

The Story of Photography - Michael Langford. Focal Press. Oxford. 1998.

Web:

Many of the links to the above photographers can be found at http://photography.about.com

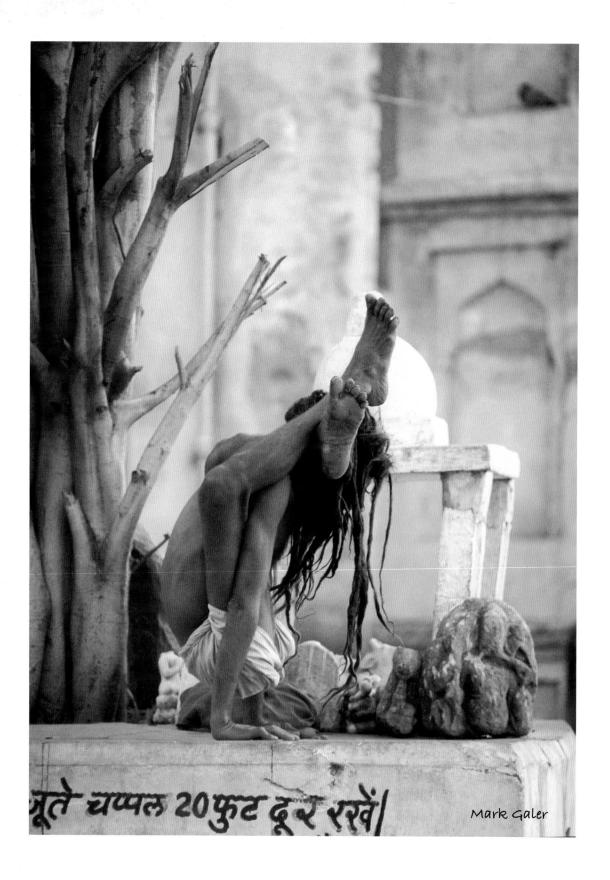

the photographic essay

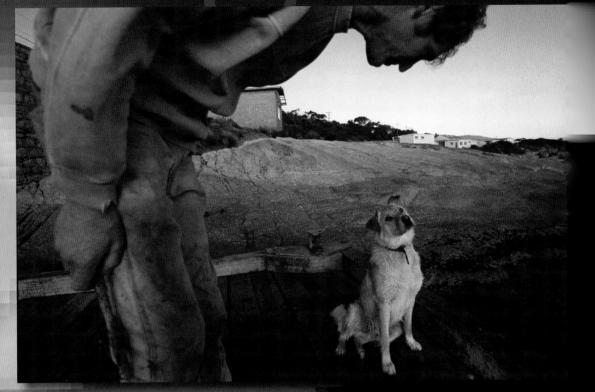

Orien Harvey

essential skills

- Increase knowledge of the historical development of the photographic essay.
- Understand visual communication through narrative techniques.
- Develop an awareness of receptive and projective styles of photography.
- Understand the process of editing to clarify or manipulate communication.
- Increase awareness of commercial, ethical and legal considerations.
- Capture and/or create in ages to communicate a specific parrative and edit the

Introduction

The purpose of constructing a photographic essay is to communicate a story through a sequence of images to a viewer. Just as in writing a book, a short story or a poem, the photographer must first have an idea of what they want to say. In a photographic essay it is the images instead of words that must be organized to tell the story. Individual images are like descriptive and informative sentences. When the images are carefully assembled they create a greater understanding of the individual, event or activity being recorded than a single image could hope to achieve. Words should be seen as secondary to the image and are often only used to clarify the content.

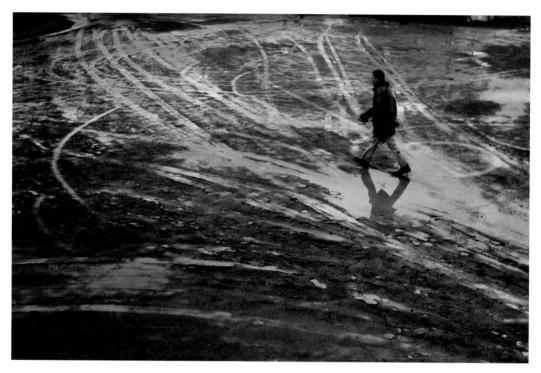

Orien Harvey

The first stories

In 1890 the photographer Jacob Riis working in New York produced one of the earliest photographic essays titled 'How the other half lives'. *National Geographic* magazine began using photographs in 1903 and by 1905 they had published an eleven-page photographically illustrated piece on the city of Lhasa in Tibet. In 1908 the freelance photographer Lewis W. Hine produced a body of work for a publication called *Charities and the Commons*. The photographs documented immigrants in the New York slums. Due to the concerned efforts of many photographers working at this time to document the 'human condition' and the public's growing appetite for the medium, photography gradually became accepted. The first 'tabloid newspaper' (the *Illustrated Daily News*) appeared in the USA in 1919. By this time press cameras were commonly hand-held and flash powder made it possible to take images in all lighting conditions.

'I saw and approached the hungry and desperate mother, as if drawn by a magnet. I do not remember how I explained my presence or my camera to her, but I do remember she asked me no questions. I made five exposures, working closer and closer from the same direction. I did not ask her name or her history. She told me her age, that she was thirty-two. She said that they had been living on frozen vegetables from the surrounding fields, and birds that the children killed. She had just sold the tires from her car to buy food. There she sat in that lean-to tent with her children huddled around her, and seemed to know that my pictures might help her, and so she helped me. There was a sort of equality about it.

Dorothea Lange, from: Popular Photography, Feb. 1960.

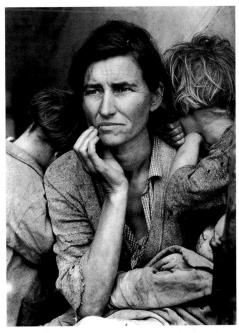

Migrant Mother - Dorothea Lange

FSA

The 1930s saw a rapid growth in the development of the photographic story. During this decade the Farm Security Administration (FSA) commissioned photographers to document America in the grip of a major depression. Photographers including Russell Lee, Dorothea Lange, Walker Evans and Arthur Rothstein took thousands of images over many years. This project provides an invaluable historical record of culture and society whilst developing the craft of documentary photography.

The photo agencies

In the same decade *Life* magazine was born along with a host of like-minded magazines. These publications dedicated themselves to showing 'life as it is'. Photographic agencies were formed in the 1930s and 1940s to help feed the public's voracious appetite for news and entertainment. The greatest of these agencies, Magnum, was formed in 1947 by Henri Cartier-Bresson, Robert Capa, Chim (David Seymour) and George Rodger. Magnum grew rapidly with talented young photographers being recruited to their ranks. The standards for honesty, sympathetic understanding and in-depth coverage were set by such photographers as W. Eugene Smith. Smith was a *Life* photographer who produced extended essays, staying with the story until he felt it was an honest portrayal of the people he photographed. He went on to produce the book *Minamata* about a small community in Japan who were being poisoned by toxic waste being dumped into the waterways where the people fished. This was and remains today an inspirational photo-essay.

Practical activity

Find a photographic story that was captured by either an FSA photographer or a photographer working for the Magnum photo agency.

What do the images communicate about the human condition?

Visual communication

Photographic stories are the visual communication of personal experience; as such, each story is potentially unique and is the ideal vehicle for personal expression. To communicate coherently and honestly the photographer must connect with what is happening. To connect the photographer should research, observe carefully, ask questions and clarify the photographer's personal understanding of what is happening. Unless the photographer intends to make the communication ambiguous it is important to establish a point of view or have an 'angle' for the story. This can be achieved by acknowledging feelings or emotions experienced whilst observing and recording the subject matter. All images communicate and most photographers aim to retain control of this communication. Photography can be used as a powerful tool for persuasion and propaganda and the communication of content should always be the primary consideration of the photographer.

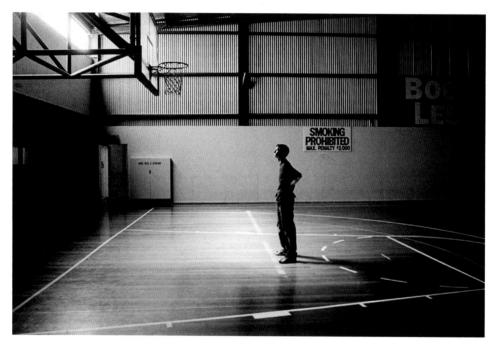

Kim Noakes

Choosing a subject

The most popular subject for the photographic story has always been the 'human condition'. This is communicated through experience-based discovery. The aim is to select one individual or group of individuals and relate their story or life experience to the viewer. The story may relate the experience of a brief or extended period of time.

Finding a story, gaining permission to take images and connecting with the individuals once permission has been granted are some of the essential skills required to produce a successful story. Tracking down a story often requires curiosity, perseverance, motivation and patience. These skills are required by the majority of professional photojournalists who are freelance. Freelance photographers find, document and sell their own stories.

The comfort zone

The 'comfort zone' is a term used to describe the familiar surroundings, experiences and people that each of us feel comfortable in and with. They are both familiar and undemanding of us as individuals. Photography is an ideal tool of exploration which allows us to explore environments, experiences and cultures other than our own. For professional photojournalists this could be attending the scene of a famine or a Tupperware party.

Photographer's may feel they have to travel great distances in order to find an exotic or unusual story. Stories are, however, much closer at hand than most people realize. Interesting stories surround us. Dig beneath the surface of any seemingly bland suburban population and the stories will surface. People's triumphs, tragedies and traumas are evolving every day, in every walk of life. The interrelationships between people and their environment and their journey between birth and death are the never ending, constantly evolving resource for the documentary photographer. The photographer's challenge is to find and connect in a non-threatening and sympathetic way to record this. The photojournalist should strive to leave their personal 'comfort zone' in order to explore, understand and document the other. Photographer's should aim to become proactive rather than waiting to become inspired and find out what is happening around them.

Dorothy Connop

Practical activity

Find a meaningful photographic story containing at least four images.

What is being communicated by the story?

Have the captions influenced your opinion about what is happening?

Could a different selection of images alter the possible communication?

Make a list of photo-essays you could make in your own home town.

Describe briefly what you would hope to find out and communicate with your images.

Capturing a story

How many movies have you seen where the opening scene begins with a long and high shot of a town or city and moves steadily closer to isolate a single street or building and then a single individual. This gives the viewer a sense of the place or location that the character inhabits. A story constructed from still images often exploits the same technique. To extend and increase the communication of a series of images the photographer should seek to vary the way in which each image communicates. There is a limit to the communication a photographer can achieve by remaining static, recording people from only one vantage point. It is essential that the photographer moves amongst the people, exploring a variety of distances from the subject. Only in this way will the photographer and the viewer of the story fully appreciate and understand what is happening.

The photographer should aim to be a witness or participant at an activity or event rather than a spectator.

Vietnam Vet Motorcycle Club at the Shrine of Remembrance, Melbourne

The images that create a well-crafted photographic story can usually be divided or grouped into four main categories. Not all stories contain images from all four categories but many editors expect to see them. The categories are:

- 1. Establishing image.
- 2. Action image.
- 3. Portraits.
- 4. Close-up or detail image.

Establishing image

In order to place an event, activity or people in context with their environment it is important to step back and get an overview. If the photographer's essay is about a small coal-mining community in a valley, the viewer needs to see the valley to get a feeling for the location. This image is often referred to as the establishing image but this does not necessarily mean that it is taken or appears first in the story. Often the establishing image is recorded from a high vantage point and this technique sets the stage for the subsequent shots. In many stories it can be very challenging to create an interesting establishing image. An establishing image for a story about an animal refuge needs to be more than just a sign in front of the building declaring this fact. The photographer may instead seek out an urban wasteland with stray dogs and the dog catcher to set the scene or create a particular mood.

Coal mine in the Rhondda valley

Action image

This category refers to a medium-distance image capturing the action and interaction of the people or animals involved in the story. Many of the images the photographer captures may fall into this category, especially if there is a lot happening. It is, however, very easy to get carried away and shoot much more than is actually required for a story to be effective. Unless the activity is unfolding quickly and a sequence is required the photographer should look to change the vantage point frequently. Too many images of the same activity from the same vantage point are visually repetitive and will usually be removed by an editor.

Portraits

Portraits are essential to any story because people are interested in people and the viewer will want to identify with the key characters of the story. Unless the activity the characters are engaging in is visually unusual, bizarre, dramatic or exciting the viewer is going to be drawn primarily to the portraits. The portraits and environmental portraits will often be the deciding factor as to the degree of success the story achieves. The viewer will expect the photographer to have connected with the characters in the story and the photographs must illustrate this connection. Portraits may be made utilizing a variety of different camera distances. This will ensure visual interest is maintained. Environmental portraits differ from straight head and shoulder portraits in that the character is seen in the location of the story. The interaction between the character and their environment may extend the communication beyond making images of the character and location separately.

Orien Harvey

Close-up or detail image

The final category requires the photographer to identify significant detail within the overall scene. The detail is enlarged either to draw the viewer's attention to it or to increase the amount or quality of this information. The detail image may be required to enable the viewer to read an inscription or clarify small detail. The detail image in a story about a craftsperson who works with their hands may be the hands at work, the fine detail of the artifact they have made or an image of a vital tool required for the process. When the detail image is included with images from the other three categories visual repetition is avoided and the content is clearly communicated.

Practical activity

Find a photographic story that contains images from all four categories listed. How does each image contribute to the story?

Consider alternative images for each of the categories in the story.

Working styles

The photographer working on a story often has to switch between creating images (portraits, overall and detail images) and capturing images (action or decisive images). The styles of working are very different, each requiring a different mind-set, and photographers can find the switch between the two uncomfortable. Many photographers tackle the different images required for a photographic essay separately rather than alternating between the two styles of work.

Receptive

Decisive images and action shots require a receptive approach where the photographer is focused solely on the environment and the activities, facial expressions or mannerisms of the characters. The photographer working receptively is not looking for specific images but is accepting circumstances 'as they are'. Photographers aim to increase their awareness of the activities and their surroundings as they change or unfold, many of the resulting images being photographed 'intuitively'. The ability to photograph intuitively rests on the degree of familiarity photographers have with their equipment. Many professional photojournalists are able to operate their cameras instinctively without even looking to change shutter, aperture and exposure compensation controls. The camera becomes an extension of the hand and eye and the photographer is primarily concerned with seeing images rather than with the equipment necessary to capture them.

Moving in close

The standard equipment for a photojournalist is a DSLR camera equipped with a wide-angle lens. Many photographers choose a fixed focal length lens rather than a zoom for the advantage that the wider maximum apertures afford in low light. Wide-angle lenses are chosen above standard and telephoto lenses due to the steep or dramatic perspective they give the images when working very close to the subject (see page 83). The steep perspective and the relative position of the photographer to the action has the effect of involving the viewer. Viewers feel like participants rather than spectators.

Practical activity

Find a photographic essay where the photographer has made extensive use of a wide-angle lens. Consider the composition and communication of each image.

Without resorting to the use of telephoto lenses, take ten images of people engaged in a group activity.

Create depth by the use of foreground, middle distance and distant subject matter.

Make use of edge of frame detail to create the feeling of involvement.

The photographer's presence

When the photographer is working at close range it is worth considering the impact this presence has on the event or activity being photographed. Most photojournalists practice the art of working unobtrusively to minimize the effect on their surroundings. This can be achieved in the following ways:

- Raise the camera to take the image not to find the image.
- Be decisive, don't procrastinate.
- Minimize the amount of equipment being carried two bodies and three lenses is sufficient.
- Carry the camera in the hand rather than around the neck use a wrist strap or the neck strap wrapped around the wrist.
- Reduce the size of the camera bag and do not advertise the cameras that are inside.
- Use the available light present use a high ISO, image stabilization and fast lenses rather than flash.
- Choose appropriate clothing for the location or company that you are in.
- Move with the activity.
- Familiarize yourself with the location and/or the people prior to capturing the images.

Shooting ratios

A photographer capturing images spontaneously should not expect to contribute all of the images to the final story. This will lead to undershooting and missed opportunities. The photographer cannot hope to wait for the single most dramatic moment of the event or activity before releasing the shutter. This would lead to a projective approach that is used when a photographer is creating rather than capturing images. The photographer cannot control events, only predict them as they are about to happen. Recording images as an event unfolds or as the photographer changes vantage point means that many images will be captured that will be not be used. This is called a 'shooting ratio'. For every image used, ten may be discarded as unnecessary to the narrative of the story (a shooting ratio of 1:10). The value of each image is not assessed as it is captured but later during the editing process. The unused images are not to be seen as wasted or failed images but as part of the working process of photojournalism.

Practical activity

Make a list of the ideal range of equipment you would take to record a crowded event in a foreign country where spontaneous and decisive images are required.

List brand names and the cost of each item new or second-hand.

List the cost of insuring these items against 'all risks' and theft from a locked room or vehicle. How would you review the images on location at the end of each day to monitor your progress?

Projective

In creating images the photographer is able to plan and arrange either the timing, the subject matter or location so that the resulting imagery fits the photographer's requirements for communication of content. Photographers illustrate what is often in their mind's eye. To create images in collaboration with the characters of the story a connection must be made. For this to happen the photographer must overcome the fear that most people have about talking to strangers. It is a little like door-to-door sales. The first contact is always the most nerve racking. The more you connect, the easier it becomes.

Shane Bell

An honest document

Some people find the projective approach (used by many photojournalists) controversial, and do not like the degree of manipulation involved in assembling a story which is claiming to be an accurate and honest record or document. On the other hand all photographs are a manipulation of reality to some degree. The selection of timing and framing is a manipulation in itself. As soon as a character within a story makes eye contact with the photographer the event has been changed or manipulated. Without manipulation and interaction the resulting stories can appear detached and shallow. Each individual photographer must weigh up the advantages and disadvantages of working in a projective style. The photographer must personally feel comfortable that the story being created is an accurate translation of events, people and circumstances. Photographs are, however, just that, a translation, and each storyteller will tell their tale differently.

Editing a story

The aim of editing work is to select a series of images from the total production to narrate an effective story. Editing can be the most demanding aspect of the process, requiring focus and energy. The process is a compromise between what the photographer originally wanted to communicate and what can actually be said with the images available.

Editorial objective

The task of editing is often not the sole responsibility of the photographer. The task is usually conducted by an editor or in collaboration with an editor. The editor considers the requirements of the viewer or potential audience whilst selecting images for publication.

The editor often has the advantage over the photographer in that they are less emotionally connected to the content of the images captured. The editor's detachment allows them to focus on the ability of the images to narrate the story, the effectiveness of the communication and the suitability of the content to the intended audience.

The process

Images are viewed initially as a collective. A typical process is listed as follows:

- All images are viewed as thumbnails in the image-editing software.
- All of the visually interesting images and informative linking images are selected or ranked and the rest are hidden from view.
- Similar images are grouped together and the categories (establishing, action, portrait and detail) are formed.
- Images and groups of images are placed in sequence in a variety of ways to explore possible narratives.
- The strength of each sequence is discussed and the communication is established.
- Images are selected from each category that reinforce the chosen communication.
- Images that contradict the chosen communication are removed.
- Cropping and linking images are discussed and the final sequence established.

Practical activity

Capture at least 20 images of a chosen activity or event, taking care to include images from all of the four categories discussed in this chapter.

Edit the work with someone who can take on the role of an editor.

Edit and sequence the images to the preference of the photographer and then again to the preference of the editor.

Discuss the editing process and the differences in outcome of both the photographer's and editor's final edit.

Ethics and law

Will the photograph of a car crash victim promote greater awareness of road safety, satisfy morbid curiosity or just exploit the family of the victim? If you do not feel comfortable photographing something, question why you are doing it. A simple ethical code of practice used by many photographers is: 'The greatest good for the greatest number of people.' Paparazzi photographers hassle celebrities to satisfy public curiosity and for personal financial gain. Is the photographer or the public to blame for the invasion of privacy? The first legal case for invasion of privacy was filed against a photographer in 1858. The law usually states that a photographer has the right to take a picture of any person whilst in a public place so long as the photograph:

- is not used to advertise a product or service;
- does not portray the person in a damaging light (called defamation of character).

If the photographer and subject are on private property the photographer must seek the permission of the owner. If the photograph is to be used for advertising purposes a model release should be signed.

Other legal implications usually involve the sensitivity of the information recorded (military, political, sexually explicit, etc.) and the legal ownership of copyright. The legal ownership of photographic material may lie with the person who commissioned the photographs, published the photographs or the photographer who created them. Legal ownership may be influenced by country or state law and legally binding contracts signed by the various parties when the photographs were created, sold or published.

Digital manipulation

Original image files may never be sighted by an editor. A photographer, agency or often the publication itself may enhance the sharpness, increase the contrast, remove distracting backgrounds, remove information or combine several images to create a new image. What is legally and ethically acceptable is still being established in the courts of law. The limits for manipulation often rest with the personal ethics of the people involved.

Interpreting reality

Photographs interpret reality and can often distort reality when the context (time and place) surrounding the image is removed from view. When the camera is used to document a 'slice of life' for the press, people usually expect to view these images as an accurate document. Photojournalists are free to frame, crop and wait for the decisive moment when the subject matter within frame communicates the photographer's point of view or aesthetic tastes. Photographers are also free to remove color holistically, or selectively, dodge and burn and edit their images to the precise number that communicates the correct 'point of view'.

Photography by Abhijit Chattaraj

What we see above is a montage or composite image. It is a construct of several images captured moments apart. The image is no longer a frozen moment but a record of the passage of time over a fleeting moment. Some would argue that this could represent a more accurate document of this time and place. It is, however, no longer a single decisive moment but the decisive moments over a period of time that the photographer feels best represents this time and place. Everybody represented in this image are exactly where they were at the moment the camera shutter was released. It is just that the camera shutter was released three times instead of once.

Practical activity

Consider the following ethical dilemma for a photographer or picture editor:

There are repeated stories of incidences where the photographer has interacted with the subject he or she is documenting to create a 'better' picture. Photographers have restaged events, moved people or items within the frame to enhance the composition or communication. Does the photographer, however, 'cross the line' between what is acceptable and what is unacceptable when the manipulation is carried out in post-production image-editing software?

Distribution and sale of photo-essays

The majority of photojournalists are either freelance or work for agencies. Freelance photographers are commissioned to cover stories for a wide variety of media and corporate publications. Photojournalists also self-assign. They seek out and research possible commercial stories and then sell the finished piece to a publication. Many photographers contact publications with the idea or concept for a story before taking the images. They complete the story when they find a publication interested in the idea. Newspapers cannot hope to cover all world news and feature stories using staff photographers only. They therefore rely heavily on input from freelance photographers. The

material is brought in from photo and news agencies, wire services, stock libraries and through

In order to succeed, a freelance photojournalist usually requires the following skills:

- Curiosity, self-motivation and patience to find and complete a story.
- Knowledge of publications currently buying photographic material (a media directory with contact names, addresses and circulation is usually available in large libraries).
- Commercial requirements for stories (these include image format, publication deadlines, content, length, style and copy).

Titles and copy

All images require an image description prior to submission. This can be achieved by entering metadata into the image files using your editing software. Metadata should include the following information:

- Location and date.
- A brief description of the content including names of people.
- Photographer's name.

direct contact with photographers.

Contact details and copyright information

Accompanying copy is sometimes prepared by a staff writer working from the factual information provided by the photographer or is submitted by the photographer along with the images. Photographers often team up with a writer on projects and submit the work as a team effort. The average length of each story and the style for written copy (humorous, factual, etc.) need to be researched prior to submission.

Practical activity

Research possible distribution and sale of a photo-essay.

Locate a local photo agency, stock library and photographic archive.

Research the possibility of submitting one essay or image to a magazine to which you currently subscribe.

Assignments

Produce a ten-image photo-essay giving careful consideration to communication and narrative technique. For each of the five assignments it is strongly recommended that you:

- Treat each assignment as an extended project.
- Choose activities, events or social groups that are repeatedly accessible.
- ~ Avoid choosing events that happen only once or run for a short period of time.
- Approach owners of private property in advance to gain relevant permission.
- Have a back-up plan should permission be denied.
- Introduce yourself to organizers, key members or central characters of the story.
- 1. Document manual labor or a profession.
- 2. Document a minority, ethnic or fringe group in society.
- 3. Document an aspect of modern culture.
- 4. Document an aspect of care in the community.
- 5. Document a political or religious group.

Resources

Books:

American Photographers of the Depression - Charles Hagen. Thames & Hudson. 1991.

Don McCullin (Photofile). Thames & Hudson. 2008.

Farewell to Bosnia - Gilles Peress. Scalo. New York. 1994.

In This Proud Land - Stryker and Wood. New York Graphic Society. New York. 1973.

Minamata - W. Eugene and Aileen Smith. Chatto & Windus. London. 1975.

W. Eugene Smith (Aperture Masters of Photography). Aperture. 2005

Terra: Struggle of the Landless - Sebastião Salgado. Phaidon Press. 1998.

The Concerned Photographer 2 - Cornell Capa. Thames & Hudson. 1972.

Dorothea Lange: The Photographs of a Lifetime. Aperture. 2005.

Workers - Sebastião Salgado. Aperture. London. 2005.

Magazine:

National Geographic magazine.

Websites:

Black Star photo agency - http://www.blackstar.com

FSA - http://lcweb2.loc.gov/ammem/fsowhome.html

Magnum Photo Agency - http://www.magnumphotos.com

VERY R DEWEY DIMMY D HUMPHRES GERALD WIDESTEEL TOM RADIER TOHN H GRUBER BANDAR (S) MICHAELD RIDDLE, MEIVIN ROBINSON, IERONIWESTE ROBERT L BROWN - STEPHEN CHAVIEN JOSEPHO THOMAS G BLAIR JE STEPHEN GDAVIES (D. 1911 · ROBERT K CAIN II - ERVIN B CHERY SAIL · STEVEN J KLAKNS / CINION AND · ROBERT DIMERINATION · ROBERT P SANCHEZ IF A HELL · JAMES W AND S. R. LARRY LEE MILLERS TO THE STORY OF THE STATE OF BILLY HWATT STORY OF THE STATE OF TH ... HAROLD E BARNARD . CALL W BOKCHERS . WARTE LOUIE G MO · RICHARD J GR LEONARD L BROENN FLOYD BRADSHAW Mark Galer

Glossary

ACR

Adjustment layer

Ambient

Analyze Aperture

Aspect ratio Auto focus Available

ACK

Adobe Camera Raw.

Image adjustment placed on a layer above the background layer.

Available or existing light.

To examine in detail.

Lens opening controlling intensity of light entering camera.

The ratio of height to width. Automatic focusing system. Ambient or existing light.

Background

Backlight

Backlit Balance

Banding

Bit Bit depth

Blend mode

Blurred

Body copy

Bounce Bracketing

Brightness value

Byte

Area behind main subject matter.

Light source directed at the subject from behind.

A subject illuminated from behind.

A harmonious relationship between elements within the frame. Visible steps of tone or color in the final image due to a lack of

tonal information in a digital image file.

Short for binary digit, the basic unit of the binary language. Number of bits (memory) assigned to recording color or tonal

information.

The formula used for defining the mixing of a layer with those

beneath it.

Unsharp image, caused by inaccurate focus, shallow depth

of field, slow shutter speed, camera vibration or subject

movement.

Written word, main content of advertisement.

Reflected light.

Overexposure and underexposure either side of MIE.

The value assigned to a pixel to define the relative lightness of

a pixel.

Eight bits. Standard unit of data storage containing a value

between 0 and 255.

Cable release

Camera Camera Raw

Camera shake CCD

Channel

Cloning tool

Device to release shutter, reduces camera vibration.

Image capturing device.

Unprocessed image data from a camera's image sensor. Blurred image caused by camera vibration during exposure. Charge Coupled Device. A solid-state sensor used in digital

image capture.

A division of color or luminance data.

A tool used for replicating pixels.

Close down Decrease in aperture size.

Closest point of focus Minimum distance at which sharp focus is obtained.

CMOS A type of image sensor used in digital cameras.

CMYK Cyan, Magenta, Yellow and black (K). The inks used in four-

color printing.

Color balance Photoshop adjustment feature for correcting a color cast in a

digital image file.

Color fringing Bands of color on the edges of lines within an image.

Color gamut The range of colors provided by a hardware device, or a set of

pigments.

Color Picker Dialog box used for the selection of colors.

Compensation Variation in exposure from MIE to obtain appropriate exposure.

Complementary Color - see *Primary* and *Secondary*.

Composition The arrangement of shape, tone, line and color within the

boundaries of the image area.

Compression A method for reducing the file size of a digital image.

Concept Idea or meaning.

Context Circumstances relevant to subject under consideration.

Continuous tone An image containing the illusion of smooth gradations between

highlights and shadows.

Contrast The difference in brightness between the darkest and lightest

areas of the image or subject.

CPU Central Processing Unit of a camera used to compute exposure.

Crop Alter image format to enhance composition.

Curves Control in the full version of Adobe Photoshop for adjusting

tonality and color.

Dedicated flash Flash regulated by camera's exposure meter.

Depth of field (DOF)

Area of sharpness variable by aperture or focal length.

Design Basis of visual composition.

Diagonal A line neither horizontal nor vertical.

Differential focusing Use of focus to highlight subject areas.

Diffuse Dispersion of light (spread out) and not focused.

Diffuser Material used to disperse light.

Digital Images recorded in the form of binary numbers.

Digital image Computer-generated image created with pixels, not film.

Dioptres Close-up lenses.

Direct light

Distortion

Distortion

Lens aberration or apparent change in perspective.

A camera Raw file format developed by Adobe.

DOF Area of sharpness variable by aperture or focal length.

DPI Dots Per Inch. A measurement of resolution.

DSLR camera Digital Single Lens Reflex camera.

Dynamic

Visual energy.

Dynamic range

The ability of the image sensor to record image detail across the subject brightness range. This is often expressed in f-stops.

Edit

To select images from a larger collection to form a sequence or theme or to optimize, enhance or manipulate an image using

editing software.

Electronic flash

Mobile 5800K light source of high intensity and short duration.

Evaluate

Estimate the value or quality of a piece of work.

EVE

Electronic ViewFinder.

Exposure

Combined effect of intensity and duration of light on light-

sensitive material.

Exposure compensation

To increase or decrease the exposure from a meter-indicated

exposure to obtain an appropriate exposure.

Exposure meter

Device for the measurement of light.

Exposure value

Numerical values used in exposure evaluation without reference

to aperture or time.

Extreme contrast

Subject brightness range that exceeds the image sensor's

ability to record all detail.

F-stop Fast lens Numerical system indicating aperture diameter. Lens with a large lens opening (small f-stop).

Feather

The action of softening the edge of a digital selection.

Figure and ground

Relationship between subject and background.

File format

The code used to store digital data, e.g. TIFF or JPEG.

File size

The memory required to store digital data in a file.

Fill

Use of light to increase detail in shadow area. Flash used to lower the subject brightness range.

Fill flash Filter

Optical device used to modify transmitted light.

Fixed lens camera

Non-DSLR camera where the lens cannot be removed.

Flare Flash Unwanted light entering the camera and falling on image plane. Mobile 5800K light source, high intensity, short duration.

Focal plane shutter

Shutter mechanism next to image plane.

Focal point

Point of focus at the image plane or point of interest in the

image.

Focusing

Creating a sharp image by adjustment of the lens to sensor

distance.

Foreground

Area in front of subject matter.

Format

Image area or orientation of camera.

Frame Front light Boundary of composed area. Light from camera to subject.

Gaussian Blur A filter used for defocusing a digital image.

Genre Style or category of photography.

Gigabyte A unit of measurement for digital files, 1024 megabytes.
Gray card Contrast and exposure reference, reflects 18% of light.

Grayscale An 8-bit image used to describe monochrome (black and white)

images.

Guide number Measurement of flash power relative to ISO and flash to subject

distance.

Halftone Commercial printing process, reproduces tone using a pattern

of dots printed by offset litho.

Hard/harsh light Directional light with defined shadows.

High Dynamic Range (HDR) An image created from multiple exposures where the subject

brightness range exceeded the latitude of the image sensor.

High key Dominant light tones and highlight densities.

Highlight Area of subject giving highest exposure value.

Histogram A graphical representation of a digital image indicating the

pixels allocated to each level of brightness.

Hot shoe Mounting position for on-camera flash.
Hue The name of a color, e.g. red or green.

Hyperfocal distance Nearest distance in focus when lens is set to infinity.

ICC profile A color profile embedded into the digital image file to ensure

color consistency.

Image sensor Light-sensitive digital chip used in digital cameras.

Image size The pixel dimensions, output dimensions and resolution used to

define a digital image.

Incandescent Tungsten light source.

Infinity Point of focus where bellows extension equals focal length.

Infrared Wavelengths of light longer than 720nm invisible to the human eye.

Interpolation A method of resampling the image to alter its pixel dimensions.

Inverse square law Mathematical formula for measuring the fall-off (reduced

intensity) of light over a given distance.

IPTC Metadata information standard designed by the International

Press and Telecommunications Council.

Iris Aperture/diaphragm.

ISO Sensitivity rating - International Standards Organization.

JPEG (.jpg) Joint Photographic Experts Group. Popular image compression

file format used for images destined for the World Wide Web.

Key light

Main light source relative to lighting ratio.

Landscape

Horizontal format.

Latitude

Image sensor's ability to record the brightness range of a

subject.

Layer

A feature in digital editing software that allows a composite

Layer mask

digital image where each element is on a separate layer.

A mask attached to an adjustment layer that is used to define the visibility of the adjustment. It can also be used to limit the

visibility of pixels on the layer above if that layer is grouped or

clipped with the adjustment layer.

LCD

Liquid Crystal Display.

LED

Light Emitting Diode. Often used in the camera's viewfinder to

inform the photographer of the camera's settings.

Lens

Optical device used to bring an image to focus at the image

plane.

Lens angle

Angle of lens to subject.

Lens hood Levels Device to stop excess light entering the lens. Shades of lightness or brightness assigned to pixels.

Light

The essence of photography.

Light meter

Device for the measurement of light. Difference between highlights and shadows.

Lighting contrast Lighting ratio

Balance and relationship between light falling on subject.

Long lens Low key Lens with a reduced field of view compared to normal. Dominant dark tones and shadow densities.

Luminance range

Range of light intensity falling on subject.

Macro

Extreme close-up.

Magic Wand tool

Selection tool used in digital editing.

Matrix metering

Reflected meter reading averaged from segments within the image area. Preprogrammed bias given to differing segments.

Maximum aperture

Largest lens opening, smallest f-stop.

Megapixels

More than a million pixels.

Memory card

A removable storage device about the size of a small card.

Meter

Light meter.

MIE Minimum aperture Meter Indicated Exposure.

Minimum aperture Movement blur Smallest lens opening, largest f-stop. Blur created by using a slow shutter speed.

Multiple exposure

More than one exposure in the same image file.

ND filter

Neutral Density filter.

Neutral density

Filter to reduce exposure without affecting color.

Noise

Electronic interference producing speckles in the image.

Normal lens

Perspective and angle of view approximately equivalent to the

human eye.

Objective

Factual and non-subjective analysis of information.

Opaque Open up Does not transmit light.

Optimize

Increase lens aperture size. The process of fine-tuning the file size and display quality of an

Out of gamut

Beyond the scope of colors that a particular device can create,

reproduce or display.

Overall focus

Image where everything appears sharp.

Exposure greater than meter-indicated exposure. Overexposure

Panning

Camera follows moving subject during exposure.

Perspective

The illusion of depth and distance in two dimensions. The

relationship between near and far imaged objects. Image created by the action of light and chemistry.

Photograph Pixel

The smallest square picture element in a digital image.

Pixellated

An image where the pixels are visible to the human eye and

curved or diagonal lines appear jagged or stepped.

Plane

Focal plane.

Polarizing filter Portrait

A filter used to remove polarized light. Type of photograph or vertical image format.

Post-production editing

Image enhancement or manipulation in editing software.

Posterization

Visible steps of tone or color in the final image due to a lack of

tonal information in a digital image file.

Preview

Observing image at exposure aperture.

Previsualize

The ability to decide what the photographic image will look like

before the exposure.

Primary colors

The colors red, green and blue.

Raw

The unprocessed data recorded by a digital image sensor.

Sometimes referred to as camera Raw or the 'digital negative'.

Reflected Reflection Light coming from a reflective surface. Specular image from a reflective surface.

Reflector

Material used to reflect light.

Refraction

Deviation of light.

Resample

To alter the total number of pixels describing a digital image.

Resolution

RGB

Optical measure of definition, also called sharpness.

Red, green and blue. The three primary colors used to display

images on a color monitor.

Sample

To select a color value for analysis or use.

Saturation

Intensity or richness of color.

SBR

Subject Brightness Range, a measurement of subject contrast.

Scale

Size relationship within subject matter.

Secondary colors Selective focus

Complementary to primary colors, yellow, magenta, cyan. Use of focus and depth of field to emphasize subject areas.

Shadow

Unlit area within the image.

Sharp

In focus.

Shutter

Device controlling the duration (time) of exposure.

Shutter priority

Semi-automatic exposure mode. The photographer selects the

shutter and the camera sets the aperture automatically. Specific time selected for correct exposure.

Shutter speed

Light from side to subject.

Side light Silhouette

Object with no detail against background with detail.

SLR

Single Lens Reflex camera; viewfinder image is an optical view of

the framed image.

Softbox

Heavily diffuse light source.

Soft light

Diffuse light source with ill-defined shadows.

Specular

Highly reflective surfaces.

Speed

ISO rating, exposure time relative to shutter speed.

Spot meter

Reflective light meter capable of reading small selected areas.

Standard lens

Perspective and angle of view equivalent to the eye.

Stop

Selected lens aperture relative to exposure.

Stop down

Decrease in aperture size.

Subject reflectance

Main emphasis within image area. Amount of light reflected from the subject.

Subjective

Interpretative and non-objective analysis of information.

Symmetrical

Image balance and visual harmony.

Sync

Flash sychronization.

Sync lead Sync speed

Cable used to synchronize flash. Shutter speed designated to flash.

System software

Computer operating program, e.g. Windows or Mac OS.

Thyristor TIFF

Electronic switch used to control electronic flash discharge. Tagged Image File Format. Popular digital image file format for

desktop publishing applications.

Time

Shutter speed, measure of duration of light.

Tonal range

Difference between highlights and shadows.

Tone

A tint of color or shade of gray.

Transmitted light

Light that passes through another medium.

Transparent

Allowing light to pass through.

Tripod

Camera support.

TTL

Through The Lens light metering system.

Tungsten light

3200K light source.

Unsharp Mask

See USM.

URL

Uniform Resource Locator. A unique web address given to each

web page.

USB

Universal Serial Bus. A computer interface for connecting

peripheral devices such as cameras.

USM UV Unsharp Mask. A software filter used to sharpen images.

Ultraviolet radiation invisible to the human vision.

Vertical

At right angles to the horizontal plane.

Viewpoint

Camera to subject position.

Visualize

Ability to exercise visual imagination.

Wide angle

Lens with a greater field of view than normal.

Workflow

Series of repeatable steps required to achieve a particular result

within a digital imaging environment.

X-sync.

Synchronization setting for electronic flash.

X-sync. socket

Co-axial socket on lens or camera for external flash cable.

Zoom tool

A tool used for magnifying a digital image on the monitor.

Index

18% gray card (exposure compensation), 100	Bracketing exposure, 100, 122
	Brandt, Bill, 60
Accuracy of printers, 165	Bridge cameras, 14
ACR see Adobe Camera Raw	Brightness, 96, 135
Action images, 207	Broken line, 67
Adams, Ansel:	
'Realism', 172	Camera shake, 80
references, 186	Canon cameras:
'The Zone system', 121	DSLR development, 3
Adobe Camera Raw (ACR) format:	megapixels, 5
data processing, 51	sensors, 6
dynamic range, 7, 53	speed, 13
'exposing right', 55, 57	Capa, Robert, 203
exposure, 50, 53, 54-7	Cartier-Bresson, Henri, 65, 203
interface, 7	Catalog combining in Lightroom, 32
multiple exposures, 57	Caucasian skin (exposure compensation), 100
noise suppression, 11	CCD (charge coupled devices) sensors:
sharpening, 145	aspect ratio, 6
speed, 13	image stabilization, 19
Adobe Photoshop see Photoshop	night photography, 184
Adobe RGB (1998) settings, 159	Nikon cameras, 3
Adobe RGB profile in Photoshop, 163	noise in images, 10
Allard, William Albert, 62	shadow management, 52
Alternative realities in landscape, 175	Centre-weighted metering, 42
Aperture role in exposure, 36, 43	Characters in environmental portraits, 194, 198
Appropriate exposure, 37	Chattaraj, Abhijit, 214, 218
Archiving in Lightroom, 32	Choice of digital cameras, 4
Aspect ratio, sensors, 6	Chromatic Aberration option, 146
Aspect Ratio option, 148	Clarity settings, 137-8
Asset management:	Close-up image, 208
Digital, 22	Closed landscape, 178
Lightroom 22, 23-4, 25-32	CMOS sensors:
Auto Tone option, 12	digital cameras, 3
Automatic flash units, 110	image stabilization, 19
Automatic TTL exposure, 42	ISO settings, 9
Average tones (exposure), 45	shadow management, 52
	Color:
Back lighting compensation, 101	correction, 93
Balance (framing the image), 63	exposure, 49
Banding:	light, 93
colors, 165	Color management:
exposure, 52, 57	Photoshop, 164
noise, 10	printers, 158-9
Barker, Tim, 79	printing, 155
'Before & After' option, 135	Comfort zone in visual communication, 205
Bell, Shane, 109, 211	Communication (framing the image), 61
Black Star Photo Agency, 216	Compare View option, 136
Blakemore, John, 174, 186	Compatibility in Photoshop, 24
Bounce flash for lighting on location, 115	Composing two or more people, environmental portraits, 192

Composition for landscape, 178	Chromatic Aberration option, 146
Compression of perspective, 83	Clarity settings, 137-8
Connection with subject for environmental portraits, 195	Compare View option, 136
Connop, Dorothy:	contrast, 135
asset management, 34	Detail option, 143
comfort zone, 205	Expodisc, 131
creative controls, 85	exposure, 131-3
direction of subject, 197	fill light option, 134
post-production editing, 152	Grayscale, 140-1
printing, 153	Luminance noise, 144
Connop-Galer, Matthew, 183	presence, 137-8
Constable, John, 171	Raw Format, 145
Constructed environment, 185	Sharpening option, 145
Contact with subject for environmental portraits, 196	Show Clipping option, 132-3
Content (framing the image), 62	Split Toning option, 142
Context (framing the image), 61	Sync Settings option, 136
Contrast:	Tone Curve option, 140
develop module, 135	Vibrance option, 139
exposure, 48	white balance, 129-30
light, 95	Diagonal lines, 68
Copy for photographic essays, 215	Diffraction, 12, 76
Corner sharpness, 12	Diffusion in lighting on location, 115
Correction, exposure, 48	Digital asset management (DAM), 22, 32
Creative controls, 71-86	Digital Camera System (DCS), 2
decisions, 82	Digital histogram (exposure compensation), 100
focus, 73-7	Digital manipulation of images, 213-4
perspective, 83	Digital single lens reflex (DSLR) cameras:
Creative decisions, 82	development, 2-3
Crop tool, 147-8	dynamic range, 7
Cross platforms in Lightroom, 23	fixed lens digicams, 14
Curves, 68	ISO settings, 9
Custom profile in Photoshop, 163	LCDs, 15-19
Custom prome in Photoshop, 105	lenses, 12, 193, 209
DAM see digital asset management	live view, 18
Data distribution (exposure), 52	megapixels, 5
Daylight, 89	noise, 10
Daylight balanced fluorescent lamps, 118	previsualization, 97
DCS see Digital Camera System	sensors, 6, 8
Decisive moment, 65	speed, 13
Dedicated flash units, 111	viewfinders, 15-19
Depth of composition, 69, 179	
	Digital storage unit (DSU), 2
Depth of field, 74-5, 77, 193	Direction of light, 94
Design:	Direction of subject in environmental portraits, 197
environmental portraits, 191	Distance in depth of field, 75
line, 67-8	Distribution of photographic essays, 215
Detail:	Documentary in landscape history, 173
Images, 208	Dominant tones (exposure), 46
landscape, 183	Double exposures, 120
noise reduction, 143-6	DSLR cameras see digital single lens reflex cameras
Develop module:	DSU see digital storage unit
'Before & After' option, 135	Duration of exposure:
brightness, 135	camera shake, 80

light, 36, 40-1, 78-81	location lighting, 99-100, 101, 122
panning, 79	meter readings, 42, 45
shutter speeds, 40-1, 78, 80, 81	multiple, 57
Dynamic range, 7, 53, 121-2	night photography, 184 shutters, 40-1, 43
Early light, 94	time, 36
Editing of stories, 212	TTL meters, 42-3, 44
Electronic flash units, 112	Expression of subjects, 197
Electronic viewfinders (EVFs), 16, 17	Expressive techniques in landscape, 176-82
Emerson, Peter, 171	Extended shutter speeds, 81
Environmental portraits, 189-200	Extreme brightness range for landscape, 177
characters, 194, 198	Extreme contrast, 97-8, 107
composing two or more people, 192	
connection with subject, 195	F-number, 39
contact with subject, 196	F64 group (landscape history), 172
depth of field, 193	Familiarity with subject for environmental portraits, 196
design, 191	Farm Security Administration (FSA), 203, 216
direction of subjects, 197	Fast shutter speeds, 78
familiarity with subject, 196	File management in Lightroom, 24
format, 191	Fill flash for lighting on location, 116
interaction with subject, 196	Fill light for lighting on location, 107
lenses, 193	Fill Light Slider, 10, 134
motive, 196	Filters:
value, 196	neutral density, 102
Epson R800 printer, 162	polarizing, 103
Establishing image, 207	UV, 102
Ethics in photography, 213	Filtration of light, 102-3
Evans, Walker, 173	Firelight, 89
EVFs see electronic viewfinders	Fixed lens digicams, 14, 16
Expodisc, 131	Flash for lighting on location, 109-11, 114, 117
'Exposing right' option, 55, 57	Flash to subject distance (FSD), 112
Exposure:	Fluorescent light, 89
Adobe Camera Raw format, 50, 53, 54-7	Focal length:
apertures, 36, 43	depth of field, 75
appropriate, 37	landscape, 182
average tones, 45	Focal plane shutter, 41
banding, 52, 57	Focus, 73-7
bracketing, 122	depth of field, 74-5
color, 49	diffraction, 76
compensation in location lighting, 99-100, 101	electronic viewfinders, 17
contrast, 48	selective, 77
correction, 48	Format:
data distribution, 52	framing for environmental portraits, 191
definition, 36	landscape, 178
develop module, 131-3	Framing the image, 59-70
dominant tones, 46	balance, 63
duration, 40-1, 78-81	communication, 61
	content, 62
'exposing right' 55, 57 histogram optimization, 49	context, 61
intensity, 38-9	decisive moment, 65
JPEG files, 47	depth, 69
levels, 47	line, 67-8
icveis, T/	11110, 07-0

rule of thirds, 64	exposure compensation, 99
subject placement, 63	extended shutter speeds, 81
vantage point, 66	Inverse Square Law, 91
FSA see Farm Security Administration	landscape, 170, 187
FSD see Flash to Subject Distance	light, 92
	lighting on location, 124
Full forms assessed 8	photographic essays, 201, 202, 208
Full frame sensors, 8	Hasselblad H2D camera, 5, 6
C.1 - W.1	High dynamic range in lighting on location, 121-2
Galer, Mark:	Highlight detail for printing, 166
asset management, 21, 34	Hine, Lewis W., 202
back lighting compensation, 101	
communication and context, 61	Histogram:
composing two or more people, 192	high dynamic range, 121-2 levels, 49
content, 62	
creative controls, 72, 86	optimization for exposure, 49
depth, 69	History of landscape, 170-3
depth in landscape, 179	Home master catalog in Lightroom, 26-7
digital cameras, 1	Honesty in photographic essays, 211
environmental portraits, 189, 200	Horizon line, 178
exposure, 37, 58	Horizontal lines, 67
extreme brightness range in landscape, 177	Hot-spots with flash lighting, 114
extreme contrast, 98	Hue, Saturation and Luminance (HSL), 140-2
fill lighting, 107, 108	
format and horizon line, 178	Illustrated Daily News, 202
framing the image, 59, 70	Image posterization see banding
high dynamic range, 121	Images:
landscape, 169, 176, 187	action, 207
light, 87	detail, 208
light direction, 94	digital manipulation, 213
lighting on location, 105	establishing, 210
line, 67	framing, 59-70
panoramic images in landscape, 181	stabilization, 19
photographic essays, 217	story editing, 207
polarizing filters, 103	Import options for master catalog (home), 27
post-production editing, 125-52	In-camera noise suppression, 11
scale for landscape, 182	Incident light meters, 44
selective focus, 77	Inkjet printers, 158-9
subject contrast, 95	Intelligent memory management in Lightroom, 24
subject contrast, 99	Intensity of light (role in exposure), 36, 38-9, 90
vantage point, 66	Interaction with subject for environmental portraits, 196
Glossary, 219-26	Inverse Square Law of light, 91
GN see guide numbers	ISO settings:
	exposure, 36
Goldsworthy, Andy, 185	image stabilization, 19
Grayscale, 140-2	levels, 4
Guide numbers (GN) for electronic flash units, 112-13	luminance noise, 144
11.1	night photography, 184
Halogen lamps, 118	noise, 10, 11
Harvey, Orien:	
asset management, 33	photographer's presence, 210
creative decision, 82	sensors, 9
decisive moment, 65	shutter speeds, 40, 78
environmental portraits, 190, 191	

JPEG files:	color, 93
color correction, 93	contrast, 95
dynamic range, 7	direction, 94
exposure, 47	dynamic range, 97
high dynamic range, 121	exposure compensation, 99-100
landscape, 177	extreme contrast, 97-8
Raw format, 11, 13, 50	filtration, 102-3
white balance, 129	intensity, 90
Judgement of exposure compensation, 100	Inverse Square Law, 91
	landscape, 177
Karuson, Itti, 63, 171	latitude, 97, 107
Killen, Sean, 198	measurement, 37
Kit lenses, 12	neutral density filters, 102
Kodak DCS 100 camera, 2	polarizing filters, 103
	previsualization, 97
Landscape, 169-88	quality, 92
alternative realities, 175	reflectance, 90
composition, 178	sources, 89
constructed environment, 185	
contrast, 121	UV filters, 102
depth, 179	Lighting on location, 105-24
detail, 183	bounce flash, 115
	daylight balanced fluorescent lamps, 118
documentary, 173	diffusion, 115
expressive techniques, 176-82	double exposures, 120
extreme brightness range, 177	exposures, 122
focal length, 182	fill flash, 116
format, 178	fill light, 107
history, 170-3	flash, 109-11
horizon line, 178	flash as key light, 117
light, 177	flash as primary light source, 114
macro lens, 183	guide numbers, 112-13
merge to HDR option, 177	halogen lamps, 118
naturalism, 171	high dynamic range, 121
night photography, 184	reflectors, 108
open/closed, 178	slave units, 117
panoramic images, 180-1	slow-sync flash, 119
personal expression (history), 174	Lightroom, 126-52
pictorial photography (history), 171	archiving, 32
'Realism', 173	Auto Tone option, 128
scale, 182	'Before & After' option, 135
Lange, Dorothea, 203	catalog combining, 32
Late light, 94	Clarity option, 137-8
Latitude of light, 97, 107	Compare View option, 136
Law in photography, 213	contents, 23-4
LCD (liquid crystal display) screens, 15-19	databases, 23
Leaf shutter, 41	Detail option, 143-6
Leica cameras, 15	Develop module, 129-146
Lens controls, 73	digital asset management, 22, 23-4, 25-32
Lenses, 12, 193	dynamic range, 7
Levels for exposure, 47	Fill Light option, 134
Light, 87-104	Grayscale, 140-2
brightness, 96	Hue, Saturation and Luminance option, 140-2
0	1 rue, oaturation and Lummance option, 140-2

location catalog, 28-30, 31-2	vibration reduction system, 19
master catalog (home), 26-7	Noakes, Kim, 204
metadata templates, 31	Noise:
noise suppression, 11	duration of exposure, 81
optimization of photos, 126	ISO settings, 10
printing, 154, 167	suppression, 11
Quick Develop option, 127-8	
Show Clipping option, 132-3	Off-camera flash, 114
Split Toning option, 142	Olympus cameras, 6
Tone curve option, 140	Open landscape, 178
tool options, 147-51	Orchard, Matthew, 175
Vibrance option, 139	Ouchterlony, Ann, 194
Virtual Copy option, 128	Overexposure, 36, 48
White Balance option, 129-31	
workflow, 25-32	Panasonic cameras, 6
working catalog (location), 28-32	Panning (duration of exposure), 79
Line design, 67-8	Panoramic images in landscape, 180-1
Live view, 18	Part, Martin, 175
Location catalog in Lightroom, 28-30, 31-2	Passive subjects, 197
Location lighting see lighting on location	Personal expression in landscape history, 174
Luminance noise, 144	Perspective, 83
	Photo agencies, 203
Macro lens for landscape, 183	Photographer's presence in photographic essays, 210
Magnification factor in sensors, 8	Photographic essays, 201-18
Magnum photographic agency, 203, 216	close-up detail, 208
Manual focus with electronic view finders, 17	copy, 215
Master catalog (home) in Lightroom, 26-7	distribution, 215
Matrix metering, 42	ethics, 213
Megapixels, 4-5	honesty, 211
Merge to HDR option, 123, 177, 184	images, 207
Metadata templates, Lightroom, 31	law, 213
Meter indicated exposure (MIE), 43, 45, 46	photographer's presence, 210
Metering for exposure, 42, 45	portraits, 208
MIE see meter indicated exposure	sales, 215
Minamata (book), 203, 216	shooting ratios, 210
Monitors, 156-7	story capture, 206-8
Motive for environmental portraits, 196	story editing, 212
Moving in close style for photographic essays, 209	titles, 215
Multiple exposures, Adobe Camera Raw format, 57	visual communication, 204-5
1 1	working styles, 209-11
National Geographic magazine, 62, 199, 202, 216	Photographs reality check, 213
Naturalism in landscape history, 171	Photoshop:
Naturalistic Photography for Students of Art, 171	ACR data processing, 51
Neutral density filters, 102	Adobe RGB profile, 163
Newman, James, 105	color management, 158, 164
Night photography, 184	custom profile, 163
Nikon cameras:	Image Size dialog box, 4
DSLR development, 2-3	inkjet printers, 158
magnification factor, 8	levels, 49
megapixels, 5	Merge to HDR option, 123, 177, 184
sensors, 6	multiple exposures, 57
speed, 13	panoramic images in landscape, 180

print settings, 159, 161	Retouch tool, 150-1
printer preferences, 162, 164	Ricoh cameras, 15
printer profiles, 160	Riis, Jacob, 202
Photoshop Lightroom see Lightroom	Rodger, George, 203
Pictorial photography in landscape history, 171	Rothstein Arthur, 185
Point of focus for depth of field, 75	Rule of thirds, 64
Polarizing filters, 103	
Portraits:	S5 Pro DSLR camera, 7
environmental, 189-200	Sales of photographic essays, 215
lenses, 193	Saturation option, 139
story for photographic essays, 208	SBR see subject brightness range
Post-production editing:	Scale for landscape, 182
Develop module, 129-146	Seeing light, 88
optimization of photos, 126	Selective focus, 77
Quick develop option, 127-8	Semi-automatic exposure, 43
tool strip, 147-151	Sensors:
Posture of subjects, 197	charge coupled devices, 9
Presence (develop module), 137-8	CMOS, 9
Previsualization of light, 97	digital cameras, 6-11
Printers:	dynamic range, 7
accuracy, 165	full frame, 8
color characteristics, 158	in-camera noise suppression, 11
nozzles, 159	magnification factor, 8
preferences in Photoshop, 162, 164	noise, 10
profiling, 160	reduced frame, 8
settings in Photoshop, 159, 161	size and aspect ratio, 6
Printing, 153-68	Seymour, David, 203
Color Management, 155, 158	Shadow detail printing, 166
highlight detail, 166	Shadow management, 52
Lightroom, 167	Sharpening option, 145
monitor position, 156-7	Shooting:
shadow detail, 166	ratios, 210
workshop, 156	subjects decisively, 197
Profiling for printers, 160	Show Clipping option, 132-3
Projective style for photographic essays, 211	Shutter speeds:
Prosumer digicams, 6, 14, 16-17	exposure, 40-1, 43
1105umer digitalitis, 0, 14, 10-1/	extended, 81
Quality:	fast, 78
light, 92	slow, 80
megapixels, 5	Sigma DP1 camera, 7
Quick Develop option, 127-8	Single lens reflex (SLR) camera technology, 15, 17
Quick Develop option, 127 o	Size ratio, 6
Raw format see Adobe Camera Raw format	Size of reflectors, 108
Re-framing (exposure compensation), 100	Slave units, 117
'Realism' (landscape), 172	Slow shutter speeds, 80
Reality of photographs, 213	Slow-sync flash, 119
Receptive style for photographic essays, 209	Smith, W. Eugene, 203, 216
Red-eye, 114	Sontag, Susan, 170
Reduced frame sensors, 8	Sony cameras, 7
Reflectance of light, 90	Sources of light, 89
Reflectors for lighting on location, 108	Speed in digital cameras, 13
Remove Spots tool, 149	Speedlights, 112

Split Toning option, 142 Steep perspective, 83 Stern, Michael E., 71, 112, 188 Stieglitz, Alfred, 172 Story for photographic essays, 206-8, 212 Strand, Paul, 172 Subject brightness range (SBR), 96-7 Subjects: contrast, 95 framing the image, 64 portraits, 195-7 shooting decisively, 197 Suggested line, 67 Suppression of noise, 11 Surface quality of reflectors, 108 Sync Settings option, 136 Synchronized folders, Lightroom, 24 Szarkowski, John, 61 Talbot, Fox, 170 The Big Issue, 198 The Photographers's Eye, 61 'The Zone System', 121 Through the lens see TTL TIFF files: color correction, 93 high dynamic range, 121 landscape, 177 Raw format, 50 Time role in exposure, 36 Titles for photographic essays, 215 Tone Curve option, 140 Tones: average, 45 distribution, 52 dominant, 46 posterization, 10 Tool Strip options, 147-51 TTL (through the lens) metering: aperture priority, 43 back lighting, 101 centre-weighted, 42 extreme contrast, 98 flash, 111 incident readings, 44 matrix, 42 semi-automatic, 43 shutter priority, 43 Turner, William, 171 Tungsten light, 89 Underexposure, 36, 48

UV (ultra violet) filters, 102

Value of subjects in environmental portraits, 196
Vantage point, 66
Vertical lines, 67
Vibrance option, 139
Vietnam Vet Motorcycle Club, 206
Viewfinders, 15-19
Vignetting, 12
Virtual Copy option, 128
Visual communication:
comfort zone, 205
subjects, 204

Wardhana, Mikael, 190 Wennrich, Michael, 104, 184 Weston, Edward, 172 White balance, 129-31 Workflow in Lightroom, 25-32 Working catalog (location) in Lightroom, 28-32 Working styles for photographic essays, 209-11